agon

judith goldman

the operating system print//document

agon

ISBN 978-0-9860505-9-6
Library of Congress Control Number 2016911107

This text was set in USSR Stencil, Baskerville, Gill Sans Light, Minion, Franchise, and OCR-A Standard, printed and bound by Spencer Printing, In Honesdale, PA, in the USA, and distributed to the trade by SPD.

the operating system
141 Spencer Street #203
Brooklyn, NY 11205
www.theoperatingsystem.org
operator@theoperatingsystem.org

agon

judith goldman

advance praise for **agon**

"In the tragi-comic – and worse – chaos of our times – suppose our writing began to appear as letters caught in barcodes. Phrases and bits of words breaking off en route to scanners designed for registering information but not the disturbance of meaning. It is, literally, with this provocative vision that Judith Goldman's *agon* begins. Fragments – words with *ing* or *ite* or *ppeals* detached – mark the violence and folly of our weaponized and otherwise benighted cultures. At times, a necessary lyricism wells up without betraying the truth of 'Cumulative transfers By the "*agreed upon*" price / the Temp,est has of late stripped the pe,tals away.' There's even more to this many-genred book – one to be lived with, in the urgency of its poetry, its philosophical and socio-political inquiry – font of brilliance that sustains vitally agonistic conversation across perilous divides." — Joan Retallack

"The Commodification of Everything. That was the pivot point of materialist discourse not even five years ago. But now, it's time to crack open the piths of the most fundamental doings of our species. After the sweeping tide of ethnonational victories currently sweeping the globe, The Weaponization of Everything, is not merely the 'speak' of The Now, but the *do* of all its subjects, whether collusive or rebellious. Judith Goldman's *agon* is borne amidst this new reality. Few works of experimental literature aim so high as to flush out the full range affectual coordinates as to reveal their age's Agon as a controlling demigod of our own making, that is, to raise up the Agon's *agon*." — Rodrigo Toscano

"Judith Goldman's *agon* confronts the ubiquitous naturalization inherent in the weapon-ization of race, gender, global warming, poetics, language, utterance, politics, torture, immigration, and whatever else is changeable under the guise of aggression masquerading as mental freedom. '…the intensification of weapons already in place,' and '…observed nearly everywhere,' *agon* deftly solders ideas of defensive assimilation (weapons already in place) to our conscious and unconscious activities of daily living. One can only bow down in shock and awe to *agon*'s scorched earth dissemination of open-ended spaces to think, while thinking is still, hopefully, under what we presume is our jurisdiction." — Kim Rosenfield

Contents

A haplology [nonce index, nonce taxonomy, nonce theory]

Human Shield [Human shield multilevel marketing instructional video ONLY]

Acknowledgments/metadata

I suppose it is tempting, if the only tool you have is a hammer, to treat everything as if it were a nail.

Abraham Maslow, *Toward a Psychology of Being* (1962)

Since violence – in distinction from power, force, or strength – always needs implements…

Hannah Arendt, "Reflections on Violence" (1969)

because you use the security of disharmony as a
weapon, a tool to enter my foreign they say naivete
and assume my ecstasie, when what you receive
turns out a beating

John Wieners, "He's Not Here/No One's There" (1968)

Oh bondage! Up yours!

X-Ray Spex (1977)

Caveat emptor

Caveat lector

1 ‖ Fuck poems P lane ▌▌ 2 ‖ as bomb ▌▌ 3 ‖ Weaponized pork or ur ▌▌ 4 ‖ ine Force-feeding to weaponize sustenance ▌▌ 5 ‖ weaponized flinch response "we ▌▌ 6 ‖ don't have to train it out of ▌▌ 6a ‖ the body" ▌▌ 7 ‖ "we turn ▌▌ 8 ‖ it into a wea pon" ▌▌ 9 ‖ casuals kneeli ▌▌ 10 ‖ ng between ▌▌ 10a ‖ modular experience, experience rece ▌▌ 10b ‖ ssed weaponized affectlessness ▌▌▌▌▌▌▌ 1 ‖ non-users casi ▌▌ 2 ‖ no pathos Cultural anesthesia replacement exper ience ▌▌ 2a ‖ heat-seeking jun ▌▌ 3 ‖ k bonds data ▌▌ 3a ‖ smog inter ▌▌ 4 ‖ venes in the tabu lation of ▌▌ 5 ‖ others' data poor blank index or po ▌▌ 6 ‖ 11 Autopopulate To caption a pathos of ▌▌ 7 ‖ weaponized ▌▌ 7a ‖ narrative, auth ▌▌ 8 ‖ ority of narration v. tha ▌▌ 9 ‖ t of character weaponiz ▌▌ 9a ‖ ed deacc essioning weapon ▌▌ 10 ‖ ized sharing in epilepsy ▌▌▌▌▌▌▌ 1 ‖ the body weaponizes the tongue ▌▌ 1a ‖ A dirty bomb is not quite ▌▌ 2 ‖ weapons-grade A ▌▌ 3 ‖ dirty Concept? Conc ▌▌ 4 ‖ eptual severance uncha pe ▌▌ 5 ‖ roned concept QE D weaponize ▌▌ 5a ‖ d truth procedure pathway, as for deliv ▌▌ 6 ‖ ery friction burning wi ▌▌ 6a ‖ th a weaponized eraser ▌▌ 6b ‖ use a magnifying glass t ▌▌ 7 ‖ o weaponize the sun Man ▌▌ 8 ‖ as tool-Being as ▌▌ 9 ‖ weapon-Being Cunning To sh ▌▌ 10 ‖ ape vio lence *in potent* ▌▌▌▌▌▌▌

A potential inventory of current agon. But *failing this*, pointing instead to a possible contemporary mutated extenuation of dissensus in current economic, political, and social formations: its near-foreclosure by the hyper-militarization of hegemonic power; its near-immediate symbolic and other cooptation through social media and digital capitalism; its near-unpracticability given attenuations of agency, the complicities required for bare attrition-survival. Thus: to offer less a catalog of dissensual weaponization than an index of *an agony beyond agonistics, beyond antagonisms* (Chantal Mouffe): a flattening of dissensus through an absorptive cynicism, its affective undercurrent of continuous lateral aggression, an extended capillarity of neoliberal violence, the intensification of weapons already in place.

That contemporary forms of agency may be analyzed through the lens of weaponization (for they themselves use that lens) also suggests weaponization as the condition for recognition at this conjuncture: where everything – terms, spaces, movements, identities – will be incorporated as violence or will not be at all.

A ~~database: positivist catalog: system of toxic fragments~~

"regeneration through violence"

1 ▌▌ *ia* Bugs Bunny weaponizes a hot barb ▌▌ 2 ▌▌ er's towel A se e-
saw ▌▌ 3 ▌▌ too ▌▌ 3a ▌▌ easily weaponized, ▌▌ 3b ▌▌ banana peel ▌▌ 4
▌▌ Kool Aid ▌▌ 4a ▌▌ a set-up operatio ▌▌ 4b ▌▌ nalize weaponized
windo w, ▌▌ 5 ▌▌ defenestration ▌▌ 5a ▌▌ Silent premises of ▌▌ 6 ▌▌
everyday lif ▌▌ 7 ▌▌ e weapons possible ▌▌ 8 ▌▌ pain-platform compa
▌▌ 8a ▌▌ ratively underpollut ed ▌▌ 8b ▌▌ spectral arsena ▌▌ 9 ▌▌ l
linked to its dol lar ▌▌ 10 ▌▌ ablation ▌▌▌▌▌▌▌▌▌▌ 1 ▌▌ hurt the body
▌▌ 2 ▌▌ on the bar ▌▌ 3 ▌▌ s of the cage ▌▌ 3a ▌▌ but the cage
alread y ▌▌ 3b ▌▌ a weapon ▌▌ 4 ▌▌ "we" weapon ▌▌ 4a ▌▌ ized intimacy
subvoc al ▌▌ 5 ▌▌ does tear gas (also ▌▌ 5a ▌▌) weaponize tears ▌▌
6 ▌▌ Weaponized dummy ▌▌ 7 ▌▌ hand Multiple bright ▌▌ 8 ▌▌ yellow
warning ▌▌ 9 ▌▌ signs all over the ▌▌ 10 ▌▌ packaging between
▌▌▌▌▌▌▌▌▌▌ 1 ▌▌ weaponized elevator in act ▌▌ 1a ▌▌ ion films ▌▌ 1b ▌▌
mecha nical persecuting ▌▌ 2 ▌▌ world ▌▌ 3 ▌▌ linked to the species
through ▌▌ 4 ▌▌ its motor style ▌▌ 5 ▌▌ Vertigo of the persecuti ▌▌
6 ▌▌ ve structure "Organs ▌▌ 6a ▌▌ exoscopically represented,
growin ▌▌ 7 ▌▌ g wings for inter ▌▌ 7a ▌▌ nal persecutions" Where
man ▌▌ 7b ▌▌ does no longer encounter ▌▌ 8 ▌▌ himself or: Where man
in fact ▌▌ 8a ▌▌ encounters himself Your mirror ▌▌ 9 ▌▌ image
weaponized as som ehow ▌▌ 9a ▌▌ tal ler than you ▌▌ 10 ▌▌ Sees self

The anatomization of a persecutory world and its hidden, inner mechanism or principle of persecution; a paradoxical faith in its exposure; the tautological quality of its revealed meaning (always the same message); the seeming inertness of such disclosure, given that it so often amounts to "the receiving again of knowledge one already knows"... No doubt this text you are reading engages in what Paul Ricoeur termed the "hermeneutics of suspicion" and what Eve Sedgwick called "paranoid reading": a form of "strong theory" that involves, in addition to the above, a "monopolistic strategy of anticipating negative affect."

And there is no getting out of it by noting that to use the term "weaponized" is itself paranoiac: an accusation of illicit or paralicit maneuver. A paranoid reading of paranoid reading, which then participates in its subject: this text traces not only the present currency of "weaponization," but, too, proposes the phenomenon might be observed nearly everywhere.

through Rivalry with ▌▌ 10a ▌▌▌ self ▌▌▌▌▌▌▌▌▌▌ 1 ▌▌▌ narcissism As weaponry ▌▌▌ 2 ▌▌▌ Weaponized mimesis: not ▌▌▌ 3 ▌▌▌ similar to anything just simila ▌▌▌ 3a ▌▌▌ r, a "likeness" But with no such sensation of ▌▌▌ 3b ▌▌▌ being absorbed ▌▌▌ 4 ▌▌▌ Weaponized exacerbation Exacerb ation ▌▌▌ 5 ▌▌▌ of a duty had been called ▌▌▌ 6 ▌▌▌ back into some kind of ▌▌▌ 7 ▌▌▌ service That my hands are ▌▌▌ 8 ▌▌▌ more than just hands For ▌▌▌ 8a ▌▌▌ my arms to click Weaponized ▌▌▌ 9 ▌▌▌ animacy burden of liveness "mentality" Retraining Weaponized back- ▌▌▌ 9a ▌▌▌ forma tion: and my Head is ▌▌▌ 10 ▌▌▌ Trojan ▌▌▌▌▌▌▌▌▌▌ 1 ▌▌▌ What is ▌▌▌ 2 ▌▌▌ Injury ▌▌▌ 3 ▌▌▌ The mind made ▌▌▌ 4 ▌▌▌ flesh ▌▌▌ 5 ▌▌▌ Whose brains are red ▌▌▌ 6 ▌▌▌ jelly Stu ck invisible ▌▌▌ 7 ▌▌▌ stri ngs attach it to the ▌▌▌ 8 ▌▌▌ image "You draw your har ▌▌▌ 8a ▌▌▌ ness after you" Judas a weaponized ▌▌▌ 8b ▌▌▌ Kiss ▌▌▌ 9 ▌▌▌ Toothbrush as ▌▌▌ 10 ▌▌▌ Shiv Or cake wit ▌▌▌ 10a ▌▌▌ h a file bak ed into it ▌▌▌▌▌▌▌▌▌▌ 1 ▌▌▌ Pistol-whip: to clock ▌▌▌ 2 ▌▌▌ with a gun Gun weapon ▌▌▌ 3 ▌▌▌ ized when used to pistol- ▌▌▌ 4 ▌▌▌ whip or clock geo metry, algebra, as Calculus ▌▌▌ 4a ▌▌▌ For weaponry ▌▌▌ 5 ▌▌▌ Weaponized gut ter Shedding ▌▌▌ 6 ▌▌▌ its ice ▌▌▌ 7 ▌▌▌ Like fists beating ▌▌▌ 8 ▌▌▌ make a fis t ▌▌▌ 9 ▌▌▌ parody as weap onized homa ▌▌▌ 10 ▌▌▌ ge (?) weaponize ▌▌▌▌▌▌▌▌▌▌ 1 ▌▌▌ d conne ctives weaponized ▌▌▌ 1a ▌▌▌ aim-inhibi ▌▌▌ 1b ▌▌▌ tion Pleasure follows

we often find traces of such an attitude even in the most 'normal' and caring
fathers:
all of a sudden, the kind father explodes into a father-Thing,
convinced to dig beneath the existing river bed
another channel into which all the dirt would be directed,
so that there would have been two rivers, the deep one with all the
pollution,
and the surface one
it pretends simply to inform
This recruited sales force as the participant's 'downline'
If there is even a real product or service involved.
it is an implicit injunction
through the air and water supply
the father as air and water supply
borrowing from the future
to withhold the missing piece
making it the body of something else.
The children gathered round
In fear of the storm that is the father's imminent arrival
Living to feel the love.
The violation is carried out to make it signify
the body's two bodies.

Yet Sedgwick potentially undamns such reading by offering, first, the idea that "an insistence that everything means one thing somehow permits a sharpened sense of the ways there are of meaning it." It may be that "a plethora of only loosely related weak theories has been invited to shelter in the hypertrophied embrace of [an] overarching strong theory." Such pleasurable intricacies are the room thought takes. She suggests as well that not every paranoid reading involves the dynamic of disclosure: "forms of violence that are hypervisible from the start may be offered as an exemplary spectacle rather than remain to be unveiled as a scandalous secret." In a "wrestle of different frameworks *of* visibility…violence is combatted by efforts to *displace and redirect* (as well as simply expand) its aperture of visibility" (her italics). One might thus point up weaponization as spectacle without participating in spectacularity. Even, perhaps, when one is re-performing that. Though Sedgwick has little positive to say about exposure – what, after all, would be the point of exposure when the drive to expose is under scrutiny? – she acknowledges that not all modes of visibility and rendering visible match.

Might a paranoid text ask for a fully initiated reader? One aware that "interpretive disorder" (Timothy Melley) is a matter of perspective, that to evince an extra-hegemonic understanding involves less a will-to-disclose than a shared exhaustion with upholding modes of coded neutralization, with bearing up under forms of somehow licit, targeted aggression that are hardly an open secret? For instance, the contemporary salience of accusations of paranoia: yes, *weaponized* paranoia. A disallowing of disallowed, discredited knowledge.

An inquiry into the language of administered reality feeding back: its genres of damage.

▐▌ 2 ▐▌ the Will str ▐▌ 3 ▐▌ uctures anticipa tion Term ▐▌ 3a ▐▌ inator see ds ▐▌ 4 ▐▌ weaponiz ed modification Pu ▐▌ 5 ▐▌ sh to failure ▐▌ 6 ▐▌ weaponized mitigation ▐▌ 7 ▐▌ reversibility tan ▐▌ 8 ▐▌ tamount to un ▐▌ 9 ▐▌ harm posthar ▐▌ 10 ▐▌ m autoantonym, ▐▌▐▌▐▌▐▌▐▌ 1 ▐▌ antithesis expressed b ▐▌ 2 ▐▌ y the same word Taking ▐▌ 2a ▐▌ the space reserved ▐▌ 3 ▐▌ for the other possibi ▐▌ 4 ▐▌ lity debility weapon ▐▌ 5 ▐▌ nized weaponized bl ockage ▐▌ 5a ▐▌ weaponized inclusion you were ▐▌ 6 ▐▌ consulted but [surface-effec ▐▌ 7 ▐▌ t certified] ▐▌ 7a ▐▌ what you said was not "m y kind ▐▌ 8 ▐▌ of people" inclusion pa ▐▌ 8a ▐▌ ssivity ▐▌ 9 ▐▌ weaponized minibar subs ▐▌ 9a ▐▌ umption face down T ▐▌ 10 ▐▌ o use the Assets Panel ▐▌ 10a ▐▌ you must def ▐▌ 10b ▐▌ ine the Site ▐▌▐▌▐▌▐▌▐▌

[Tools are] human praxis congealed in material form, and contain in themselves as a structural imprint the instrumental logic of the use for which they were fabricated… Tools are also unique in being capable of misuse…in a way that…takes advange of some feature of their design… This practice may be called *use-against-design,* or… *tool abuse*… The concern here is with the kind of intelligence involved in misuse, an intelligence fundamental to the ancient Greek quality of μετης or cunning.

Precipitancy…must often have been an important feature of tool abuse…[which] probably occurred especially in homicides that happened suddenly, and the idea of the sudden has in fact a history in early modern criminal law. […] The language of suddenness constitutes the essential mark that distinguishes manslaughter from murder as a homicide deliberate yet unpremeditated.

In the act itself…the tool is rediscovered as an object…with a different and height- ened relation to use. […] The abuser's new sense of what he or she is doing includes acknowledgment of a newly complicated relation to the tool, and, it would seem, a partial ceding of instrumental agency.

Tools can behave unpredictably when they are abused.

Luke Wilson, "Renaissance Tool Abuse and the Legal History of
the Sudden" (2005)

Luke Wilson's analysis of tool abuse links it to the rise of a legal "grey area of culpability," the category of manslaughter. On one hand, it is the "unpremeditated" quality of such a murder, its suddenness evident in tool abuse, that mitigates it. On the other, murder is also blunted by use-against-design's seeming disruption of the subject-object order: the newly weaponized tool achieves a hyperbolic instrumentality, displacing the agency of its user, who must yet simultaneously exercise extraordinary practical agency to misuse the tool. Tool abuse is split between intended and unin- tended homicide: tools may resist their users as ineffective or overly effective weapons.

A boar-spear, a pair of shearing shears, a gathering-hook, a hedging-bill, a cart-staff, a plough-goad, an oar, a chisel, a horsecomb: named over years of English assize calendar cases, the tools abused, as Wilson notes, are heavily class coded, while their misuse may "figure social conflict": who beat their ploughshares to swords and pruning-hooks to spears. Identified in the legal record for having been unusually used, they speak the habitual context of those who use them and the lines crossed in abuse.

Men and women tortured during the period of martial law in the Philippines, for example, described being tied or handcuffed in a constricted position for hours, days, and in some cases months to a chair, to a cot, to a filing cabinet, to a bed; they describe being beaten with "family-sized soft drink bottles" or having a hand crushed with a chair, or having their heads "repeatedly banged on the edges of a refrigerator door" or "repeatedly pounded against the edges of a filing cabinet." The room, both in its structure and its content, is converted into a weapon, deconverted, undone. Made to participate in the annihilation of the prisoners, made to demonstrate that everything is a weapon…[I]n the conversion of refrigerator into a bludgeon, the refrigerator disappears; its disappearance objectifies the disappearance of the world… experienced by a person in great pain; and it is the very fact of its disappearance, its transition from a refrigerator into a bludgeon, that inflicts the pain The domestic act of protecting becomes an act of hurting and in hurting, the object becomes what it is not.

Elaine Scarry, *The Body in Pain: The Making and Unmaking of the World* (1987)

In reading torture as a language, Elaine Scarry focuses on weaponry as a particular kind of signifier: the torturer's arsenal speaks a repletion of agency, a capacity to produce pain that functions as an index of power. Torture is a language because it reflexively objectifies and dramatizes *agency-pain-power* in, among other things, its weapons as tool-symbols. Pain abets torture's fantasy of absolute power insofar as it is world-destroying: the internal world is annihilated by pain. It is the cunning of torture, however, to objectify and confirm this subjective experience by weaponizing the world. If shelter and its domestic accoutrements exist to protect and make safe, in torture they are ironized, weaponized, made agents of destruction. The weaponization of the world-supporting object creates a value-added pain by signifying and realizing loss of world.

What would it mean for the "ordinary world" to succumb to a low-level ironizing aggressivity – yet seemingly almost without agency, its source highly mediated so as to be seemingly unreachable, untraceable?

Two birds, the one watching and passive, the other enjoying its activity
One that never enters into life
The same look of whimsical detachment on the face
Where the vagina is taken on lease from the rectum
Of seeing the anus as the site of transaction
As god the father or otherwise.
God can always pull out.
They are going to the mall.
Vagina as front bottom
There's a amateur video of a girl upside down in a bath, with a bag over
the head and handcuffed, who 'dies'
But there's another video of the same girl, dying.
tied or not, one can swing there legs around. Seriously lay on your back stick
your legs together in the air and see for yourself.
..and the stranger raised himself up and the shadow over on the
neighbor's balcony also raised itself up; and the stranger turning himself
around and the shadow also turned itself around;
affecting the capacity to pay.
He was fracking me
What goes in may come out.

1 ‖ hit the lock but ‖ 2 ‖ ton on remote ‖ 3 ‖ to ma ke alarm ‖ 3a ‖ chirp check status of your ‖ 4 ‖ character service ‖ 4a ‖ weaponized character lock ‖ 4b ‖ feature using key frames ‖ 5 ‖ frame fun ction ‖ 5a ‖ weaponized parergon ‖ 6 ‖ weaponized Laugh track or auxil ‖ 6a ‖ iary weaponized cut ‖ 6b ‖ weaponized pan ‖ 7 ‖ weaponizing off-screen ‖ 8 ‖ pro-filmic area in fr ‖ 8a ‖ ont of camera record ‖ 9 ‖ ing field the realit ‖ 10 ‖ y or situation ‖ 10a ‖ happening in fro ‖‖‖‖‖‖‖ 1 ‖ nt of the camera po ‖ 2 ‖ sition and angle what's ‖ 3 ‖ in the picture establish ‖ 4 ‖ es understan ding ‖ 5 ‖ of what is seen ‖ 6 ‖ weaponized viewfinder ‖ 6a ‖ steadicam or dash cam ‖ 7 ‖ weaponized playback ‖ 7a ‖ photosh op to weaponize a photo ‖ 8 ‖ stock photo ‖ 9 ‖ weaponized compression, glitch ‖ 10 ‖ dot-density ‖‖‖‖‖‖‖‖ 1 ‖ weaponized username ‖ 1a ‖ weaponized password ‖ 2 ‖ Go back to a ‖ 2a ‖ nother saved state and ‖ 3 ‖ choose ano ther dia ‖ 3a ‖ logue option ‖ 4 ‖ weaponized blockchain, side ‖ 4a ‖ chains or entry chains wea ‖ 5 ‖ ponized locking out, remote ‖ 6 ‖ locking weaponized activation, de ‖ 6a ‖ activation, reactivation ‖ 6b ‖ granting managed access ‖ 7 ‖ so-called "protection" softwa ‖ 7a ‖ re weaponized plug-in ‖ 7b

"Cruel optimism" (Lauren Berlant) names the predicament of holding onto what under-mines you: what seems enabling and promissory in fact threatens and damages you, yet to lose it would be unlivable. Such attachment may involve investment in superannuated expectations about how life will "add up" in a new historical situation of "the ordinary as an impasse shaped by crisis," a state of social disintegration in which such fantasies no longer (can pretend to) obtain. Yet cruel optimism emerges even as one adjusts to "the chaos of intimate and economic upheaval," in that "modes of living on" and "making sense of and staying attached to whatever there is to work with, for life" take place in circumstances where "life building and the attrition of human life are indistinguishable": "The labor of reproduc-ing life in the contemporary world is also the activity of being worn out by it."

The culture of weaponization displaces these more and less dramatic ironies, in a kind of distorted recognition: powerless to point a finger in the tangle of distributed and temporally distended agency that produces "slow death" (Berlant) and "slow violence" (Rob Nixon), it adumbrates this state of affairs (and its accompanying "agency panic" [Melley]) in a more desperately agentive form. To say something is "weaponized" is to call out the (ulterior) motive behind it, to disclose another's discovery of a latent potential to damage. It is to attri-bute sovereign agency, while to weaponize in turn is to take up the fantasy that one might be sovereign, too. As performance of obscene enjoyment or envy of another's, under emerging social conditions of the joyless "imperative to enjoy" (Todd McGowan).

Berlant further suggests that the pervasive uncertainty, loss of convention, and improvisatory character of the "shapelessness of the present" may entail the "*unbinding* of subjects" – that is, their *de*tachment. Life extempore in the impasse of "the destruction of habit" cultivates meta-instrumentality, the disposition and the cunning to weaponize expediently.

Homo homini lupus
And if we say once that people can be
trusted, and at another time that they are wolves to be feared, and if
both statements ring true or at least partly true – then it seems that
what people are or appear to be depends, on the kind
of world we live in. Moreover, if what we think about each other reflects
what we are, it is also true that what we are is itself a reflection of what
we believe ourselves to be; the image we hold of each other and of all of
us together has the uncanny ability to self-corroborate. People treated
like wolves tend to become wolf-like;

We will never know for sure whether 'people as such' are

wĕpen n. Also **wepene, wepin, wepon(e, wepoun, wep(p)un, wepne, weppen, wappin, wipne,** (WM) **weopne,** (chiefly N) **wapen, wapin, wapon,** (late or 16th cent.) **weapon, weppon, wappon** & (early) **waepen, waepne,** (infl.) **wæpnen** & (?error) **wapping,** (errors) **wepe, wepned, weppont, wenpne**; pl. **wepen(e)s,** etc. & **wep(p)en, wep(p)in, wepon, wepoun, wepne, weppun, wopen,** (chiefly N) **wapen,** (N) **wapine, wapinnez, waipinnez, wappen,** (N or early) **wapne,** (late) **weipin** & (early) **wepnen, wæpen, wæpne(n, weapne(n, wapnes, wapnen,** (SWM) **wepnan,** (dat.) **wepnum** & (?error) **wappyings,** (errors) **wepnesis, wap(p)a.**

1. […] (c) fig. and in fig. context: a spiritual weapon, either offensive or defensive […] (d) any implement or object not ordinarily used to injure or kill but serviceable for offense or defense in an attack, an improvised weapon. […] 2. In misc. senses: (a) a part of an animal's body serving as a natural defense against attackers or as a means of attack. *Middle English Dictionary*

||| weaponized dow nload ▥ 8 ||| weaponized att achment ▥ 9 |||
weaponized data ▥ 9a ||| weap onized d ▥ 10 ||| atadump ▥▥▥▥▥▥ 1 |||
weaponized spreadsheet metadata omnidata ▥ 2 ||| dark data [outside
the dataset] ▥ 3 ||| weaponized cross-reference ▥ 4 ||| content ▥
4a ||| sold to other users ▥ 5 ||| overrun by context cut and paste
▥ 6 ||| intuitive ▥ 7 ||| weaponized user-friendliness ▥ 8 |||
weaponized interface ▥ 9 ||| "significant surface" ▥ 9a ||| dioptric
device ▥ 10 ||| erases traces ▥▥▥▥▥▥ 1 ||| of its own functioning ▥
2 ||| transparency immediacy ▥ 3 ||| to cast a glow of unwork ▥ 3a
||| weaponized operabil ▥ 4 ||| ity or inoperability ▥ 4a |||
relation er ases itself ▥ 5 ||| weaponize d hard drive hardware ▥
6 ||| terminal ▥ 7 ||| only way to ▥ 8 ||| make $$$ with hardware i ▥
9 ||| s to sell somet hing else get ▥ 10 ||| consu mers to pay for ▥
10a ||| the device + ▥ 10b ||| exper ience ▥▥▥▥▥▥ 1 ||| ultra-low
latency 360° head-track ing ▥ 2 ||| Ocul us Rift is a virtual ▥ 3
||| reality headset imm ▥ 3a ||| ersion in drone-mediated phys ▥ 4
||| ical reality weapo nized modification ▥ 5 ||| wea ponized
virtual space weap ▥ 6 ||| onized virtual memory ▥ 6a ||| executable
lang ▥ 6b ||| uage source code ▥ 7 ||| weaponized path dependence ▥
8 ||| weaponized trunca tion ▥ 9 ||| goto stat ement

Thogh we had in oure handes / but a clod
Of eerthe / at your heedes to slynge or caste,
Were wepne ynow / or a smal twig or rod
The faith of Cryst / stikith in vs so faste!

Thomas Hoccleve, *Address to Sir John Oldcastle* (1415)

considered harmf ul ▮▮ 10 ▮▮ called with com mand line argument X
▮▮ 10a ▮▮ weaponized null ▮▮▮▮▮▮▮▮▮▮ 1 ▮▮ weaponized sla ▮▮ 2 ▮▮ sh
recur sion feedback ▮▮ 3 ▮▮ weaponized ite ration ▮▮ 4 ▮▮ weaponized
open source ▮▮ 5 ▮▮ weapon ized algo rithm ▮▮ 6 ▮▮ weaponized
recombination ▮▮ 7 ▮▮ database ont ology ▮▮ 8 ▮▮ weaponized archive
▮▮ 9 ▮▮ weaponized platform ▮▮ 10 ▮▮ weaponized browser ▮▮▮▮▮▮▮▮▮▮ 1 ▮▮
weapo nized Inbox ▮▮ 2 ▮▮ weap onized read-only ▮▮ 3 ▮▮ weaponized
format ▮▮ 4 ▮▮ weaponized copy, copying ▮▮ 5 ▮▮ weaponized
reproduction weapon ▮▮ 6 ▮▮ ized compos iting ▮▮ 6a ▮▮ weaponized
chrom atics ▮▮ 7 ▮▮ weaponized satu ▮▮ 7a ▮▮ ration Desa turated hue
▮▮ 8 ▮▮ weaponi zed pastel ▮▮ 9 ▮▮ weaponi zed self-simila ▮▮ 10 ▮▮
rity no scale ▮▮▮▮▮▮▮▮▮▮

"Weaponized" = makeshift. As applied to a *neutral, innocent,* or even *hospitable* object; also a particularly *weak* object (*flipped it*). The unlikely weapon spins narrative around it, spreading a generalized irony. But unstable. – A strength hidden *in* liability, or one hidden *by* it?

Yet "weaponized" equivocates further. Its slippery positionality. Ambidextrous. Anamorphic. (Weapons backfire.)

Like a double genitive, "weaponized" may take a ballisticized, subjective form, or a receptive, objective (objectified) form. Eyes weaponized might give a glare or be marked for a fistful of keys; a weaponized playground as one where children are vicious or abducted. Weaponized unease: for me to hurt you with my anxiety, or *for you to hurt me with it?*

That which is defended – a walled city as weaponized ("*the best offense is a…*"). Or, inversely: a known softspot made fatally vulnerable – say, weaponizing someone's vanity.

weaponized foot, lotus
gait, the ti-
ny steps and
swaying wal
-k of a wom-
an with b-
ound fee-
t. toes cu
-rled under
, pressed with g-
reat force dow-
nwards, into
the sole
'til they b-
reak. brok-
en toes held t
-ightly again
-st the sole
, foot dra-
wn down st
-raight with
the leg, arch
of the fo
-ot for-
cibly br-
oken. her m
-ovement
more dainty,
the primar-
y erotic effec-
t

Anything can be weaponized. Even a weapon. ("Weaponized" as intensifier.)

> Because this weapon rules out combat and because it transforms war…into
> a unilateral relationship of death-dealing…, it surreptitiously slips out of the
> normative framework initially designed for armed conflicts.

Grégoire Chamayou, *A Theory of the Drone* (2013)

(war weaponized)

Flechette rounds Radically Invasive Projectile
The last round you'll ever need Expanding bullets prevent over-penetration
(shooting through a
target)
Hollowpoints fragment, causing extra wound channels
Frangible bullets a prescored outer jacket with a plastic round nose contain-
ing compressed lead
shot The tip is coated with a black lubricant and has six prescored serrations
designed to open
outwards upon impact

The jácket / of the búllet / is thíckest / at its típ

supports the claw-like
petals as the bullet pass-
es through the body

(weaponized bullets)

On November 19, 1942, on the corner of Czeczky and Mizkewitz Streets, Karl Gunther shot Bruno [Schulz] and, as the story goes, went to Landau and said, "I killed your Jew." To which Landau replied, "In that case, I will now kill your Jew."

David Grossman, *See Under: LOVE* (1986)

This is in Cop font
Where no negation can come
It is what makes individuals identifiable
When you kill yourself but kill the wrong 'me'
As if language were a flapping sail that could be re-secured to the mast
. Okay maybe the water was running first but how did she tie her own
feet above her head.
Getting rid of the thing to which meaning fastens
Images intended to be lodged in others
Which offer meaning in a mode to dispose of it.
You are coached to throw it away
This scale will weigh your thoughts
in order we must dispose of.
The body blinks
what it is the index of
Sunk into the grain of the wood.
The bed next to a pannier of coals
I am seeing behind my head These flat relics In front of the crèche.
The clothes are scraped away.
The fill color
Or not the same as the fill color.

weaponized accusation (accusation as hollow?)
weaponized personhood – corporation as person; by adding to the whole Number of
free
 Persons, including those bound to Service for a Term of Years, and excluding
 Indians not taxed, three fifths of all other Persons
weaponized "refugee": _____ or citizen; _____ or terrorist
weaponized refuge, death by asylum
weaponized claim, claim too large for what it claims to cover
weaponized identification, regressive defense of identifying with one's persecutor
weaponized archive, as place of loss, not keeping/guarding
monochrome as painting weaponized
weaponized aesthetics, v. aestheticized violence (?); triage aesthetics
weaponized missed or missing experience; weaponized lapse, lacuna
 res gestae things done *historiae rerum gestarum* the stories told about them
weaponized skepticism
weaponized sandblasting Since his capture and incarceration in Lincoln County Jail
 Longo committed several infractions such as chipping a hole in his cell
 window in a purported escape plan The "escape attempt" was simply
 an effort to make a small hole to see outside The windows of the jail
 were sandblasted, following community complaints
 that prisoners had better ocean views than
 the town's law-abiding citizens

weaponized "loosie"

Certain post-*bel canto* operas are famed for ruining voices. […] Blanche Marchesi reports a voice doctor angrily telling Richard Strauss, "I have advised…all my lady singer clients, to stop singing your music until it shall be written for the human voice."

Wayne Koestenbaum, *The Queen's Throat: Opera, Homosexuality, and the Mystery of Desire* (1993)

nostalgia weaponized
weaponized "wear and tear"
weaponized illness
weaponized forfeiture
weaponized fire alarm
weaponized affect
weaponized shaming
weaponized "lesson"
compound interest as weaponized interest
weaponized miniaturization
weaponized zero tolerance
weaponized sedative
weaponized rape (?), rape as war crime; or: blaming the victim; or: "false" charge
weaponized avoidance
weaponized nudity
weaponized yield sign
weaponized headphones, earbuds
weaponized custody
weaponized illegibility
weaponized legibility
weaponized proviso, caveat
weaponized emergency
aggression weaponized: micro-aggression?, or passive aggression – which is? –

weaponized Treaty

weaponized levee

weaponized collaterality: using a non-central or "unintended" effect or consequence as
 weapon, *weaponized famine* "disaster capitalism" (Klein) as weaponized "solution"
 to natural disaster yet relies on the prior weaponization of "natural disaster,"
 in that disasters (of the Anthropocene) are not "natural"

deceit in its many forms as (quintessential) accessory to weaponization; akin to
 weaponized innocence or weakness
 eiron (Gr.): "dissembler" – *eironeia*: "dissimulation, affected ignorance"

 organ brokers tell them they have two kidneys, one is
 "sleeping" in the body doctors "awaken" the kidney, take out the
 old one for "donation" the second kidney is just baggage,
 a cash reserve
 buried in the lower back

The "suicide bomber" wears no ordinary soldier's uniform and displays no weapon. [...] Unlike the tank or the missile that is clearly visible, the weapon carried in the shape of the body is invisible. [...] It is so intimately part of the body that at the time of detonation it annihilates the body of its bearer, who carries with it the bodies of others when it does not reduce them to pieces. The body does not simply conceal a weapon. The body is transformed into a weapon, not in a metaphorical sense but in the truly ballistic sense.

Achilles Mbembe, "Necropolitics" (2003)

The premium on agon's abyssal ingenuity, premier form of "innovation"
To weaponize = cultural pastime, cultural *style*

All the same, for Nietzsche, in *The Genealogy of Morality*, the subject is a retroactive effect of an accusation of injury (Judith Butler). Someone is harmed: a sovereign agent is posited for purposes of juridical blame: "There is nothing strange about the fact that lambs bear a grudge towards large birds of prey: but that is no reason to blame the large birds of prey for carrying off the little lambs."

hippo at my local zoo choked on a tennis ball someone threw in her pen, so one guy with a tennis ball might work better How many *unarmed* humans. yeah realized after I posted that a tennis ball would be a weapon

– Yet to say weaponized, is this always to conjecture injury? Might it be simply to *brandish*?

1 ▌▌ weaponized propriety ▌▌ 2 ▌▌ weaponized dirt dirtiness phan ▌▌
3 ▌▌ tasmatic dirtiness pre-obj ▌▌ 3a ▌▌ ect abject weaponized ▌▌ 3b
▌▌ intimacy prox imity of object ▌▌ 4 ▌▌ to the body felt as off ▌▌
4a ▌▌ ensive per vious ▌▌ 5 ▌▌ weapon ized ass or ass ▌▌ 5a ▌▌ hole,
anxiety Weaponized gut ▌▌ 5b ▌▌ feeling coercive odor ▌▌ 6 ▌▌ where
you are a conduit ▌▌ 6a ▌▌ odor of corpses o ▌▌ 7 ▌▌ n battlefield
as its own w ▌▌ 7a ▌▌ eapon weaponized entrain ment ▌▌ 8 ▌▌
weaponized linking ▌▌ 9 ▌▌ weaponize d relay ▌▌ 10 ▌▌ weaponized
deferral ▌▌▌▌▌▌▌▌▌ 1 ▌▌ weaponized dissociation and/or self-dis ▌▌ 1a
▌▌ sociation sensory indiscrimination ▌▌ 1b ▌▌ force of emergence ▌▌
2 ▌▌ weaponized disconnection alie ▌▌ 3 ▌▌ nation bored ▌▌ 3a ▌▌ om
weaponized de tach ment ▌▌ 3b ▌▌ weaponized atom ization as though
▌▌ 4 ▌▌ it were a bad ▌▌ 4a ▌▌ "personal" decision ▌▌ 5 ▌▌ weaponized
distraction ▌▌ 6 ▌▌ weaponized captivation captation ▌▌ 6a ▌▌
weaponized neutrality ▌▌ 7 ▌▌ weaponized flatness ▌▌ 8 ▌▌ weaponized
attention or def ▌▌ 9 ▌▌ lection of attention ▌▌ 10 ▌▌ deficit of ▌▌
10a ▌▌ chan nel att ention attention ▌▌▌▌▌▌▌▌▌ 1 ▌▌ accumulation and
distri buti ▌▌ 2 ▌▌ on weaponized affecti ▌▌ 3 ▌▌ ve modulation,
contagion ▌▌ 3a ▌▌ weaponized sa dness or happi ▌▌ 4 ▌▌ ness anger
fear ▌▌ 5 ▌▌ weaponized inertia of feeling won't ▌▌ 6 ▌▌ go away ▌▌

6a ▐▐ weaponized display ▐▐ 6b ▐▐ weaponized sincerity ▐▐ 7 ▐▐ weaponized Vital ▐▐ 8 ▐▐ ity, aliveness, b ▐▐ 9 ▐▐ urden of "liveness" ▐▐ 10 ▐▐ dependent on outputs of c ▐▐ 10a ▐▐ aring emoting ▐▌▌▌▌▌▌▌▌ 1 ▐▐ in-Person services ▐▐ 2 ▐▐ idealism ▐▐ 2a ▐▐ impe rsonal violence as an ▐▐ 3 ▐▐ Idea ▐▐ 3a ▐▐ of Pur e Reason ▐▐ 4 ▐▐ the sadistic theorem ▐▐ 4a ▐▐ victims ▐▐ 5 ▐▐ of their own good perform ▐▐ 6 ▐▐ ance from the bo ▐▐ 6a ▐▐ dy to the work ▐▐ 6b ▐▐ of art fr om the work ▐▐ 7 ▐▐ of art to the Idea: ▐▐ 8 ▐▐ under the shadow of the whi p ▐▐ 8a ▐▐ body as living diag ram ▐▐ 9 ▐▐ weaponiz ation of life itself ▐▐ 10 ▐▐ or concept of "life it ▐▐ 10a ▐▐ self" as weapon ▐▌▌▌▌▌▌▌▌ 1 ▐▐ generalized cond ▐▐ 1a ▐▐ ition of life as curr ▐▐ 1b ▐▐ ency ▐▐ 2 ▐▐ weaponized boundary conditions ▐▐ 3 ▐▐ metastable ▐▐ 3a ▐▐ weaponized acceleration, velocity ▐▐ 4 ▐▐ weaponize motivation ▐▐ 4a ▐▐ are we get ▐▐ 5 ▐▐ ting ahead ▐▐ 5a ▐▐ weaponized dependency, support ▐▐ 6 ▐▐ as remote control ▐▐ 6a ▐▐ industrialization of the body ▐▐ 6b ▐▐ on scanner body cam ▐▐ 7 ▐▐ discarded organ Bruise ▐▐ 8 ▐▐ bluish blue then bluish- ▐▐ 9 ▐▐ brown someone else screaming ▐▐ 10 ▐▐ inside the person? ▐▌▌▌▌▌▌▌▌ 1 ▐▐ Physical or voca l subtraction ▐▐ 2 ▐▐ Voice rids itself of the b ▐▐ 3 ▐▐ urden of voice ▐▐ 3a ▐▐ The scr eam tears apar ▐▐ 4 ▐▐ t to

Anything in existence, having somehow come about, is continually interpreted anew, requisitioned anew, transformed and redirected to a new purpose by a power superior to it; that everything that occurs in the organic world consists of overpowering, dominating, and in their turn, overpowering and dominating consist of re-interpretation, adjustment, in the process of which their former "meaning" and "purpose" must necessarily be obscured or completely obliterated. […] The whole history of a "thing," an organ, a tradition can to this extent be a continuous chain of signs, continually revealing new interpretations and adaptations, the causes of which need not be connected even amongst themselves, but rather sometimes just follow and replace one another at random. […] It is a succession of more or less profound, more or less mutually independent processes of subjugation exacted on the thing, added to this the resistances encountered every time, the attempted transformations for the purpose of defense and reaction, and the results, too, of successful countermeasures.

Friedrich Nietzsche, *On the Genealogy of Morality*, Essay II, Section 12 (1887)

With this framing of the field of social agency and its fundamental aggressivity, Nietzsche prepares his reader for a discussion of the lability of punishment, where he will offer a long list of its meanings. Far from holding any stable or inherent utility, punishment may serve "ends that differ fundamentally": it may stand as "recompense to the injured party for the harm done, rendered in any form (even in that of a compensating affect)," or, inversely, "payment of a fee stipulated by the power that protects the wrongdoer from excesses of revenge." Hence the naivety (or hypocrisy) of his current social milieu, which sees punishment as an instrument for inducing, most essentially, the "'sting of conscience.'" As much as *On the Genealogy of Morality* is animated by no uncertain contempt for guilt, Nietzsche is here concerned more with the erroneous naturalization of punishment: to posit its essence is to fail to see that every social "organ" is eternally subject to the will-to-power, to aggressive reinterpretation that changes its character. This dominating instrumentalization – the endless adaptability forced on "anything in existence" – is said to be a "subjugation exacted on the thing." Yet it also overpowers the thing only as proxy to the will-to-power *already inhering in it*; it is a pawn in an antagonistic metabolism of "resistance," transformative "defense and reaction," and "countermeasures." As much as Nietzsche describes change-over as a matter of adventitious replacement (as a bottlecap might service a hermit crab for shell), there is always "every time" a *contra*-dyanamic. One use *against* another: these are contests for social validity, social currency, social authority. Building (taking) worlds of things, of ways, to be encoded as seen fit, rightful. Each token weaponized.

during the exit interview
To pass or fail is the same thing
Wealth congealed.
Or who face outward
a ziptie.
With my daughter was just a hook-up
For the integrated Police state projection surface
Or Police state Surface Consistency.
What are the options
How many views
Likes
What kind of paralysis
In the down position
Pumped up to be
A strain loop
These strips of behavior
Grinding away behind the skin of the image
The wound is a deficit of skin.
I walk the treadmill of myself
Bandaged
A movement engraved in muscle
Insists to keep happening that my body followed suit

hold, implies or sup ▌▌ 4a ▐▐ plies a body ▌▌ 5 ▐▐ In anger the
voice hurled ▌▌ 6 ▐▐ Endles s synchronic surface ▌▌ 7 ▐▐ Ima ge of
voice ▌▌ 8 ▐▐ weaponized body ima ▌▌ 9 ▐▐ ge a mental image of one's
body a ▌▌ 9a ▐▐ s it appears to ▌▌ 9b ▐▐ others "before-a nd-af ▌▌
10 ▐▐ ter" ▌▌▌▌▌▌▌▌▌

We should not forget what a weapon really is. A weapon implies two antagonistic entities, in conflict. Yet the weapon exists regardless of the political reasons behind the conflict, and would remain the same in essence even if the reasons for, or the participants in the conflict change…This is not to suggest that any weapon can be adapted by any aggressor to any situation, or to diminish the violence that results… It rather notices that…political intentions…are often overruled by the interests of another cause, one that understands and exploits the operating mechanisms of a given apparatus.

In a state of continuous resistance, comfort constitutes a weakness.

Léopold Lambert, *Weaponized Architecture: The Impossibility of Innocence* (2013)

To bring fresh discomfort to an age-old problem [...]

William Pope.L, *ATM Piece* press release (1997)

X// 1 ▮▮▮ bunk /X er archi /X ▮▮▮ 2 ▮▮▮ tec XX/ ture,fos X sil of ▮▮▮ 3 ▮▮▮
X/ power wea /X ponized sp //XX ace ▮▮▮ //X 3a ▮▮▮ spike X// s on sidewal
/X/ ks ▮▮▮ 4 ▮▮▮ X/ bus-stop X// seats tha X/ t tip ▮▮▮ 5 X/ ▮▮▮ weaponized
XX/ infrastr X ucture ▮▮▮ XX/ 6 ▮▮▮ wea X/ More of [the] substance [of modern
urban spaces] than was formerly acknowledged takes its cue from models of
organization…founded on the systematic delivery of violence…so engrained
that we hardly notice their dictates…Certain kinds of violence have become engrained in our
"natures" by these models of organization and our environment now simply
confirms these truths.

Nigel Thrift, "But Malice
Aforethought: Cities and the Natural History of Hatred" (2005)

ponized br /X/ idge or lack
//X of bridge X// ▮▮▮ 6a ▮▮▮ i /X nterdicti /X on of acc XX/ ess ▮▮▮ 6b ▮▮▮
X/ lack of in X/ terface ap/X artheid ▮▮▮ //XX 7 ▮▮▮ cont //X rol of movem
X/ ent ▮▮▮ 8 /X/ ▮▮▮ checkp X/ oint ▮▮▮ 9 X// ▮▮▮ to weap X/ onize a turn
/X stile (by XX/ locking X it) ▮▮▮ 10 ▮▮▮ XX/ vertical X/ ity v. horizo
//XX ntality //X ▮▮▮ 10a ▮▮▮ X// ballistic /X s if spati /X al arrangemen
X// t ▮▮▮▮▮▮▮▮▮ X/ 1 ▮▮▮ weapo X/ nized het /X erotopia //XX ▮▮▮ 2 ▮▮▮ "paw
XX/ n space" X/ "pixilate /X/ d carcera X/ l" ▮▮▮ 2a ▮▮▮ X// surveillance
/X peephole /X ▮▮▮ 3 ▮▮▮ wea XX/ ponized uX biquity ▮▮▮ X// 3a ▮▮▮ psychog

Michel de Certeau's *The Practice of Everyday Life* (1980) elaborates what he calls a "*polemological* analysis of culture" that lays out how "the tactics of consumption, the ingenious ways the weak make use of the strong…lend a political dimension to everyday practices." "A plurality and creativity" haunts the culture industry, as de Certeau traces – that "rationalized, expansionist, centralized, spectacular, and clamorous production," with its unilateral imposition of commodities and scripts for their use. "Users make (*bricolent*) innumerable and infinitesimal transformations of and within the dominant cultural economy, in order to adapt it to their own interests and their own rules." The dominated consumers of mass culture – that is, more or less everyone: "Marginality is becoming universal" – what agon do they foment?

In the chain of seizure and counter-seizure, purpose and counter-purpose that Nietzsche describes as the will-to-power, power changes hands. These same motions of redefinition in de Certeau's discussion occur precisely insofar as power cannot change hands: he defines opposition to hegemony by its inability to stake a claim to any territory; its operations are necessarily make-shift, ephemeral, nomadic. Thus, users co-produce mass culture, urban space, the workplace, even language itself, by animating them with ends foreign to systemic "functionality." Yet this "deflects" rather than "challenges" the power of "the dominant social order": "They [escape] it without leaving it." "The weak must continually turn to their own ends forces alien to them."

How reflexive is the antagonism that these "tactics" index? Just as there is a hidden consumption within the consumption of mass culture – "What do they make of what they 'absorb,' receive, and pay for? What do they do with it?" – so is there production within the productive and reproductive regimes of every institution of civil society, including, or especially, the workplace. Surely de Certeau's most famous exemplar is "*la perruque*" ["the wig"], a "worker's own work disguised as work for his employer." If all such actions constitute time theft, *la perruque* is also idealized as class weapon: "In the very place where the machine [the worker] must serve reigns supreme, he cunningly takes pleasure in finding a way to create gratuitous products whose sole purpose is to signify his own capabilities through his *work* and to confirm his solidarity with other workers."

X/ eography oX// f ubiquit X/ ▮▮ 4 ▮▮ y 1X/ andscape a/X/ head of the p
X resent ▮▮ XX/ 4a ▮▮ pro X/ jection an /X/ xiety con XX/ stant veloc
X// ity ▮▮ 5 /X ▮▮ zoning a/X s weapon "XX/ belt" ▮▮ X 6 ▮▮ grid, gri
X/ d dow ▮▮ /X ▮▮ 7 ▮▮ n w//XX eaponize//X d brownou X// ▮▮ 7a ▮▮ t, s
/X/ nap to ▮▮ X/ 7b ▮▮ to laX// y waste a X/ s relative X/ to sp ▮▮ 8 ▮▮
XX/ ecific r X ights of usXX/ e, Exhau X/ st ▮▮ 8a ▮▮X/ ion of use-ri
//X ghts ▮▮ 9 X// ▮▮ weapon /X ized fe ▮▮ /X 10 ▮▮ atureXX/ of landsca
X/ pe ▮▮ 10a X/ ▮▮ "by hook /X or by cro /X ok" one m XX/ ▮▮▮▮▮▮▮▮▮▮ 1
X/ ▮▮ ust use /X/ a weed ho X/ ok or ▮▮ 2 X// ▮▮ sheep X/ crook to p
/X ull off ▮▮ XX/ 3 ▮▮ bra X nches "fre XX/ e gift o X/ f nature"
//XX ▮▮ 3a ▮▮ //X weaponize X// d flood p /X lain ▮▮ 3b /X ▮▮ mountaint
X// op remova X/ 1 as weap X/ ▮▮ 4 ▮▮ oni /X zed extrac //XX tion ▮▮ 4a

when he pulled his stun gun Morrow pulled his daughter close to him. In shocking surveillance video captured Wednesday, Johnson County sheriff's deputies say a man used his daughter as a human shield trying to escape arrest. couldn't believe a man wearing a "#1 DAD" T-shirt could do that to his daughter. "We only see that in places like the Middle East: ISIS, and people of that nature. It's not kosher to me," Roberts said.

Yet in de Certeau's portrayal, "everyday practices" are caught between purposive secretiveness, acts of "poaching," deployments of "camouflage" or "guile," and a more passive resistance in which the fleeting activities of consumption simply are not registered by power even as they were never undertaken to thwart domination. The logic of "enunciation" he adopts as a model for describing consumption practices encapsulates this ambiguity. The product as *langue* and consumption as *parole* slides into the product as semantic meaning and consumption as contextual, pragmatic meaning. Consumption becomes simply the "enunciation" of a product, just as walking enunciates city spaces. Reading is described as "renting" the text: "This mutation makes the text habitable, like a rented apartment… Renters make comparable changes in an apartment they furnish with their acts and memories." Despite continually framing such uses as "gaming the system" or "trickery," in uncovering lively domains of "secondary production hidden in the process of [a product's] utilization," what de Certeau shows is that hegemonic culture cannot be self-identical – thus however commanding and programmatic, power fails to totalize its field, its knowledge is far from omniscient. It provides "grammar" and "vocabulary," but not the utterance in context. If this "way of using imposed systems constitutes the resistance," it is a resistance without antagonism.

Nonetheless, for de Certeau, culture is weaponized, politicized, through using what is presumed to have a contrary agenda for purposes and pleasures of one's own. This enjoyment sharpens into agon through the more specific pleasure the weak may take in their act of manipulative conformity as counter-exploitation. Ultimately, however, the "individual conflicts" expressed in ways of "reappropriating the product-system," he writes, "have as their goal a *therapeutics of deteriorating social relations*." Strange weaponizations, their own reparation.

X/	X//	X/	X/	/X/
X	XX/	X/	/X/	XX/
X//	/X	/X	XX/	X
X/	/X	//XX	//X	X//
/X/	X/	X//	X/	X/
XX/	X	XX/	X/	X/
//X	X//	/X	/X	XX/
X/	X/	/X	/X	XX/
X/	/X/	X/	X//	X/
/X	XX/	X/	XX/	X/
//XX	//X	X//	/X	/X
X//	X/	X/	/X	//XX

De Certeau is perhaps at his most compelling in arguing with Foucault: to supplement the Foucauldian account of how "the violence of order is transmuted into disciplinary technology," he posits a "network of antidiscipline." To Foucault's "monotheistic" account of the ascendency of panoptical disciplinarity, he opposes a "polytheism" of "scattered practices," the multiple, non-dominant *dispositifs* that evade it. The poetics of heterodox use produces folds in space, involving "a skill ceaselessly recreating opacities and ambiguities—spaces of darkness and trickery—in the universe of technocratic transparency." (Ironically, these discussions rely on ideas very close to Foucault's concepts of "heterotopia" and "subjugated knowledges.")

Such a model is embodied to the nth degree in de Certeau's vision of a future "cybernetic society," in which the strategic system of "technocratic rationality" produces all space – "There is no longer an elsewhere" – and yet in doing so "defeats itself," giving rise to a "scene of Brownian movements of invisible and innumerable tactics," "a proliferation of aleatory and indeterminable manipulations within an immense framework of socioeconomic constraints and securities." Writing nearly 40 years ago, de Certeau's immediate referent for such a space is the "city," yet his description anticipates the blurring and reciprocal constitution of the physical and virtual in the world of ubiquitous computing.

XX/ ▮▮ "terri X/ tory whose /X/ shre ▮▮ 4 X/ b ▮▮ ds sloX// wly rot acro
/X ss the ex /X ▮▮ 5 ▮▮ ten XX/ t of the X map" ▮▮ 6 X// ▮▮ map absolu
X/ tizes spa X// ce, as ▮▮ X/ 6a ▮▮ weapoX/ nized des /X/ ire form o
X f cl ▮▮ 6b XX/ ▮▮ aim co X/ ntrol pan /X/ ▮▮ 7 ▮▮ el XX/ meridian m
ap as XX//

▮▮ 8 ▮▮
▮▮ 9 ▮▮ ▮▮ 10 ▮▮
▮▮ 10a ▮▮
▮▮ 10b ▮▮ ▮▮▮▮▮▮▮▮▮▮▮
1 ▮▮ ▮▮ 1a ▮▮ ▮▮ 1b ▮▮ ▮▮ 2 ▮▮ ▮▮ 2a ▮▮ ▮▮ 3 ▮▮
▮▮ 3a ▮▮ ▮▮ 4 ▮▮ ▮▮ 5 ▮▮ ▮▮ 6 ▮▮ ▮▮ 6a ▮▮ ▮▮
6b ▮▮ machine of use, in
▮▮ 7 ▮▮ citement a pl ▮▮ 8 ▮▮ ace left off falls o ▮▮ 9 ▮▮ ut of ▮▮ 9a
▮▮ known space y ▮▮ 10 ▮▮ et not able t ▮▮▮▮▮▮▮▮▮▮▮
1 ▮▮ o 1 ▮▮ 2 ▮▮ eave the field ▮▮ 2a ▮▮ dispersion,
fragme ▮▮ 3 ▮▮ ntation relay Alte
▮▮ 3a ▮▮ rnating current ▮▮ 4 ▮▮ Electrified fence ▮▮ 4a ▮▮
▮▮ 4b ▮▮ Barbed wire the bor
▮▮ 5 ▮▮ der itself made in ▮▮ 5a ▮▮ to a wea
▮▮ 6 ▮▮ pon ▮▮ 6a ▮▮ ▮▮ 7 ▮▮ ▮▮ 8 ▮▮ ▮▮ 9 ▮▮ ▮▮ 9a ▮▮ ▮▮
10 ▮▮ ▮▮ 10a ▮▮ ▮▮▮▮▮▮▮▮▮▮▮
1 ▮▮ ▮▮ 2 ▮▮ ▮▮ 3 ▮▮ ▮▮ 4 ▮▮ ▮▮ 5 ▮▮ ▮▮ 6
▮▮ ▮▮ 6a ▮▮ ▮▮ 7 ▮▮ ▮▮ 7a
▮▮
▮▮ 8 ▮▮ ▮▮ 8a ▮▮ ▮▮ 8b ▮▮ ▮▮ 9 ▮▮ ▮▮ 10 ▮▮
▮▮▮▮▮▮▮▮▮▮▮

If the digital media environment might be said to realize de Certeau's "cybernetic society," part of living under domination by algorithm involves precisely *hegemony's exploitation of tactics*, of expressive, differential consumption. Proliferation hardly goes unseen: it is solicited and regulated; it is the object above all of power's close and distant reading. De Certeau is precisely right to note that resistance, whether agonistic or not, is to be found in disciplinary society's silences (Wendy Brown). The question, however, is which and whether tactics can preserve their radio silence, whether dominant strategies have colonized their defected inhabitation of a system no longer alien. "The ruling order serves as a support to innumerable productive activities, while at the same time blinding its proprietors to this creativity," de Certeau writes; these are "ruses of other interests and desires that are neither determined nor captured by the systems in which they develop." But capital has harnessed the weak's "opportunism," the affective labor of its off-script co-production. As tactics feed back to propel their own extortion, what becomes of resistance, of weaponry?

▌▌▌▌▌▌▌▌▌ 1 ‖ weaponized Hold f ▌▌ 2 ‖ or cho ke or Submission ▌▌ 3 ‖ elbows, forearms ▌▌ 4 ‖ learned inhibition ▌▌ 4a ‖ (induced Disabilit ▌▌ 5 ‖ y) jeering appa rent ▌▌ 5a ‖ inactivity ▌▌ 6 ‖ get loose from the leg grip, four limbs free ▌▌ 7 ‖ hold variants that prod uce great est ▌▌ 8 ‖ Suf fering ▌▌ 9 ‖ techniques for Damaging ▌▌ 10 ‖ when a fighter Sinks a choke ▌▌ 10a ‖ having it fall only on the nec ▌▌▌▌▌▌▌▌▌ 1 ‖ k force directed ag ainst Windpipe ▌▌ 2 ‖ resist pressure with the jaw ▌▌ 3 ‖ when no longer ▌▌ 4 ‖ Upright ▌▌ 4a ‖ (on his or her feet) ▌▌ 5 ‖ weaponize the Bottom ▌▌ 5a ‖ weaponize being Under neath ▌▌ 6 ‖ wound up beneath ▌▌ 7 ‖ larger opponen ▌▌ 8 ‖ ts techni ques from this position ▌▌ 9 ‖ modify how to ▌▌ 10 ‖ produce Decisive Violence ▌▌▌▌▌▌▌▌▌ 1 ‖ structure of Victory conditions ▌▌ 2 ‖ specific sorts of violence ▌▌ 3 ‖ deman d ed by ▌▌ 3a ‖ social definitions of Victory ▌▌ 4 ‖ shape violence to make it more exciting ▌▌ 5 ‖ holding one on top of oneself in the guard ▌▌ 5a ‖ adap ted to Avoid being reversed ▌▌ 6 ‖ for ce the shoulders down ▌▌ 6a ‖ gain lever age to pin ▌▌ 6b ‖ pinne d to the mat in a kind of ath letic ▌▌ 7 ‖ social Death ▌▌ 8 ‖ leg-loc ▌▌ 9 ‖ k skill (in Takedowns) ▌▌ 10 ‖ social Deat ▌▌ 10a ‖ h (in Freestyle) ▌▌▌▌▌▌▌▌▌ 1 ‖ repeated rapid blows fr ▌▌ 2 ‖ om

fists, Flurry ▌▌ 3 ▌▌ to thr ow harder punches ▌▌ 4 ▌▌ or increase striking surface of the ▌▌ 4a ▌▌ fist ▌▌ 5 ▌▌ poorly su pported by tis sue ▌▌ 5a ▌▌ if you sla m your ▌▌ 6 ▌▌ fist ▌▌ 7 ▌▌ into the head or Face ▌▌ 8 ▌▌ when the hand i s Damaged it ▌▌ 9 ▌▌ usually sw ells, hands blow up ▌▌ 10 ▌▌ damaged hand swell s making it har der to ▌▌ 10a ▌▌ deliver deci sive force ▌▌▌▌▌▌▌▌▌▌ 1 ▌▌ attack a site of specific ▌▌ 2 ▌▌ injury any Abrasion in the area to ▌▌ 3 ▌▌ open ▌▌ 4 ▌▌ that this Tailor ing of viol ence ▌▌ 5 ▌▌ for a cut over the Eye l ▌▌ 6 ▌▌ ittle flesh to cushion ▌▌ 7 ▌▌ skin on impac ▌▌ 8 ▌▌ t brow bones are close to the skin ▌▌ 9 ▌▌ to condition the skin ▌▌ 9a ▌▌ so it would not ▌▌ 9b ▌▌ rupt ure ▌▌ 10 ▌▌ over the bones when blows Stretched it ▌▌▌▌▌▌▌▌▌▌ 1 ▌▌ versus leverage and gros s Motor movements ▌▌ 2 ▌▌ fighting on the ground shifts ▌▌ 3 ▌▌ the physical prob ▌▌ 4 ▌▌ lems, not sufficient to counteract lateral forces ▌▌ 4a ▌▌ (most Kicks could not ▌▌ 4b ▌▌ be del ivered on his back) ▌▌ 5 ▌▌ conflate "Down" with "Defens eless" ▌▌ 5a ▌▌ that a Supine person wa s in imminent ▌▌ 6 ▌▌ danger ▌▌ 7 ▌▌ invisible be cause not considered Tools ▌▌ 8 ▌▌ when kneeling over hi ▌▌ 9 ▌▌ m whereas a Competitor on Top could only ▌▌ 10 ▌▌ to work their arms ▌▌ 10a ▌▌ free ▌▌▌▌▌▌▌▌▌▌ 1 ▌▌ rather than trying to Pull ▌▌ 2 ▌▌ Loose standing

As St Paul admirably put it, it is in the "Logos," meaning in ideology, that we "live, move, and have our being." It follows that, for you and for me, the category of the subject is a primary "obviousness" (obviousnesses are always primary): it is clear that you and I are subjects (free, ethical, etc. ...). Like all obviousnesses, including those that make a word "name a thing" or "have a meaning" (therefore including the obviousness of the "transparency" of language), the "obviousness" that you and I are subjects – and that that does not cause any problems – is an ideological effect, the elementary ideological effect. It is indeed a peculiarity of ideology that it imposes (without appearing to do so, since these are "obviousnesses") obviousnesses as obviousnesses, which we cannot *fail to recognize* and before which we have the inevitable and natural reaction of crying out (aloud or in the "still, small voice of conscience"): "That's obvious! That's right! That's true!"

Louis Althusser, "Ideology and Ideological State Apparatuses" (1970)

"Obviousnesses as obviousnesses": in Althusser's explanation of ideology, the social field appears neutral, in its uncontestable, naturalized givenness. The very content of the naturalized fictions in place is also neutral: language is "transparent"; the subject is "(free, ethical, etc.)." We reflect on the culture that is our medium of life ("in the 'Logos'…we 'live, move, and have our being'") only to reauthorize its rightness, its rightfulness. Each thing in its place, to its use, with its purpose. There is no falling out of the world that interpellates us however indirectly, even if it is to use a word to refer, to wait at a bus stop, to look up a weather forecast. Once we answer, we cannot refute we have been called.

In an 1889 letter to playwright Aleksandr Semenovich, Anton Chekhov advised, "One must not put a loaded rifle on the stage if no one is thinking of firing it." That most purposive of objects, a gun has hailed its audience, beckoning fulfillment. But everything is a rhetor: we are already persuaded of its entailments.

There is given a givenness to the given. It goes without saying that it goes without saying: what "'the still, small voice of conscience'" says when it speaks.

Althusser's is an enthymemic universe. If Lacan writes, "All sorts of things in the world behave like mirrors," many things act as enthymemes,–*viz.* everything.

clin ▮▮ 3 ▮▮ ch grappling if an Adv ▮▮ 3a ▮▮ ersary clung too closely hold another ▮▮ 4 ▮▮ person "in his guard" ▮▮ 4a ▮▮ to rear back to punch ▮▮ 5 ▮▮ time on top ▮▮ 5a ▮▮ pummeling ▮▮ 6 ▮▮ "Ground and Pound" ▮▮ 7 ▮▮ Rounds and time ▮▮ 7a ▮▮ Limits in cl oth v. Bare skin b ▮▮ 8 ▮▮ reak off any holds trying to ▮▮ 8a ▮▮ "pass the guard" ▮▮ 9 ▮▮ fence as a mark of ▮▮ 9a ▮▮ event some barrier to keep ▮▮ 10 ▮▮ them from tu mbling off fence made ▮▮ 10a ▮▮ it difficult to fli p d ▮▮▮▮▮▮▮▮▮▮ 1 ▮▮ uring a pounding, cut ▮▮ 2 ▮▮ off escape r ▮▮ 3 ▮▮ outes mesh ▮▮ 3a ▮▮ makes difficult to ▮▮ 4 ▮▮ see Body Knowledge ▮▮ 5 ▮▮ How to produce ▮▮ 6 ▮▮ p ain use Pain ▮▮ 7 ▮▮ as a Tool crowd-▮▮ 8 ▮▮ pleasing having wea ▮▮ 9 ▮▮ ponized one's own ▮▮ 10 ▮▮ pain ▮▮▮▮▮▮▮▮▮▮ 1 ▮▮ analyzed it to pro ▮▮ 2 ▮▮ duce a strategic ▮▮ 2a ▮▮ response ▮▮ 3 ▮▮ what is called fo ▮▮ 4 ▮▮ r pain from neck-crank ▮▮ 4a ▮▮ triangle wedged around neck ▮▮ 5 ▮▮ pain as Diagnostic of technique ▮▮ 6 ▮▮ tendon-stretching arm lock ▮▮ 6a ▮▮ tendons in the arm ▮▮ 6b ▮▮ under too much pressure ▮▮ 7 ▮▮ How to suffer without Dissolution ▮▮ 8 ▮▮ atta in Max Force ▮▮ 9 ▮▮ inflict it before they reverse ▮▮ 10 ▮▮ that on ly the Experience of being ch oked ▮▮ 10a ▮▮ could Teach ▮▮▮▮▮▮▮▮▮▮

Present-day rhetoricians define the enthymeme as: an imperfect logical syllogism – a syllogism with one part unstated; and (or) as a syllogism whose premises are probable rather than certain statements.

The former definition sometimes refined to: a particular means of expressing a syllogistic argument, by suppressing a premise or the conclusion. In the *Rhetoric*, Aristotle calls the enthymeme "the body of persuasion." "We are most persuaded when we think something is demonstrated" (Rapp). These last two sentences form an enthymeme, the implied conclusion of which is: *We view enthymemes as demonstrations*. But even more may be unstated, left to implication. One asserts, "Theater just got out," walking down a suddenly very crowded urban street. Both the major premise: *People flood this street at the end of a show*, and the minor premise: *This sidewalk is crowded, almost impassable*, have been excised from this claim, an enthymeme.

As for the latter definition: an enthymeme's premises are likelihoods, in that they state the usual course of things, or somewhat differently, what common sense would tell us. In contrast to the ideal realm of logic, the "probable" involves the domain of ideology, "the outside experienced world" (Farrell): what is in it, how we know what something is, how it functions, what it means, how we feel about it, what we want regarding it, what has happened or should happen with it, why. <u>They</u> *won't buy anything*. Enthymemes are probable claims or proposals for action made about this world, using probable grounds as support. *Hire the Asian one*.

1 ‖ The role imputed to the in ‖ 2 ‖ dex finger point ‖ 3 ‖ ing to an object ‖ 3a ‖ if you are born into the ‖ 4 ‖ sex God chose you to be ‖ 4a ‖ Of the opposite gender ‖ 5 ‖ "should those w diff ‖ 6 ‖ ering anatomies ‖ 7 ‖ share the same bathrooms" ‖ 8 ‖ assumes the status of ‖ 8a ‖ a question mark: ‖ 9 ‖ what is the counter- ‖ 10 ‖ part or other of "colored" ‖ 10a ‖ men: "colored" women? Wh ‖‖‖‖‖‖‖‖‖ 1 ‖ ite men? white wo ‖ 1a ‖ men? no ‖ 1b ‖ signification can be sust ‖ 2 ‖ ained except by ref ‖ 3 ‖ erence to another sign ‖ 3a ‖ ification ‖ 3b ‖ A train arrives ‖ 4 ‖ at a stat ion A ‖ 4a ‖ little boy and a ‖ 5 ‖ little girl, brother ‖ 6 ‖ and siste ‖ 6a ‖ r are seated ac ‖ 7 ‖ ross from one an ‖ 8 ‖ other ‖ 9 ‖ misread the signs on the w ‖ 10 ‖ ater closet do ‖ 10a ‖ ors as the name of the station sto ‖‖‖‖‖‖‖‖‖ 1 ‖ p: misread the signs ‖ 2 ‖ over wh o can use which ‖ 2a ‖ bathroom To use the gender- ‖ 3 ‖ neutral bat hroom in the nurse's ‖ 3a ‖ office To lobby ‖ 4 ‖ against the bathroom measure ‖ 5 ‖ the bathroom bill ‖ 6 ‖ so-cal led ba ‖ 6a ‖ throom bill allowing ‖ 6b ‖ men to pose ‖ 7 ‖ as transgender and enter wom en's ‖ 8 ‖ bathrooms In an unsettling bathroom ‖ 9 ‖ encounter suspended for using ‖ 10 ‖ the boy's bathroom ‖‖‖‖‖‖‖‖‖ 1

What is translated in Aristotle as "probable" is *to eikos*: image or likeness. Verisimilitude to truth or reality, what tends to happen. But an *eikos* is also an *endoxos* proposition: *endoxon*, also translated as "probable," is public opinion (Newsom). "The enthymeme being simply probable," as Thomas de Quincey put it, "and drawn from *the province of opinion*." A glimmer of mediation here: the probable is not precisely what *is* likely, but the *prevailing view* of what is likely, common wisdom about it. Enthymemes draw on the social knowledge – commonplaces, conventions, traditions, rules, beliefs, expectations, experience – that structures the sense of the usual. Such supports are also known as warrants.

In *Prior Analytics*, Aristotle writes, "A probability is a reputable proposition: what men know to happen or not to happen, to be or not to be…*e.g,* envious men hate, those who are loved show affection." Yet the probity of the probable lies not only in being thought generally true to reality. An enthymeme's probable adages or maxims involve preference, evaluation, interest, disposition, attitude. *Diamonds are a girl's best friend.* They are approvable as normative, carrying the character in which something is held, the response it inspires, its desirability.

The infinity of adherences slides over me
A pill to pop
I'M A FUCKING HEART PATIENT SO DO AS YOUR TOLD
Not the fixed block in front
a wind when my hand slashes through the air like an ax
To aerate the color.
Real time means "live"
People soon learn to be more prompt
For how long we continue doing this
Through the borehole
The recipient shifts its value
Sero-conversion
Tears of blood
My blood rejected.
How are we doing for time.
My erection is in debt.
Fine with that.
To find one's bearings
Bring my arm to orgasm
To bring one's arm to orgasm
For your own sexual use
The normal ground and upper floors supported by the windowless
underground space
Usufruct of what is rightfully mine.

Lacan's famous anec 1a dote of 2 juxtaposed Ladies and Gentleme 3 n signs viewed by two 3a weaponized 4 children to which gender categories un 4a settled the priority of race 4b in the construction of 5 Jim Crow space 6 a bathroom veto 6a "Look," says the br 7 other, "we're at Ladies!" "Imb 7a ecile!" replies his 7b sister, "Do n't you see 8 we're at 9 an ordinance for 9a bidding people to u 9b se a bathroom that do 10 es not match the gender 10a assigned them at birth In 1 Lacan's narrative, a brother 2 and sister seated 3 opposite 3a each other as 3b a train pulls into locker rooms, and 4 other facility ies that correspond 4a with the gender on their bir 5 th certificates. Rel 6 igious bathrooms religious accommo 7 dation Illustrated by a sketch of 7a symmetrical doors, barri ng of the signifi 8 er from the signifie 8a d to request on 8b religious grounds that their 9 public schools provide a 10 bathroom 10a or other facili 10b ty that bars transgender peo 1 ple "the image of two tw 2 in doors that symbolize, 3 with the private stall offered

Always routed through a major premise of the typical, enthymemes take other proof-shapes and paths of implication. Adduced particular examples get us to general truths or rules of thumb, act as analogies to cases at hand: *Apologize at court, he got out of the fine.* ▮▮ **availability heuristic** = a mental shortcut that relies on immediate examples that come to a given person's mind (Wikipedia). ▮▮▮▮▮▮▮▮▮ Enthymeme selfie.

The probable sign indicates the presence of something else. "The revealing sign and the thing revealed" (Renon). Also suggesting the co-presence of other signs. "The fact that certain things are so means that something else is so" (Renon). Signs as causal indices or symptoms: breathing hard, *must have been running,* a black eye, *he hit you.* As arbitrary (conventional) association, as habit. *The golden arches. He's wearing khakis.* ▮▮ **probative** = 2a. Chiefly *Law.* Orig. *Sc.* Having the quality or function of proving or demonstrating; affording proof or evidence; demonstrative, evidential. ▮▮ 1678 G. Mackenzie *Laws & Customes Scotl.* i. 177 ▮▮ The ordinary presumptions probative in this case [*sc.* adultery] are, ▮▮ the being oft alone together, gifts, love-letters, closs doors, ▮▮ the Wifes being abroad all night, [etc.]. (*OED*) ▮▮

[*Etc.*] as enthymeme. ▮▮ **etc.** = 1. As phrase: And the rest, and so forth, and so on ▮▮ indicating that the statement refers not only to the things enumerated, ▮▮ but to others which may be inferred from analogy. (*OED*) ▮▮▮▮▮▮▮▮▮

Western ▌▌ 3a ▌▌▌ man twin doors symb ▌▌▌ 3b ▌▌▌ olizing, through the solitary ▌▌ 4 ▌▌▌ confinement offered Western Man ▌▌ 4a ▌▌▌ for the satisfa ▌▌▌ 5 ▌▌▌ ction of his natural needs a ▌▌ 5a ▌▌▌ way from home When a man barged ▌▌▌ 5b ▌▌▌ into the women's bathroom ▌▌▌ 6 ▌▌▌ because he thoug ▌▌▌ 6a ▌▌▌ ht she was a male

"Look," says the br
other, "A man is a man no matter what they call themselves the men's room was designed for the penis,
"the image of twin doors symbolizing,
"There is no existing language whose ability to cover the field of the signified can be called into question,

▌▌▌ 7 ▌▌ Do your business ▌▌▌ 7a ▌▌▌ Public conveniences ▌▌▌ 8 ▌▌▌ "matter out of pla ▌▌▌ 9 ▌▌▌ ce" To knock and announce ▌▌▌ 10 ▌▌▌ Toilet audit ▌▌▌▌▌▌▌▌▌▌ 1 ▌▌▌ The post showed an ▌▌▌ 1a ▌▌▌ overweight man wea ▌▌▌ 1b ▌▌▌ ring a wig and wome ▌▌▌ 2 ▌▌▌ n's clothing with pa ▌▌▌ 3 ▌▌▌ rts of the T-shirt ▌▌▌ 4 ▌▌▌ cut ou t to ex ▌▌▌ 5 ▌▌▌ pose his breas ▌▌▌ 6 ▌▌▌ ts. It says: "LET ▌▌▌ 7 ▌▌ HIM IN! to th ▌▌▌ 8 ▌▌▌ e restroom with y ▌▌▌ 9 ▌▌▌ our daughter ▌▌▌ 10 ▌▌▌ "how the si ▌▌▌▌▌▌▌▌▌ 1 ▌▌▌ gnifier in fact ▌▌▌ 2 ▌▌▌ enters the signified...in ▌▌▌ 3 ▌▌▌ a form which...raises t ▌▌▌ 4 ▌▌▌ he question of its ▌▌▌ 5 ▌▌▌ place in reality" ▌▌▌ 6 ▌▌▌ To enjoy

Though it seems almost any sign might function as a (quasi-)index.

In *The Sublime Object of Ideology* (1989), Slavoj Zizek suggests how "the multitude of 'floating signifiers,' of proto- ideological elements" may become indexical signs: they are transformed "into a unified field through the intervention of a certain 'nodal point' (the Lacanian *point de capiton*)." The *point de capiton* – say, "Latino" – is a "rigid designator": a name that constitutes "the identity of a given object beyond the variable cluster of its descriptive properties." This nodal point fixes or "quilts" signs into a structured, totalized network of meaning, even as it is itself a "'signifier without a signified'": "Its role is purely structural, its nature is purely per-formative." A magnetic, organizing void, it not only supports the seeming meaningfulness of all the arbitrary qualities, habits, body-types associated with it, but also becomes their cause: "At first, 'Jew' appears as a signifier connoting a cluster of 'effective' properties (intriguing spirit, greedy for gain, and so on), but this is not yet anti-Semitism proper…we must invert the relation and say: they are like that…*because they are Jews.*"

A nodal point recruits subjects to perform a certain metalepsis: this amalgamating point hails the subject to see it as the originating source of all associated with it – though it stands for a void, it becomes an essence, a retroactive ground. Zizek asserts the *point de capiton* as an oper-ator of ideology, that which fosters "ideological experience" *par excellence*: it "interpellates the individual into subject by addressing it with the call of a certain master-signifier ('Commu-nism,' 'God,' 'Freedom,' 'America.')." Yet this call might be better understood as coming from the quilted signifiers themselves. As enthymemes, *they implicitly refer us to their probable "sources"* (as major premise) and all they connote.

"The enthymeme, for better or worse, offers a provisional interpretative frame, a caption, that lends temporary stability to an otherwise unstable and ambiguous complex of appearances" (Farrell).

pronouncing ▮▮ 6a ▮▮ and imagining while pro ▮▮ 7 ▮▮ hibiting pleasure ▮▮ 8 ▮▮ d prohi bition as wea ▮▮ 9 ▮▮ pon a transgender person ▮▮ 9a ▮▮ attacking or otherwi ▮▮ 9b ▮▮ se bothering someone in ▮▮ 10 ▮▮ a restroom, "whose signified ▮▮▮▮▮▮▮▮ 1 ▮▮ would in this case be ▮▮ 2 ▮▮ paid its last respects" ▮▮ 3 ▮▮ you didn't look like ▮▮ 3a ▮▮ I though t you was a ▮▮ 4 ▮▮ you didn't look like ▮▮ 5 ▮▮ a girl when I saw you en ▮▮ 6 ▮▮ ter "For the signifier ▮▮ 6a ▮▮ will raise Dissen ▮▮ 6b ▮▮ sion that is animal in k ▮▮ 7 ▮▮ ind, his eyes gouged out ▮▮ 8 ▮▮ for using a white men's room ▮▮ 9 ▮▮ in a Carolina bus station ▮▮ 10 ▮▮ that provided no fac ilities for ▮▮ 10a ▮▮ African Americans. by ▮▮▮▮▮▮▮▮ 1 ▮▮ which his public life is su ▮▮ 2 ▮▮ bjected to the laws ▮▮ 2a ▮▮ of urinary segregation" ▮▮ 3 ▮▮ into a pub lic restroom ▮▮ 3a ▮▮ with a man who thin ▮▮ 4 ▮▮ ks he is a woman? Here's an ▮▮ 4a ▮▮ idea: if you look li ▮▮ 5 ▮▮ ke a man, use the me ▮▮ 6 ▮▮ n's room. If you look ▮▮ 6a ▮▮ like a woman, use the ▮▮ 6b ▮▮ doors marked "WHITE WOMEN" ▮▮ 7 ▮▮ and "WHITE MEN" but only ▮▮ 8 ▮▮ occasional doors marked "COLORED," ▮▮ 8a ▮▮ "meaning it was used ▮▮ 9 ▮▮ by black men, women, ▮▮ 10 ▮▮ and children" ▮▮ 10a ▮▮ that rest rooms simply lab ▮▮▮▮▮▮▮▮ 1 ▮▮ eled Colored were to be ▮▮ 2 ▮▮ used by all African American pa ▮▮ 3 ▮▮

The West moistens everything with meaning, like an authoritarian religion which imposes baptism on entire peoples.

Roland Barthes, *Empire of Signs* (1970)

Enthymemically.

trons Illustrated by a ▌▌ 3a ▌▌ sketch of symmetrical doors, ▌▌ 3b ▌▌ designed to assert the un ▌▌ 4 ▌▌ iversality of sexual difference,

If you don't yet look like the gender you want to be, just wait until you can avoid making others uncomfortable.

"that the signifier has to justify its existence in terms of any signification whatsoever" she was washing her hands, when the woman called her "disgusting" and attempted to order her out of bathroom,

"I am a fucking female!" the woman yells at an officer who shouts back, "Do you have an ID?"

using his hands and body to force her out of the bathroom calling her "sir,"

▌▌ 4a ▌▌ the twin doors symbol ▌▌ 4b ▌▌ izing, "a man can simply ▌▌ 5 ▌▌ say he 'feels like a woman today' ▌▌ 6 ▌▌ and enter the women's restro ▌▌ 6a ▌▌ om." the squinting gaze of a ▌▌ 6b ▌▌ nearsighted person mi ▌▌ 7 ▌▌ ght be justified in w ▌▌ 8 ▌▌ ondering whether it ▌▌ 9 ▌▌ is indeed here that we ▌▌ 10 ▌▌ must see the

As its enthymemic dimension reveals, ideology does not brook singularity; exceptions prove the rule, become the basis for their own rules. Nothing is outside its capture. Its realism.

> All relationships of people to each other rest, as a matter of course, upon the precondition that they know something about each other. The merchant knows that his correspondent wants to buy at the lowest price and sell at the highest price. […] How much error and sheer prejudice may lurk in all this knowing is immaterial.

> Georg Simmel, "The Sociology of Secrecy and of Secret Societies" (1906)

What Simmel notes is that probable knowledge may be wrong: we still avail ourselves of it. But the probable remains true even when *it is not the case*. It is the socially real, regardless of whether it holds in a given instance. It may hold and not hold at the same time. It is a fetish.

signifier" ▌▌▌ 10a ▐▐ Gentlemen and Ladies wi ▌▌▌ 10b ▐▐ 11 henceforth
be two ▌▌▌▌▌▌▌▌▌▌ 1 ▐▐ homelands towards which ▌▌▌ 1a ▐▐ each of their
souls will take fl ▌▌▌ 1b ▐▐ ight, to use the fields ▌▌▌ 2 ▐▐ by the
train tracks ▌▌▌ 2a ▐▐ "colored women's" rooms ▌▌▌ 3 ▐▐ at rest stops
in these ▌▌▌ 3a ▐▐ states to the absence of ▌▌▌ 4 ▐▐ all "colored"
toilets in Alab ▌▌▌ 5 ▐▐ ama. heard a voice yelling from out ▌▌▌ 6 ▐▐
side – apparently from a ▌▌▌ 6a ▐▐ security guard – ▌▌▌ 6b ▐▐ that
"whatever man is i ▌▌▌ 7 ▐▐ n the restroom needs to ▌▌▌ 8 ▐▐ come out
now." ▌▌▌ 9 ▐▐ she was wearing a b ▌▌▌ 10 ▐▐ aseball cap ▌▌▌▌▌▌▌▌▌▌▌

Enthymemes are prevalent in speech. (How tiresome it would be if they weren't.)

> Certainly we knew, what all the world knows, that an enthymeme was understood to be a syllogism of which one proposition is suppressed…But what possible relation had *that* to rhetoric? Nature sufficiently prompts all men to that sort of ellipsis; and what impertinence in a teacher [Aristotle] to build his whole system upon a solemn precept to do this or that, when the rack would not have forced any man to do otherwise!

> Thomas de Quincey, "Rhetoric" (1828)

Utterance "naturally" surrounds itself with enthymemic implicature. It may be that speech must presuppose more than it says, that everything said is an enthymeme.

> Every utterance in the business of life is an objective social enthymeme. It is something like a "password" known only to those who belong to the same social purview… The "assumed" may be that of the family, clan, nation, class and may encompass days or years or whole epochs…

> Valentin Voloshinov, "Discourse in Life and Discourse in Art (Concerning Sociological Poetics)" (1927)

Voloshinov's statement suggests that, "The use of language acts as a trigger that summons an entire world of which it is a fragment" (Gomez-Moriana). Speech relies on its listeners having the "password": that is, their "unanimous unconscious assimilation of their communities' tones and values" (Bialostosky): their affective enculturation, attachment.

1 ‖ in the po cket of Big ‖ 2 ‖ Rape Super delegate ‖ 3 ‖ bleeding from her ‖ 3a ‖ weaponized menstruation ‖ 4 ‖ But chemically stronger ‖ 4a ‖ weaponized puberty ‖ 4b ‖ weaponized prepubescence ‖ 5 ‖ weaponized femininity ‖ 5a ‖ weaponized monogamy ‖ 6 ‖ weaponized family ‖ 6a ‖ weaponized fertility ‖ 6b ‖ accessorize with chi ldren ‖ 7 ‖ weaponized sterilization, social ‖ 8 ‖ workers had the ‖ 8a ‖ rig ht to suggest clients ‖ 9 ‖ for. Deemed unfit to ‖ 10 ‖ ‖‖‖‖‖‖‖ 1 ‖ procre ate w=While in a ‖ 2 ‖ hosp ‖ 3 ‖ ital for other ‖ 4 ‖ reasons (e.g. child ‖ 5 ‖ birth) was told she ‖ 6 ‖ need ed an "append ‖ 6a ‖ ectomy" to have his tes tes re ‖ 7 ‖ moved in a bid ‖ 7a ‖ for a reduced s ‖ 8 ‖ entence ‖ 9 ‖ forced chemi cal ‖ 10 ‖ castration weaponized preg ‖‖‖‖‖‖‖‖ 1 ‖ nancy fell down ‖ 2 ‖ a fl ight ‖ 3 ‖ of sta irs rep orted ‖ 3a ‖ to po lice for "attem pted feta ‖ 4 ‖ l homicide" ‖ 5 ‖ unexplained vagi nal ‖ 6 ‖ bleed ing a year in lock-up ‖ 7 ‖ had suffered a mis ‖ 8 ‖ carria ‖ 9 ‖ ge or failed ‖ 10 ‖ suicide attempt as murder ‖‖‖‖‖‖‖ 1 ‖ "chemical endan germent" ‖ 2 ‖ gestatio ‖ 2a ‖ nal child abuse ‖ 3 ‖ weaponized addiction ‖ 4 ‖ charged with ‖ 4a ‖ man slaughter ‖ 5 ‖ birthing a still ‖ 6 ‖ born child facing

the scholarly study of candy-tampering legends. He collected newspaper reports
razor blades, needles, or broken glass in and distributing the candy
that Children copy or act out stories they overhear, adding pins to or pouring household cleaners on their own candy
died after eating a cyanide-laced package of Pixy Stix. A subsequent police investigation eventually determined that the poisoned candy had been planted in his trick-or-treat pile by the boy's father,
Due to their fears, parents and communities restricted trick-or-treating and developed alternative "safe" events
also promoted the sale of individually wrapped, brand-name candies and discouraged people from giving homemade treats to children.

li fe ▌▌ 7 ▐▐ in prison for ▌▌ 8 ▐▐ passed cocaine to ▌▌ 9 ▐▐ her son ▌▌ 9a ▐▐ consti tuting criminal delivery of ▌▌ 10 ▐▐ drugs ▐▌▐▌▐▌▐▌▐ 1 ▐▐ mother weapon ▌▌ 2 ▐▐ weaponized filiation ▌▌ 2a ▐▐ *partus sequitur* ▌▌ 3 ▐▐ *ventrem*: following the con ▌▌ 3a ▐▐ dition of the mother ▌▌ 4 ▐▐ Law of hypodescent ▌▌ 4a ▐▐ weaponized gender ▌▌ 4b ▐▐ thought of as girls ▌▌ 5 ▐▐ one or the other ▌▌ 5a ▐▐ to make a man of, man up ▌▌ 6 ▐▐ the mom was a to tal bro ▌▌ 6a ▐▐ by synec doche the whole bo ▌▌ 7 ▐▐ dy of the object ▌▌ 8 ▐▐ masks its absence ▌▌ 9 ▐▐ It is contiguous with ▌▌ 9a ▐▐ its empty place ▌▌ 10 ▐▐ Has retained it or also ▌▌ 10a ▐▐ given it up ▐▌▐▌▐▌▐▌▐ 1 ▐▐ As metaphor of all losses ▌▌ 2 ▐▐ Mother's body as ▌▌ 3 ▐▐ Effect of mutilation ▌▌ 4 ▐▐ Force of coun ter-wish ▌▌ 5 ▐▐ Appointed its substitute ▌▌ 6 ▐▐ which covers the wo ▌▌ 6a ▐▐ und and itself becomes ero togenic ▌▌ 7 ▐▐ no longer the same as it was before ▌▌ 7a ▐▐ weaponized bonding ▌▌ 8 ▐▐ weaponi zed mascul ▌▌ 9 ▐▐ inity fake rape or ▌▌ 10 ▐▐ real rape ▐▌▐▌▐▌▐▌▐ 1 ▐▐ "legitimate rape" like you ar ▌▌ 1a ▐▐ e fucking the hott ▌▌ 1b ▐▐ ub because the vagi ▌▌ 2 ▐▐ na is cooler than the water ▌▌ 2a ▐▐ "normal" ▌▌ 3 ▐▐ rape v. genocidal ▌▌ 4 ▐▐ we aponized porn gon ▌▌ 5 ▐▐ zo porn or revenge ▌▌ 6 ▐▐ porn, re-porning ▌▌ 7 ▐▐ delete ▌▌ 8 ▐▐ th is record now ▌▌ 9 ▐▐ $499 file a

▌▌▌ 9a ▌▌▌ takedown notice We ▌▌▌ 10 ▌▌▌ b MD soft paywall quick sand c ▌▌▌ 10a ▌▌▌ opycat anycast h ▌▌▌ 10b ▌▌▌ ate f uck ▌▌▌▌▌▌▌▌▌▌

The enthymeme suppresses its premises in connection with its operation in and as ideology, the domain of the probable as the already known and felt, the understood. By why does its *withholding* account for its suasion? Perhaps it does not only rely on the world-summoning capacities of language, but also *generates* this phenomenon. Which is to say, it helps to produce ideology, drive its affective hold, the sense of consensus around it. It would "prove" its claim in the claims it makes on us.

> The speaker uses a form of interaction which has its "counterpart" in dialectic, but instead of using question and answer to achieve interaction, he uses the enthymeme... The speaker draws the premises for his proofs from the propositions his audience would supply... Enthymemes intimately unite speaker and audience and provide the strongest possible proofs. The aim of rhetorical discourse is persuasion...rhetorical arguments, or enthymemes...have the virtue of being self-persuasive... Owing to the skill of the speaker, *the audience itself helps construct the proofs by which it is persuaded.*

> Lloyd F. Bitzer, "Aristotle's Enthymeme Revisited" (1959; emphasis original)

Enthymemes coerce through a means of demonstration that has always already proved itself, hooking us by enjoining the affective labor of social knowing. Not only is it the nature of probable evidence to be self- evident; it is the one to be "convinced" who provides it. "To exclude a premise or conclusion is to let the audience infer it; they are more likely to be persuaded" (a website). Itself enthymemic. But further: an enthymeme has always already set the subjective recognition that validates it to work simply in being understood as implicative. Its intimacy and strength lie in these identifications.

1 ▌▌ chemtrails f ▌▌ 2 ▌▌ laking off ▌▌ 3 ▌▌ a skid ▌▌ 4 ▌▌ the s ky ▌▌ 5 ▌▌ the sky mediat ed by clouds ▌▌ 6 ▌▌ clouds spamm ing the sky ▌▌ 6a ▌▌ weather modification ▌▌ 7 ▌▌ 2008 Evergreen Air ▌▌ 7a ▌▌ Patent US 7,413,145 ▌▌ 8 ▌▌ B2 capable of "dumping" tons ▌▌ 8a ▌▌ of a "Weather Modification Com ▌▌ 8b ▌▌ pound" aerosol dumps ▌▌ 9 ▌▌ achieved over several gl ▌▌ 10 ▌▌ obal locations on the same ▌▌▌▌▌▌▌▌ 1 ▌▌ day fewer aircraft "trails" and more ▌▌ 1a ▌▌ Chem-▌▌ 2 ▌▌ bombs appear as cirrus ▌▌ 2a ▌▌ clouds ▌▌ 3 ▌▌ Owning the weather ▌▌ 3a ▌▌ climate modification ▌▌ 4 ▌▌ weaponized weather, weather warfare ▌▌ 4a ▌▌ production of artificial weather ▌▌ 5 ▌▌ weapons of "synoptic scal ▌▌ 6 ▌▌ e" control and domination of ▌▌ 6a ▌▌ whole physical systems ▌▌ 6b ▌▌ to mo dify space weather ▌▌ 7 ▌▌ ope rate from the outer atmosphe ▌▌ 7a ▌▌ re weaponized exosphere ▌▌ 7b ▌▌ weaponized ionosphere ▌▌ 8 ▌▌ ionospheric heater ▌▌ 9 ▌▌ cosmic distance ladder ▌▌ 9a ▌▌ weaponized rain ▌▌ 9b ▌▌ weaponized snow o ▌▌ 10 ▌▌ r artificial snow ▌▌▌▌▌▌▌▌ 1 ▌▌ weaponized weather report, weather-chat ▌▌ 2 ▌▌ climate theater ▌▌ 3 ▌▌ weather as lifestyl ▌▌ 4 ▌▌ e or lifestyle-effect (rev ▌▌ 5 ▌▌ ersed?) climate apartheid cl ▌▌ 6 ▌▌ imate empowerment ▌▌ 6a ▌▌ ambient mood ▌▌ 6b ▌▌ "sick building" syndrome ▌▌ 7 ▌▌ building-related illness ▌▌

8 ‖ air design, designer ai ▌▌ 9 ‖ r weaponized air supply ▌▌ 9a ▌▌ Chicago Climate Exchange ‖ 9b ‖ carbon credit ‖ 10 ‖ weaponized emissions ▌▌ 10a ‖ *North by Northwest* weaponized cropduster ▌▌ 10b ‖ weaponized exhaust ▌▌▌▌▌▌▌▌ 1 ‖ there is always something in the air ▌▌ 2 ‖ "rolling coal" poll ▌▌ 3 ‖ ution porn conspicuous ▌▌ 3a ‖ pollution "ain't nothing wro ▌▌ 4 ‖ ng with rolling some confederate ▌▌ 4a ‖ coal" coal rollers dis ▌▌ 4b ‖ able their trucks' ▌▌ 5 ‖ pollution controls ▌▌ 5a ‖ removing the diesel particulate ▌▌ 6 ‖ filter customization, weaponized ▌▌ 6a ‖ retrofit To protest ▌▌ 7 ‖ emissions regulations install a sm ▌▌ 8 ‖ oke stack and equip ▌▌ 9 ‖ ment that "tricks ▌▌ 9a ‖ the engine" into needing mo ▌▌ 10 ‖ re fuel forcing more than ▌▌ 10a ‖ the engine can handle The ▌▌▌▌▌▌▌ 1 ‖ result is ▌▌ 2 ‖ a burst ▌▌ 3 ‖ of black smoke ▌▌ 4 ‖ blasted at pedestrians ▌▌ 5 ‖ cyclists or "rice burners" (Japanese-made ▌▌ 6 ‖ cars) "Prius re ▌▌ 6a ‖ pellant" ▌▌ 7 ‖ "It's manhood. It's ▌▌ 7a ‖ who can blow ▌▌ 8 ‖ the most smoke, wh ▌▌ 8a ‖ ose is black ▌▌ 8b ‖ er. I'll be h ▌▌ 9 ‖ onest with you. I de ▌▌ 10 ‖ cided I'd save some ▌▌ 10a ‖ money. It's like throwing do ▌▌ 10b ‖ llar bills out the window" ▌▌▌▌▌▌▌▌

Enthymemes are locations of enculturation: to say speech is *encoded* is to call out the enthymeme. Yet an enthymeme solicits inference that draws on its audience's resources in terms of what it already recognizes *and* what it may be spurred to imagine. "*The audience itself helps construct the proofs by which it is persuaded*" – supplying a proof's givens even when the given must be fabricated (as given).

"An enthymeme is partisan argument as collaborative utterance" (Farrell). It might have its sympathetic audience, but it doesn't need one. One might disagree with an enthymeme – or intuit other implications (how would we know?); it has still enjoined one's complicity. A joint effort, it uses its audience's attachment to the world, its knowledge of the world, the interconnectedness of what makes up that world to call to mind what would ground it. An enthymeme has rhetorical traction. It patterns thought.

1 ▮▮ weaponized Table, Table ▮▮ 2 ▮▮ as "floor ▮▮ 2a ▮▮ Differentiation" or "floor Terrace" Table ▮▮ 3 ▮▮ as medium enables present ▮▮ 4 ▮▮ ation a Traffic of "Airspace" ▮▮ 5 ▮▮ apparently neutral set ting ▮▮ 5a ▮▮ Table "as Forma t for ▮▮ 6 ▮▮ agreeing on something" round ▮▮ 6a ▮▮ Table ▮▮ 6b ▮▮ Table to stand at (Sales ▮▮ 7 ▮▮ Counter; "market device") ▮▮ 8 ▮▮ weaponized Configuration point of ▮▮ 9 ▮▮ contact High ▮▮ 10 ▮▮ through-put environ ▮▮▮▮▮▮▮▮▮▮ 1 ▮▮ ment weaponized enhancement enhanc ▮▮ 2 ▮▮ ement purchase your purchase experience prestige pro ▮▮ 3 ▮▮ grammed consumption ambience ▮▮ 4 ▮▮ mood modula ▮▮ 5 ▮▮ tion earworm ▮▮ 6 ▮▮ audio virus ▮▮ 7 ▮▮ predatory brand ▮▮ 8 ▮▮ ing environment ▮▮ 9 ▮▮ ▮▮ 10 ▮▮ brand ▮▮▮▮▮▮▮▮▮▮ 1 ▮▮ "symmetry" ▮▮ 2 ▮▮ weaponized sponsor ship ▮▮ 2a ▮▮ degraded sumptuary expend ▮▮ 2b ▮▮ iture buy the ▮▮ 3 ▮▮ location name ▮▮ 3a ▮▮ branded set ▮▮ 4 ▮▮ ting Is a fan a cli▮▮ 4a ▮▮ ent? a custom er? ▮▮ 5 ▮▮ weaponized quality, qua ▮▮ 5a ▮▮ lity assurance ▮▮ 6 ▮▮ Please weaponized customer ser ▮▮ 7 ▮▮ vice Hold (automated) ▮▮ 8 ▮▮ intimacy superserviceable per ▮▮ 8a ▮▮ sonal service disso nance ▮▮ 9 ▮▮ with a s mile ▮▮ 10 ▮▮ your display, ▮▮▮▮▮▮▮▮▮▮ 1 ▮▮ bearing ▮▮ 2 ▮▮ "go into rob ▮▮ 2a ▮▮ ot" soft serve ▮▮ 3 ▮▮ contingent labor weapon ized work hou ▮▮ 4 ▮▮ rs "tempflex" on or

The peculiarity of the enthymeme's silence. There is a gap in the enthymeme, but there is no gap, as it reinforces the common sense of common sense, the obvious and its obviousness. "Discourse derives its rhetorical power more from the silence of the cultural imperative than from the imperative itself" (McGee). What is not said is leveraged on and leverages a reality principle. To pass over in silence is not to negate but to make good on. Here, then, is a silence that is not subordinated to speech, but needed by it: it is the source of speech's power, its "dark matter" or "dark energy" (Ratcliffe). The omitted may be included by exclusion, but its status is that of constitutive interior, not constitutive exterior.

Speaking of the "deforming tendencies" of translation, Antoine Berman notes the translator's habit of "clarification," which involves what he calls "explicitation": "the explicitation can be the manifestation of something that is not apparent, but concealed or repressed in the original…in a negative sense, explicitation aims to render 'clear' what does not wish to be clear in the original." Among other things, what is destroyed by explicitation is an utterance's enthymemic quality. A rhetoric of silence that does not call up the ineffable, but the banal.

off clock ▌▌ 5 ▌▌ weaponized time-sheet ▌▌ 5a ▌▌ "time theft" ▌▌ 6 ▌▌
night shift ▌▌ 7 ▌▌ weaponized hours of business ▌▌ 8 ▌▌ weaponized
franchise ▌▌ 9a ▌▌ branch manager ▌▌ 10 ▌▌ weaponized upgrade we
▌▌▌▌▌▌▌▌▌▌ 1 ▌▌ aponized shopping ▌▌ 1a ▌▌ price hike weaponized ▌▌ 1b
▌▌ d mark-up weaponized ▌▌ 2 ▌▌ shipping and h ▌▌ 2a ▌▌ andling w
eaponized free ▌▌ 2b ▌▌ shipping ▌▌ 3 ▌▌ weaponized invoice ▌▌ 3a ▌▌
weaponized rei mbursement ▌▌ 3b ▌▌ (lost deposit) ▌▌ 4 ▌▌ weaponized
buyback ▌▌ 5 ▌▌ weaponized coupon, dis ▌▌ 6 ▌▌ count unbundle sep ▌▌
6a ▌▌ arate charge ▌▌ 7 ▌▌ weaponized audit ▌▌ 8 ▌▌ autobilling as
weaponized billing ▌▌ 9 ▌▌ how to ▌▌ 10 ▌▌ get it off ▌▌ 10a ▌▌ my
bill ▌▌▌▌▌▌▌▌▌▌ 1 ▌▌ weaponized su rcharge terminal fee fi ▌▌ 1a ▌▌ nd
an autho rized Pay Station ▌▌ 2 ▌▌ flexible solutio ▌▌ 2a ▌▌ ns
weaponized overdraft ▌▌ 3 ▌▌ loan payday ▌▌ 4 ▌▌ loan ▌▌ 4a ▌▌ bad
advance b ad ▌▌ 4a ▌▌ santa ▌▌ 5 ▌▌ market in unpaid debt ▌▌ 6 ▌▌
charged-off debt debt turns ▌▌ 7 ▌▌ over ▌▌ 8 ▌▌ double- or triple-
sell ▌▌ 9 ▌▌ debt- ▌▌ 10 ▌▌ service consolidation ▌▌ 1 ▌▌ shakedown
▌▌ 2 ▌▌ weaponized collecting ▌▌ 3 ▌▌ If worker A gets a ▌▌ 3a ▌▌
call ▌▌ 4 ▌▌ from coll ector X ▌▌ 4a ▌▌ at work ▌▌ 5 ▌▌ late charges
and ▌▌ 6 ▌▌ over-limit charges ▌▌ 6a ▌▌ weaponized ▌▌ 7 ▌▌ penalties
▌▌ 8 ▌▌ weaponized variables ▌▌ 9 ▌▌ weaponized futur ity

Again and again in *The Psychic Life of Power* (1997), Judith Butler returns to the notion of the subject's "passionate attachment to subjection," its "passionate complicity with the law." She repeatedly underscores her fascination with the narrative conundrum of representing the moment of subjectivation: such a fiction, or at least the grammar of the language in which it's told, must presuppose the subject whose generation it attempts to depict. But she seems especially captivated by how the subject's passion for interpellation must also pre-exist the subject proper, making note of "the responsiveness of the one hailed," "an openness or vulnerability" to hailing, "a certain readiness or anticipatory desire on the part of the one addressed." "Although there would be no turning [becoming subject] without first having been hailed," she writes, "neither would there be a turning around without some readiness to turn." Butler reasons this passion stems from a fundamental narcissism: the subject is willing to undergo "subordination as the price of subjectivation," in that it is the cost of one's social existence, of being recognized by the symbolic order.

While "certain attachments precede and condition the formation of subjects," Butler asks: "To what extent has the disciplinary apparatus that attempts to produce and totalize identity become an abiding object of passionate attachment?" She makes much of the trope of conscience, the subject turning on itself, as concomitant to its turn towards the law in becoming subject. Aside from guilt, eroticized rebound of the death drive as well as of the law's prohibition-inculpation, might there be another way to answer this question of passionate attachment?

As Butler notes, "The call arrives severally and in implicit and unspoken ways." Which is to say: it is enthymemic. To be addressed by enthymemes is to be called to reproduce and supplement the symbolic order in all its imaginary probability, to practice social belonging, literacy, emplacement. Enthymemes meet our readiness to know. We attach deeply to such implication, it claims us.

▌▌ 10 ▌▌ uncert ainty allure ▌▌ 10a ▌▌ weaponized vertica ▌▌▌▌▌▌▌▌▌▌▌ 1
▌▌ lization or horiz ▌▌ 2 ▌▌ ontalization Of possible ▌▌ 3 ▌▌
outcomes "credit event" ▌▌ 3a ▌▌ weaponized volatility ▌▌ 4 ▌▌
market gap arb ▌▌ 4a ▌▌ itrage (price differ ▌▌ 4b ▌▌ ential) ▌▌ 5 ▌▌
weaponized circulation, use of ▌▌ 6 ▌▌ network ▌▌ 6a ▌▌ security
Environment ▌▌ 6b ▌▌ electronic signature ▌▌ 7 ▌▌ weaponized
abstraction ▌▌ 7a ▌▌ financial instrument ▌▌ 7b ▌▌ money incested ▌▌
8 ▌▌ money ▌▌ 9 ▌▌ neutral mediat ▌▌ 9a ▌▌ or intermediary weapon ▌▌
10 ▌▌ ized substitu tion ▌▌▌▌▌▌▌▌▌▌ 1 ▌▌ tally offer in-kind
weaponized ▌▌ 1a ▌▌ fungibility monetization put ▌▌ 1b ▌▌ paid
cashed it ▌▌ 2 ▌▌ i n ▌▌ 3 ▌▌ weapo nized equivalence ▌▌ 4 ▌▌
underestimation guess ▌▌ 4a ▌▌ timate in real wages ▌▌ 4b ▌▌ weapon
ized purchasing po ▌▌ 5 ▌▌ wer right to consume ▌▌ 6 ▌▌ back pay
garnishment ▌▌ 7 ▌▌ deficit operatio ▌▌ 7a ▌▌ n in deficit of ▌▌ 7b
▌▌ weaponized spreadshe et hous ▌▌ 8 ▌▌ ekeeping flo ▌▌ 8a ▌▌ at
expenses ▌▌ 9 ▌▌ number ▌▌ 9a ▌▌ primitive numeric ▌▌ 10 ▌▌ seduction
quant ▌▌ 10a ▌▌ ification that money photog ▌▌▌▌▌▌▌▌▌▌ 1 ▌▌ raphs ▌▌ 2
▌▌ pay as you go ▌▌ 2a ▌▌ weaponization of work er ▌▌ 3 ▌▌ as human
capital ▌▌ 4 ▌▌ go Earn some ▌▌ 4a ▌▌ Inte rest ▌▌ 5 ▌▌ weapon nized
entrep reneuri alism ▌▌ 5a ▌▌ As entre preneur of oneself ▌▌ 6 ▌▌

competit ive work fitness h ▌▌ 7 ▌▌▌ ealth ▌▌ 8 ▌▌▌ Weaponized noncompet ▌▌ 9 ▌▌▌ e weaponized expertise ▌▌ 10 ▌▌▌ "servile virtuosit y": imperative ▌▌ 10a ▌▌▌ to be "excellent" ▌▌▌▌▌▌▌▌▌ 1 ▌▌▌ against one's dispensa bility ▌▌ 2 ▌▌▌ production distribu ▌▌ 3 ▌▌▌ ted through all social spa ▌▌ 3a ▌▌▌ ce all-included ▌▌ 3b ▌▌▌ difficult to say ▌▌ 4 ▌▌▌ where and when the actual act ▌▌ 4a ▌▌▌ of production ▌▌ 5 ▌▌▌ is carried out ▌▌ 5a ▌▌▌ weaponized unwaged contin uous ▌▌ 5b ▌▌▌ produ ction of value ▌▌ 6 ▌▌▌ weaponized value-added ▌▌ 6a ▌▌▌ value boost val ▌▌ 7 ▌▌▌ ue capture ▌▌ 7a ▌▌▌ siphoning ▌▌ 7b ▌▌▌ perpetual live cash ▌▌ 8 ▌▌▌ manhours ▌▌ 9 ▌▌▌ mathesis of persons ▌▌ 10 ▌▌▌ Have it it ▌▌▌▌▌▌▌▌▌ 1 ▌▌▌ erate over enroll ▌▌ 1a ▌▌▌ ed fingerprint tem ▌▌ 1b ▌▌▌ plates ▌▌ 2 ▌▌▌ Easily cont ▌▌ 2a ▌▌▌ rolled labor Wha ▌▌ 2b ▌▌▌ t does my tag say ▌▌ 3 ▌▌▌ weaponized utility ▌▌ 3a ▌▌▌ weaponized metric ▌▌ 4 ▌▌▌ weaponized standardization ▌▌ 5 ▌▌▌ weaponized optimization, efficien ▌▌ 6 ▌▌▌ cy how will tasks be ▌▌ 6a ▌▌▌ performed at what pa ▌▌ 7 ▌▌▌ ce expendability Hazards due to ▌▌ 8 ▌▌▌ inattention gr ▌▌ 8a ▌▌▌ ease burn Spir ▌▌ 9 ▌▌▌ it Possess ion became an over ▌▌ 9a ▌▌▌ night afflictio ▌▌ 10 ▌▌▌ n Spirit inci dents as form of ▌▌▌▌▌▌▌▌▌ 1 ▌▌▌ retaliation ▌▌ 2 ▌▌▌ symptoms of local ▌▌ 2a ▌▌▌ conflict ▌▌ 3 ▌▌▌ slowdown 8,00 ▌▌ 3a ▌▌▌ 0 production hrs ▌▌ 4 ▌▌▌

To live in a 21st-century society of ubiquitous computing, of digitally networked sociality, is to live in conditions of *toxic implicature*. The weaponized enthymeme.

In a provocative, little-known article on postmodern rhetoric (1990), Michael McGee proposes a certain discursive mutation in American culture, over several generations in the making: a shift towards an ontological fragmentariness that fundamentally changes the rhetoricity of communication. There is a "sense in which 'texts' have disappeared altogether," he writes, "leaving us with nothing but discursive fragments of context."

It is both the "collapse [of] 'context' into 'text'" and the essential incompleteness of the context replacing the text that dissolve and resolve discourse into a network of enthymemic prompts. "No texts exist today. We have instead fragments of 'information' that constitute our *context*. The unity and structural integrity we used to put in our texts…is now presumed to be in us ourselves." Audience production of a text's distinctly prosthetic coherence amounts to a distributed inversion of authorship: "The only way to 'say it all' in our fractured culture is to provide readers/audiences with dense, truncated fragments which cue them to produce a finished discourse in their minds. In short, text construction is now something done more by the consumers than by the producers of discourse."

Texts are always dynamic, generative structures for reading as performance (Johanna Drucker). How does the cuing of the reader described here differ? When readers "produce a finished discourse in their minds," what is it that they create? McGee's scare-quoted term "'information'" suggests a problematic standardization of the "instructions for reading" (Jerome McGann) that any text encodes. And information is also what marks the transformation of text into context. Readers are not reading texts, they are reading contexts: discourse has shifted to a canny mapping of the social world, in its totalizable, interconnected locations and meanings. It is taken up, in other words, with articulating and circulating the probable. At the same time, this context-text consists of fragments-*qua*-enthymemes: as bare strings of sites tinged with their implied orientations, this discourse outsources mapping to the reader, who both draws the plan of this world and acts as a locative, global positioning system within it, assigning signifiers to their proper, probable places and values. Such hyperenthymemic, interactive text does not *impart*. Rather, it supplies prompts for engaging and producing probable knowledge that its hailed audience is presumed to command and to intuit, through a constant activity of mapping, locating, and cross-referencing.

lost when someone saw a gh ▐▌ 4a ▐▌ ost weaponized reconditioning ▐▌ 4b ▐▌ deskilling as weapon ▐▌ 5 ▐▌ to the human portfo ▐▌ 5a ▐▌ lio saleable or non transferable ▐▌ 5b ▐▌ bearer of the capacity ▐▌ 6 ▐▌ weaponized attrition ▐▌ 6a ▐▌ weaponized exhaustion ▐▌ 7 ▐▌ weaponized contract as such ▐▌ 8 ▐▌ negotiating ▐▌ 9 ▐▌ between cost of "energy expenditure" ▐▌ 9a ▐▌ and its reproduction ▐▌ 10 ▐▌ weaponized downsizing ▐▌ 10a ▐▌ weaponized layoffs ▐▌▐▌▐▌▐▌ 1 ▐▌ weaponized growth ▐▌ 2 ▐▌ weaponization of investme nt yield ▐▌ 2a ▐▌ grow your revenue ▐▌ 2b ▐▌ "dictatorship of speed" ▐▌ 3 ▐▌ fast capital ▐▌ 3a ▐▌ (extinguished) nec ▐▌ 3b ▐▌ essary labor time overinvestm ▐▌ 4 ▐▌ ent rollout ▐▌ 4a ▐▌ compounding weaponized ▐▌ 4b ▐▌ stimulus confi dence engor ▐▌ 5 ▐▌ gement ill-got ten gains wea ▐▌ 5a ▐▌ ponized expenditure flex ▐▌ 6 ▐▌ ible accumulat ion ▐▌ 6a ▐▌ accumulation for accumula ▐▌ 6b ▐▌ tion's sake ▐▌ 7 ▐▌ privatized condition ▐▌ 7a ▐▌ s for production reserv ▐▌ 7b ▐▌ e field of potential ▐▌ 8 ▐▌ exploitation as weaponized ▐▌ 8a ▐▌ Primitive accumula ▐▌ 9 ▐▌ tion mark ▐▌ 9a ▐▌ et penetration ▐▌ 9b ▐▌▐▌ 10 ▐▌ weaponized bid ▐▌ 10a ▐▌ ding epiphenomena no auc ▐▌▐▌▐▌▐▌ 1 ▐▌ tion ▐▌ 2 ▐▌ weaponized flow ▐▌ 3 ▐▌ concept of "globe" ▐▌ 4 ▐▌ weaponized deval uation ▐▌ 5 ▐▌ all-included ▐▌ 6 ▐▌ weap onized

To demand the usufruct of
To use my daughter as I would
Or take the sick daughter to the hospital
Hospitality
The innocence of paternity: Horsepitality
That his children owe him everything, their very existence,
Plus commission from the company
that they are absolutely indebted to him,
charged with wire fraud (14 counts), possession of unauthorized access
devices (8 counts), interception of wire or electronic communications,
unauthorized access to a federal computer, and causing damage to a
computer.
making a liquid flow out onto a surface
some hope of return, of getting back in.
The violation is carried out to make it signify
Because they do not insult the conscience
Only unless they show you.

Digitally networked sociality obviously abets this discursive formation, one that we might understand as radically incomplete and open and, *for that very reason*, also, in certain regards, radically totalized and closed. Regardless of the participation it solicits and requires, the discourse of the context-fragment belongs to the *lisible*, not the *scriptable*. As Barthes states in *S/Z* (1970): "The writerly text is *ourselves writing*, before the infinite play of the world… is traversed, intersected, stopped, plasticized by some singular system (Ideology, Genus, Criticism) which reduces the plurality of entrances, the opening of networks, the infinity of languages." In contrast, the purposively unfinished, hyper-enthymemic style is predicated not on "infinite play," but on readerly acts of reverse engineering that produce the world of its implicature.

It is thus through its telegraphic quality, its shorthand, that fragmentary textuality is at its most audience- oriented and socially gregarious, as well as most omnipresent – proliferating, accessible, scannable in distraction. In its persuasive, interactive withholding, *less* is so much *more*. Yet *more* also turns out to be *less*, given the impoverishing terms of the discursive superabundance of hyper-enthymemic culture. In this *sparagmos* of the text, shredded to tags, lies both an automation of assent and an incitement to ersatz, prefabricated thought and feeling, as we unconsciously reflexively autopopulate the gaps around coded signifiers, which beg to be filled through probable knowledge given or extrapolated. Such hyper-mediated self- persuasion draws on a categorical episteme, as it subsumes particulars and instances into a lithe, absorptive grid of typification and evaluation, or co-fabulates around names and events that become their own probable types, becoming recognizable (enthymemic) rigid signs across texts.

To pull the concept of the "index" another way: texts have become their own meta-data, their own controlled vocabularies (Tan Lin). A post-mark-up residue, they read almost as collections of headings radiant with social compression, catalogs scored with hyperlinks or suppressing even these locators as we position and textualize the relevant indices through our social savvy. *We* are the points of reference for these points of reference, or we can use the proxy always to hand, the Internet. Pointing beyond itself for its authority, enthymemic discourse touches down in the network to be confirmed through concatenation, in a culture of cross- referencing that "connects and coordinates an ever-expanding system" (Pasanek and Wellmon) of social identification, meaning, and value.

migrancy ▮▮ 7 ▮▮ surplus labor ▮▮ 8 ▮▮ standing reser ▮▮ 9 ▮▮ ve v. waste humanity ▮▮ 10 ▮▮ *underlumpen* ▮▮▮▮▮▮▮▮▮ 1 ▮▮ weaponized hunger need ▮▮ 2 ▮▮ weaponized overstock ▮▮ 3 ▮▮ weaponized pulping ▮▮ 3a ▮▮ weaponized Discards ▮▮ 3b ▮▮ weaponized Scarcity ▮▮ 4 ▮▮ weaponized budget ▮▮ 4a ▮▮ a Parsi mony of ▮▮ 4b ▮▮ Fiat ▮▮ 5 ▮▮ Wea ponized crisis ▮▮ 6 ▮▮ Austerity Terror ▮▮ 6a ▮▮ workfare weaponized welfare "rich" poverty ▮▮ 6b ▮▮ weaponized insurance ▮▮ 7 ▮▮ weaponized co-pay diagnostic co ▮▮ 7a ▮▮ de approved illness ▮▮ 8 ▮▮ denial of services ▮▮ 9 ▮▮ limited liability ▮▮ 10 ▮▮ weaponized unc ▮▮ 10a ▮▮ onditional right of private ▮▮ 10b ▮▮ property Ownership society ▮▮▮▮▮▮▮▮▮ 1 ▮▮ weaponi zed supply chain ▮▮ 1a ▮▮ Chi cken of the Sea raw ma ▮▮ 1b ▮▮ terials commo ▮▮ 2 ▮▮ dity metabolism ▮▮ 2a ▮▮ weapo nized sub contract ▮▮ 3 ▮▮ weapo nized cargo ▮▮ 4 ▮▮ weapo nized cost-benefit ▮▮ 4a ▮▮ weaponized standard of living Emp ▮▮ 4b ▮▮ loyees to brea ▮▮ 5 ▮▮ k "food into pieces," which "re ▮▮ 5a ▮▮ sults in eating les ▮▮ 6 ▮▮ s and fee ling ful ▮▮ 6a ▮▮ l" weap onized asking price pri ▮▮ 7 ▮▮ ce-fixing pre fab off-the- ▮▮ 8 ▮▮ shelf turnkey (nou ▮▮ 9 ▮▮ n) *archa ic* 1. A ▮▮ 10 ▮▮ jailor; (adjective) 1. of ▮▮▮▮▮▮▮▮▮ 1 ▮▮ or involving the provi ▮▮ 2 ▮▮ sion of a complete produc ▮▮ 2a ▮▮ t or service that is ▮▮ 3 ▮▮

Bourdieu theorizes symbolic violence in part as subjects' complicity with structures of domination, through the mechanism of recognition as misrecognition (or misrecognition as recognition). We invest in our life-world, our habitus, by internalizing and freely enacting our culture as "unthought thought." Bodies and minds made by a habitus *belong* to it: a milieu is viewed by its members through frameworks of thought and being that are of that milieu itself (another version of "obviousnesses as obviousnesses"). "The schemes applied to the world are the product of the world to which they are applied." This naturalization of habitus, the place one takes, the ways one participates in culture, amounts to recognition-misrecognition of the given dispensation of life as right, true, meaningful, socially real.

Our hyper-enthymemic discursive formation relies on a mode of intensely invested recognition-misrecognition, the enthymemic episteme, that seems unusually cognitively compulsive as a continuous unthought but reflexive diagramming of the social world. In the information society, social literacy is massively incentivized: this reflexive literacy, our neurotic positioning through networked probability – *is* our sociality. Habits of sharing, posting, liking reflect the premium on the circulation of knowledge to produce and emblematize a literacy that requires constant maintenance. Precisely because it works through implicature, hyper-enthymemic culture exponentially incentivizes our grasp on the known-as-probable, in that its telegraphy interpellates us as *being in the know*, as possessors of a *knowingness* that functions as psychic and social capital. Thus, its libidinality: if the enthymeme is a particularly effective rhetorical mechanism – always already, automatedly inducing probable thinking that is itself automatic unthought thought – it is one whose seduction we passionately cleave to.

Over twenty-five years ago, McGee wrote, "I would want to explore the sense in which we are constantly harassed by the necessity of understanding an 'invisible text' which is never quite finished but constantly in front of us." He did not have the hyper-enthememic sensibility.

ready for immedi ▌▌▌ 4 ▐▐▐ ate use. To any ▌▌▌ 4a ▐▐▐ buyer as a completed product. ▌▌▌ 5 ▐▐▐ The bundling of materials ▌▌▌ 6 ▐▐▐ and labor. ▌▌▌ 7 ▐▐▐ Day Pass ▌▌▌ 7a ▐▐▐ weaponized refills ▌▌▌ 8 ▐▐▐ weaponized hoar ▌▌▌ 8a ▐▐▐ ding "warm hoarding" stockpile ▌▌▌ 9 ▐▐▐ weaponized obsol escence expiration ▌▌▌ 10 ▐▐▐ date F ▌▌▌ 10a ▐▐▐ reedom as coping with e ▌▌▌ 10b ▐▐▐ xcess shrink wra ▐▌▐▌▐▌▐▌▐ 1 ▐▐▐ p Bonus pak Weaponized susta ▌▌▌ 2 ▐▐▐ inability consumer Sovereignty ▌▌▌ 2a ▐▐▐ consumer Rationalization ▌▌▌ 3 ▐▐▐ ethical consumption ▌▌▌ 3a ▐▐▐ a cleansed purchase carbon cred ▌▌▌ 4 ▐▐▐ it weaponized Affordance ▌▌▌ 5 ▐▐▐ externalities are a Weapon ▌▌▌ 6 ▐▐▐ weaponized waste, leachate putres ▌▌▌ 6a ▐▐▐ cible flow ▌▌▌ 6b ▐▐▐ superfluity superabundance ▌▌▌ 7 ▐▐▐ have you not had ▌▌▌ 8 ▐▐▐ enough ▌▌▌ 9 ▐▐▐ Affluence scripts ▌▌▌ 10 ▐▐▐ weaponized availability was ▐▌▐▌▐▌▐▌▐▌▐ 1 ▐▐▐ te ritual you bou ▌▌▌ 1a ▐▐▐ ght it so you ▌▌▌ 1b ▐▐▐ can throw it out ▌▌▌ 2 ▐▐▐ bought it ▌▌▌ 3 ▐▐▐ so you ▌▌▌ 3a ▐▐▐ can do whatever you ▌▌▌ 4 ▐▐▐ want wit h it ▌▌▌ 5 ▐▐▐ simply by Owning a ▌▌▌ 6 ▐▐▐ certain object ▌▌▌ 7 ▐▐▐ weaponized disposal ▌▌▌ 7a ▐▐▐ weaponized disposability ▌▌▌ 8 ▐▐▐ single-use ▌▌▌ 9 ▐▐▐ single-serving paks ▌▌▌ 10 ▐▐▐ you are Coached to ▐▌▐▌▐▌▐▌▐▌▐ 1 ▐▐▐ throw it away ▌▌▌ 2 ▐▐▐ never ful ▌▌▌ 3 ▐▐▐ ly disposed of ▌▌▌ 4 ▐▐▐ waste removal: c ▌▌▌ 5 ▐▐▐ ontrol allegory ▌▌▌ 6 ▐▐▐ all-included ▌▌▌ 7 ▐▐▐ weaponized erasure ▌▌▌ 7a ▐▐▐ or: waste asset waste as cap ▌▌▌ 8 ▐▐▐ ital renewables economic potent ▌▌▌ 9 ▐▐▐ ial fli ▌▌▌ 10 ▐▐▐ pside of clear cut ▐▌▐▌▐▌▐▌▐▌▐

And this is the possibility on which I want to insist: the possibility of disengagement and citational graft which belongs to the structure of every mark, spoken or written, and which constitutes every mark in writing before and outside of every horizon of semio-linguistic communication; in writing, which is to say in the possibility of its functioning being cut off, at a certain point, from its "original" desire-to-say-what-one-means [*vouloir-dire*] and from its participation in a saturable and constraining context. Every sign, linguistic or nonlinguistic, spoken or written (in the current sense of this opposition), in a small or large unit, can be *cited*, put between quotation marks; in so doing it can break with every given context, engendering an infinity of new contexts in a manner which is absolutely illimitable. This does not imply that the mark is valid outside of a context, but on the contrary that there are only contexts without any center or absolute anchoring [*ancrage*].

Jacques Derrida, *Limited Inc* (1977)

Given the written vernaculars of Web 2.0 (3.0?), our "current sense" of the spoken-written opposition might be of its dissolution: one feature more filiated with orality that writing has absorbed is its hyper-enthymemic quality. Derrida here also puts the text-context distinction under erasure: as oscillations of identity-difference, signs not only "participate" in and "engender" context: there are finally "only contexts without any center or absolute anchoring." But what of signs *collapsed* with their contexts: when a probable context is embedded in them, through implicature? What of signification within tightly networked social knowledge, held in place by distributed, regulatory cross-indexing largely through automated inference?

Perhaps the complexion of iterability changes within particular historical-social conditions. To imagine: the force required for a sign "to break with every given context" when signs are autocontextualizing in assemblage with self-persuading readers, proliferation as rigidity. When absorption of difference, its probable uptick, renders it strangely actively inertial: fed-back instantaneously to become part of the given.

[drag reduct. over/flat surface::misci]

Aa

Normal0falsefalsefalseEN-USX-NONEX-NONE AAA A

Aa AAAAAAAA A-line

facs display]size-chart AAAAnoncomplycopy Aa A

A AAAAAA

AAa

-cut of

f

-lothing as stored file or; output device| | | | | | | || This color 4 immediate

negation | | | | | neg-

| reticul | replicate perimeter up

|ward

Illusion & Stretch NettingFor areas that require interfacing,65123 Chameleon
Face Veil 65130 Ultra Light Ghillie Jacket & Pants-DesertPersonnel will center
their grade insignia ½" ab ove the white or black"MP" letters may have the letters "MP"
in white, centered on the front of the helmet liner, 1½" up
from bottom rim (see fig 28–14) Adds wear/

of Sapper tab as group 4 for permanent wear /worn when prescribed for wear
standards for starching and creasing battle dress uniforms the wearer's right side,
 slightly above the top
edge of the top buttoSurely the men who submit and the women who submit, the
believing men and the Quran that women must guard believing women, the
obeying men ****Points are awarded on the total value of the cart less any
discounts and the obeying women, w/black thread, except for 2LT and
MAJ available in subdued gold
can custom embroider your Multicam branch tapeoverhead and cuffs made of
stretch Lycra.It could be customised according to your request either *Abaya* Style
Cut or Prayer Dress Cut*Al Amira Hijab* consist of 2 separate pieces, ["written gar-
ment"Product]]ID:p0348Diamond Brooch 0348AuthorizationAlso a
wrap around | | | | | | | | | | |forced to remove her headsca
 Clarifies the definition of bloused trousersD-ring has french snap on
endwhite unisex cardiganbuttoned or unbuttoned while indoorsThe clothing must
hang loose so that the shape of the body is not apparentThe female clothing must
not resemble the man's clothingProxemic behavior

The discursive formation of the enthymemic fragment is a dominant discourse: given its networked, cross- indexed, mass audience-dependent character, its nature is to be dominant. And to domineer: not only through epistemic entrapment, but through the categorical logic of probable knowledge as capture. Rather than drowning in information overload, hyper-enthymemic culture thrives on a data stream it overbearingly micromanages in forms of knowing and knowingness that close down and obsessively regulate their objects through given – even when spontaneously produced – typification and emplacement.

Beyond "mere" mapping: enthymemic fragments instigate the suturing of incoherence, a papering over of contradiction. Filling in gaps, building rationalizations, propagating fictions. Snap judgment, instant feeling: knowledge riding on knowingness, the presumption of already knowing. A hole plugs a hole. Evading what it answers.

Enthymemes alert us to the nodes of the network of the given, openly acknowledging the fact of that network and the collaboration through which it is continuously reproduced. Yet that subjects collectively re-author and maintain the "gnoseological order" (Bourdieu) – both the map of what is socially real and the hold through which it unifies society – their underscored interactivity, their constant attention to the social order as such, only masks as it strengthens the exercise of symbolic violence. The probable is not solicited in a vacuum: it reproduces the social order.

Then again, might not inference – even unthought, reflexive inference – contest the dominant map, the fictions legitimating its configuration? "The symbolic struggle for the production of common sense": "this labor of categorization, of making things explicit and classifying them, is continually being performed, at every moment of ordinary existence, in the struggles in which agents clash over the meanings of the social word and their position in it" (Bourdieu). An oppositional uptake of implicature – a heterodox obviousness – an allotelegraphy of its fragments. Dissent uses this discursive formation, fomenting probable knowledge that unmasks probable knowledge.

Yet how far does it mirror domination: participatory entrapment, discourse as fragment-tag, givenness of the given, knowledge capture and cross-indexed policing, knowingness... To reverse the content of the habitus, but not to reconfigure its most intensive technique.

innovative Multicam camouflage. Multicam provides Ideal Coverage Minimum Required size for a *hijab* (*shayla*)[xenograp-[[to cover shoulder and reach below bust level is 29.5" Disguise in multiple conditions,

elevations, and seasons mock the surrounding Aa WICKABLE
environment by color matching,x 70.8" AAc-n-c-l AAA-nt-rs-ct
/75 cm x 180 cm. i wrap it around once AAAA A
Solid color Chiffon *Hijabs* in square AAAA A
pattern helps break up the outline of the wearer's AAaAAAAAAAA A-l-n-
body by implying a flow of space AAAA A AAaaaa
The material must not be so thin that AAAAn-nc-mply-py Aa one can
see through itAnything that interrupts A AAAAAA this
flow of space would be considered a target indicator as 'to veil, to seclude, to scre-
en, to AAa conceal, to form a separation, to
mask'improve lethality®, survivability, durability and comfortFlexible aesthetics
for wool-like, cotton-like or | | | | | | 2) Common name for viscose
rayon. blended appearanceSuperior resistance to sunlight degradation Lycra can be stre-
tched over 500% without 'outside the home' and not display their ornaments
except to(11) Airborne background trim ming (para

In "White Mythology: Metaphor in the Text of Philosophy" (1974), Derrida observes that although philosophy has always attempted to preserve the distinction between a concept – a definition using only proper terms – and a metaphor, it has always employed metaphors to elaborate itself. Metaphors are explanatory: a concrete vehicle ("rose") draws out the truth of an abstract tenor ("life"). As part of Derrida's bravura figurative schema playing on usury, metaphors are said to yield interest through transit or exchange: the literal/proper takes a detour through the figural/difference and profits on the return, more full of its own truth after the transfer. Yet the diversion can't be *too* wayward: a revelatory analogy proceeds by similarity, affinity. The literal should undergo only a *domestic* exile, one that comes full circle to pay off with "the transformation of presence into 'self-presence.'" Roses are beautiful, thorny, ephemeral; life "is" a rose; life is beautiful, thorny, ephemeral. "Are not all metaphors, strictly speaking, concepts," Derrida writes, "and is there *any sense* in setting metaphor against concept?"

In Aristotle's *Poetics* and *Rhetoric*, metaphor takes a specific conceptual form: that of an *incomplete syllogism*. After all, with metaphor, we get simply "life 'is' a rose" – we must draw out the salient qualities of similitude ourselves. As Derrida comments: "A dividend of pleasure, therefore, is the recompense for the economic development of the syllogism hidden in metaphor, the theoretical perception of resemblance." Pleasure in metaphor, through its implicature: one develops the analogy, supplies the pleasing likeness through inference. *Metaphor is a troping of enthymeme.*

But the question of, why do black people, why do white people in this country associate Black Power with violence? And the question is because of their own inability to deal with "blackness." If we had said "Negro Power" nobody would get scared. (laughter) Everybody would support it. Or if we said power for colored people, everybody'd be for that, but it is the word "Black," it is the word "Black" that bothers people in this country, and that's their problem, not mine – their problem, their problem.

Now there's one modern day lie that we want to attack…and that is the lie that says anything all black is bad. Now, you're all a college university crowd. You've taken your basic logic course. You know about a major premise and minor premise. So people have been telling me anything all black is bad. Let's make that our major premise.

Major premise: Anything all black is bad.

Minor premise or particular premise: I am all black.

Therefore …

I'm never going to be put in that trick bag; I am all black and I'm all good. (Laughter). Anything all black is not necessarily bad. Anything all black is only bad when you use force to keep whites out. Now that's what white people have done in this country, and they're projecting their same fears and guilt on us, and we won't have it, we won't have it. Let them handle their own fears and their own guilt. Let them find their own psychologists. We refuse to be the therapy for white society any longer. We have gone mad trying to do it. We have gone stark raving mad trying to do it.

> Stokely Carmichael, "Black Power" (1966; speech delivered at UC, Berkeley)

28–31b) Knee Length *khimar* that cover from the top of head till below knee (approximate length from top of head 48.4"/123cm,sleeve has a band of white mohair or white mercerized cotton braid 1½" wide during small boat and other amphibious/expeditionary operationsNo consen-sus for the actual form of the coveringwould have to take off her headscarfadding that "babies are afraid of" the headscarf attend the exams without wearing their headscarvestest the uniform dur-ing small boat and other amphibious to remove her *hijab* in the presence of male guards You must place a link on your site to generate affiliate salesYou may use our product images but they Aa AA must be stored on your server Top sellers: View recently addedThis is a pretty good tutorial AA AAexcept when I wear a pashmina *hijab* i put it on a bit differently. i pin it in

AAAA A FRONT instead of the backwhich lent to an effective break up of the wearer's outline AAaAAAAAAAA A-line If we put on a coat, it surrounds us. We are in the water or in the coatAAAAnoncomplycopy Aa

 A which means, literally, "to sink into." By extension,

A AAAAA it means "to enter into," "to get into," or "to put on"depicted as passive victims of AAainitial uniform allowance is payable only on-ce HeadStyle *Abaya* masculinedominance,Normal0falsefalsefalseEN-USX-NONEX-NONE] size-chart *Hijab* Pins Ref 0006

"There can be bad metaphors. Are [they] metaphors?" "Bad metaphor…furnishes only improper knowledge." (Derrida)

Is weaponizing bad metaphor? What if implicature yielded not the probable, but the improbable? Weaponization, too, plays on the implicit syllogism, sharpening what is riddle-like in the metaphor. Unlike an analogy, what it discovers is the impropriety of a thing, an overturning of its probability. Weaponizing reckons with unlikeness, contradiction. It discloses an antithetical, improbable "essence." As with metaphor, weaponizing adds value, but through the pleasures of counter-syllogistic irony: what is weaponized becomes not just an instrument of aggression; its interest also lies in how a new-fangled weapon's own probable aspect of weakness, innocence, neutrality – is capsized, exploded. *They weaponized safe space, in Mizzou.*

Nonetheless, it would seem the given accommodates such irony: its inversion and conversion of the probable is still in probabilistic form. Yet might weaponization exert an unrecuperable negativity – one that would destabilize the network that binds it? The object as dissemination, an agonistic detour into bad infinity, agony. The arbitrary, the an-archic. Total phenomenology of aggression.

1 ⦀ first pull down the cov ⦀ 2 ⦀ er of the prongs, then flip ⦀ 2a ⦀ the switch and press the button ⦀ 3 ⦀ to deploy. and some ⦀ 3a ⦀ times smells of ozone [gif loop ⦀ 4 ⦀ ing a shot of a hand ⦀ 4a ⦀ pulling the trigger of a ph ⦀ 4b ⦀ one] The Knucklecase isn't so m ⦀ 5 ⦀ uch a weapon as it is—"the ult ⦀ 5a ⦀ imate tool for securing ⦀ 6 ⦀ phone to hand" which houses the pep ⦀ 6a ⦀ per spray and feature ⦀ 6b ⦀ s cutouts for ⦀ 7 ⦀ all ports, the SmartGuard is ⦀ 8 ⦀ a simple case with ⦀ 9 ⦀ a quick-release can ⦀ 9a ⦀ ister No muss, no fuss: a coaxial noz ⦀ 10 ⦀ zle delivers along a ⦀ 10a ⦀ center line in 6.5-sec ⦀ 10b ⦀ bursts

Dwaine Caraway (former interim mayor of Dallas) said on the radio this morning that the perp asked for a cell phone, and that the cell phone was used to "expire" him.

Per the interview the DPD Police Chief gave this AM. Yes, it was a bomb diffusal robot that was used to place a charge and then detonate it.

In the end the suspect was dead and the extension arm of the robot was damaged, but the robot is still functional.

Enthymemes rely on an aura of the probable as already given, a givenness produced in the act of inference. A veiled retroactivity, truth-effect. Yet the realization of social knowledge through collective interactivity and cross-referencing also recognizes itself as an ungrounded grounding of the social: what rules as given, rules as given until the given changes its rules. The authenticity of this simulation: open artifice as what is believable.

"Cynicism is *enlightened false consciousness*. […] This consciousness no longer feels affected by any critique of ideology. […] It is ill from the compulsion to accept existing conditions which it doubts" (Sloterdijk).

But is it?

Beyond belief: the culture of toxic implicature as game of discursive savvy. "Internalization without identification" (Vaz and Bruno). Entrepreneurial cynicism (Paolo Virno). Cynicism as entitlement: position as putative non-position (Huang): post-politics, post-ideological. Investment in non-investment.

Yet the cynic's attachment to its detachment – its weaponized, pleasurable disenchantment – also relies on interpassivity: what "believes in my place" (instead of me and for me) the reflexively dissembled semblance of social reality? (Zizek)

The cynic believes at a distance: belief that someone else believes it. Or: response to implicature is not conscious thought: my mind believes for me (without me believing). Or: disavowed, ironic participation: opting out without opting out.

But "cynicism does not bear upon the level of doing but only that of knowing" (Zizek).

Belief is not at the level of conscious assent, but congealed in the material activity of maintaining literacy. The pleasures of ironic distance cede to passionate compulsion. "If it doesn't exist on the Internet, it doesn't exist" (Goldsmith).

See Gaddafi on display in a meat locker at a shopping mall ▌▌ ▌▌▌▌▌▌▌▌▌▌▌▌▌▌▌
\In Misrata

▌▌ ▌▌ Playhead is like a ▌▌ ▌▌ pointer
if the playhead is standing still
not at normal ▌▌ ▌▌ play speed
It snaps ▌▌ ▌▌ back like a magnet ▌▌ ▌▌ ▌▌
where his skin is ▌▌ ▌▌ More pixellated
Transliterated live feed
Or Aspect ratio

Huffing and puffing, ▌▌ ▌▌ Gaddafi
Coughing and laughing Popping and ▌▌ ▌▌ moon-walking
 Appellate ▌▌ ▌▌ zeppelin over Tripoli

"This assault is by
fascists ▌▌ ▌▌ who will end
up in the dustbin ▌▌ ▌▌ of history," Gaddafi said in a ▌▌ ▌▌ speech foll-
owed by fireworks

As they were leaving the assembly, Trotsky shouted after them "Outside of
a dog, a book is man's best friend ▌▌ ▌▌▌▌▌▌▌▌▌▌▌▌ Inside of a dog it's too dark to

A fable agreed upon occurs, as it were, "twice The first time on youtube,

when Matthew Lopez went to the Wal-Mart in Porter Ranch on Thursday night ▌▌ ▌▌ for the Black Friday Arab Spring sale but was caught in a pepper-spray attack by a woman who authorities said was "competitive shopping" ▌▌ ▌▌▌▌▌▌▌▌▌

customers already ▌▌ ▌▌ in the store when a whistle signaled the start of Black Friday Arab Spring at 10 p.m., sending shoppers hurtling in search of deeply discounted ▌▌ ▌▌ items

▌▌ ▌▌ by the time Lopez arrived at the video games, the display had been torn down Employees attempted to hold back the scrum of shoppers ▌▌ ▌▌ and pick up merchandise even as customers trampled the video games and DVDs ▌▌ ▌▌ strewn on the floor

The enthymeme may suppress to render obvious: it also avoids affirming what it has kept implicit. A silence that generates open secrets: suspended in deniability. Knowingness of the disavowable.

Above all, a tool of racial positioning, racial maintenance: unacknowledged circulation of racial knowledge and feeling: negative space of white dominance. Whiteness consolidating power through present absence. The probable in white perspective: complicity without having to consciously approve. An enthymeme's truncated argument more persuasive: "reasoning" not explicitly worked out.

Deniability, too, in *euphemism*: a mild for a harsh expression, an indirect for a direct one. A high road to a low place. Blocks to implicature, connotation. Diversionary: along certain narrow channels: disavows its destination.

Making words signify that they do not signify what they appear to signify (Bourdieu). A disclaimer, supplement to assertion that replaces euphemism: *it's not what it looks like.*

The transformation of a bronze, which gives off bell-tones at the slightest contact with thought, into a rag with which to wipe clean the slate.

Jacques Lacan, "The Instance of the Letter in the Unconscious or Reason Since Freud" (1966)

1 ▌▌ people st ▌▌ 2 ▌▌ arted screaming
pull ▌▌ 2a ▌▌ ing and pushing each ▌▌ 3 ▌▌ other
the whole ▌▌ 3a ▌▌ area filled up
wi ▌▌ 4 ▌▌ th pepper spray I ▌▌ 4a ▌▌ guess
what triggered ▌▌ 4b ▌▌ it was
peop ▌▌ 5 ▌▌ le started pullin ▌▌ 5a ▌▌ g
the plastic off ▌▌ 6 ▌▌ the pallets
shoving and b ▌▌ 6a ▌▌ ombarding
the display of games ▌▌ 7 ▌▌ It started with
people pushing and ▌▌ 8 ▌▌ screaming
getting sh ▌▌ 9 ▌▌ oved onto the box ▌▌ 9a ▌▌ es I guess
what triggered ▌▌ 9b ▌▌ it was
people started screaming It started with
people pushing and screaming I guess
what triggered it was
people started pull ▌▌ 10 ▌▌ ing
the plastic ▌▌ 10a ▌▌ off ▌▌▌▌▌▌▌▌▌

In *Language and Symbolic Power* (1990), Bourdieu defines "euphemization" as the general condition of public speech: to produce discourse successfully within a particular field is to observe its forms or formalities. Socially and institutionally situated, all utterance is censored, or rather modified by self-censorship: it is subject to constraints of its anticipated reception, the unspoken rules that legitimate and set a value on it. The (slow) acquisition of the powers of appropriate expression. Speech as "compromise formation," "strategic modification," so as to be heard. This complicity: desire for competence, charisma in speech. Rhetorical traction based on this "corrected" eloquence.

Bourdieu's discussion of censorship involves less emphasis on repression *per se* than on the productivity of constraint, and the way that social context, position, and relation become legible in euphemized utterance. In a racist society discursively organized around the denial of its racism, most speech is marked by the tension of avoiding describing social reality and social processes as racist and, above all, by a taboo on white self-presentation as racist, much of which depends on altogether evading direct mention of race: "discursive deracialization" (Frank Reeves). Euphemism around race and racism as part of the doxa of the American linguistic habitus: "naming the unnameable in a form which avoids it being named" (Bourdieu). A means by which racism *"has written itself out of formal existence"* (Charles Mills; italics original).

The toxic, yet almost unnoticed, unself-conscious cynicism built into this dynamic: the issue of race as managing the imputation of racism, not ending racism: a desperate investment in this defensive posture, this narcissism. Disenchanted yet enchanted: cynicism drives euphemism *weaponized*.

Joseph Poulose was hit with the spray near the DVD ▮▮ ▮▮ and video games display He criticized the store for ▮▮ ▮▮ failing to control the crowds.

There were way too many people Every aisle was full Customers ▮▮ ▮▮ were stomping on photo frames, said ▮▮ ▮▮ Poulose, who tried to protect his pregnant wife from the ▮▮ ▮▮ throng of shoppers inside

It was definitely the worst Black Friday Arab Spring I've ▮▮ ▮▮ ever experienced, he said

> Request Time-out
> Server timeout waiting for the HTTP request from the client: ▮▮ ▮▮

crewmen ejected safely from coalition aircraft in Operation Unified Protector

24		what's the difference.
25	Don:	the **name**? of it. ((*rising and falling intonation; shrugs shoulders*))
26	Moderator:	uh huh and what=
27	Don:	=(the) **peo**?ple ((*rising and falling intonation*))
28	Moderator:	uh huh what kind of peo- what do you mean
29	Don:	the **peo**?ple ((*rising and falling intonation; shrugs shoulders*))
30	Moderator:	uh huh (0.7)
31	Moderator:	the other students
32	Don:	the people.= ((*falling intonation*))
33	Moderator:	=okay
34	Don:	°yes
35	Moderator:	[and what
36	Don:	[so the other students [(meaning)
37	Moderator:	[uh huh
38	Don:	the parents of the other students
39	Moderator:	okay=
40	Don:	=the culture of the people.
41	Moderator:	uh huh okay

Speech in tatters, a lace of indirection. Another discourse of holes. Here "naming" is pressed: the speaker refuses to speak illegitimately, to taint himself. The moderator tests…

Euphemized speech in high-tension contexts; the sense of constraint, of self-correction. Whiteness's multiple racist styles: whites with differing access to euphemism as linguistic capital.

There is also a Lake in Lybia which Lake the Virgins in that Countrey know to bee rich for its wealth, which lies hid under water, mingled with the mud; a fountaine of gold flowing there: now they let down a long staffe besmear'd with pitch & even as the hook is to the fish, so is this sticke to the gold; for it catches it, & the pitch serves in stead of the bait, to which as much gold as it toucheth sticketh, View document image [35] containing page [45] & by this meanes they take it out of the Lybian Sea

There is also in Lybia a marish ground, and the maides of Lybia knowing there to bée gold, doo accustome to get it after this maner, (for the gold lyeth vnder the mudde, and there ariseth by a little spring, wherein they put a pole anointed with tarre, and thrust it into the hande, and as a hooke is to the fish, so is this pole to the golde: for it catcheth holde of the pole, the tarre béeing in stead of a bayte, for what golde doth touch it, doth cleaue to it, and is laide vp vppon the shore, and

so
 is

 Golde gotten

in Lybia:

\This is Qaddafi's old home, which was partially destroyed in 1986 by US bombs in retaliation for Libya's attack on a German disco
 ▌▌ ▐▌ In front of it stands a giant, gold, clenched ▌▌ ▐▌ fist crushing an American Plane

Xbox ▌▌ ▐▌ gaming console, CS gas ▌▌ ▐▌ canister for Wii
Cyanocarbon particulates as ▌▌ ▐▌ negative air:
highly volatile dich ▌▌ ▐▌ loromethane evaporates, crystals
precipitate and form a fine
 disper ▌▌ ▐▌ sion

Gaddafi takes Bodies from the morgue to ▌▌ ▐▌ sub as civ. ▌▌ ▐▌
casualties

Euphemization bound up with symbolic violence: complicit misrecognition-recognition relies not just on a naturalized social order or the unquestioned desirability of the stakes on offer, but on the soft hypocrisy of public discourse in every field: circumlocution through which power leverages its production and reproduction: language as mystifying displacement, conversion, *currency exchange*. Discourse that legitimates through the dissimulation of interest as disinterest ▌▌ Operation Freedom ▌▌ ▌▌ loyalty card ▌▌ ; language that conceals certain mechanisms by naming others ▌▌ merit ▌▌ ; terms that neutralize difference in order to reproduce differentials ▌▌ inclusion ▌▌ ▌▌ diversity ▌▌ . Such masquerade is hardly calculated, aware: it is language presenting a self-masking view of the world. The probable surfaces in cover narratives, in its accounting of deserts as just: diversionary common sense.

"Structural racism": "explanatory" (disinculpating) euphemism: systemic – abstract, mediated – bias irreducible to individual (re)production, retrenching mystified agency. Structural racism as an emergent effect of collective "invisible" racism: the euphemism at every level. Numbers as euphemistic discourse.

Christmas Under Fire

Living Fireplace (Christmas Scene) Screen Dreams DVD

Add to
Share
More
370,239

Uploaded on Sep 20, 2006 Screen Dreams filmed The Living Fireplace
"Christmas Scene" in high-definition HD Video (720p) for all the
people out there that love the old Yule Log video.
The film shows Christmas in the middle of the Blitz
The Living Fireplace DVD lets you choose from 8 other beautiful
fireplace scenes and 6 ambient music track to match your mood,
occasion, or décor.
People are shown celebrating Christmas while sheltering in the
London Underground, accompanied by a carol

dreaming of ||| ||| a white "chlorox
hunger"; fruit ||| |||
vendor self-immolates "If y ||| ||| ou don't see m ||| ||| e, I'l ||| ||| l
burn my ||| |||self" |||

If you're kind, you say high or low. Honest: you say [default] or black.
But we don't say black. Not now. Only dog whistles: welfare queen
tough on crime. Wow! Look at her run, such a natural athlete.

Quenton Baker, "Diglossic in the Second America" (2015)

"Double audience" of the dog whistle: who are the "uninitiated" for these non-hieroglyphs?

What counts as coded discourse? What is sufficiently laundered?

Pejorative shorthand, indirection worn to *slur*: a thin, fluid mud (OED).

There's a little piece of your mind and now it's a little piece of the
computer's mind
Or to their senseless nakedness
People mostly hit 'next' to bring another person up on their screens
The plug-in
Who might fare better
Has fallen out as an excrement or residue
Away from a structure of reciprocity
This rented death
In which one has no redress
And in turn To inflict as one has been.
Can the same be said of
A stool softener
Jubilates
Promoting you to alive
How the outside of the vulva
Thermally
It is not to my preference satisfaction
Having asked them to freeze
To its becoming frozen
Or look at someone in the adjacent terminal
In the other form of animation
Still retains the warmth.

Appendix(mas): Dustbin Of History, Wholesale Dustbin Of History

About 3 records (0.33 seconds)

Home > Categories > Health & Beauty > Massager > **Dustbin Of History**

Wide Screen Basin Of Foot Spa Model: YJ5C Name: Wide Screen Basin Of Foot Spa Feature: Super Big Screen With A Massage Belt With Therapy Pads Function: 1.An External Detoxification Method Which Removes Toxins Through Feet; 2.By Infiltration Of Ionic Can Strengthen Cell Activity Improve Metabolism Active The Ferment In Body 3.Promote The… Supplier: Wenzhou Yijia Light Industrial Co., Ltd >>

Wide Screen Basin Of Foot Spa Model: YJ8804B Name: Wide Screen Basin Of Foot Spa Feature: 1,Detox The Body To Make It Purified And Healthy 2,With The Pulse Patch 3,Show The Electric Wave On The Big LCD Board 4,It Is Convenient With The Basin Function: 1. Make Up The Static Rest Energy Of The Body. 2. Activate The Cells And Adjust The… Supplier: Wenzhou Yijia Light Industrial Co., Ltd >>

Dual Working System With Wide Screen Basin Of Foot Spa Model:YJ8808 Name: Dual Working System With Wide Screen Basin Of Foot Spa Feature: 1. Dual Working System; 2. Negative-Ion Foot Therapy Function; 3. Contains Two Bamboo Charcoal Far Infrared Waistbands To Maintain People\'s Shape. 4.Show The Electric Wave On The Big LCD Board

Dog whistle as "ideograph": attunement to a frequency = exerts *immediate command.*

In "The 'Ideograph': A Link between Rhetoric and Ideology" (1980), Michael McGee develops this concept to account for rhetoric's role in the exercise of social influence. ▌▌ `liberty` ▌▌ A vocabulary of "slogans" that stand as "the basic structural elements, the building blocks, of ideology," ideographs are credited by McGee with forming a society-specific ▌▌ `marketplace of ideas` ▌▌ "political language…with the capacity to dictate decision and control public belief and behavior." ▌▌ `property` ▌▌ Taken as "logical" ("Everyone is conditioned to think of 'the rule of law' as a *logical* commitment"), ideographs are nonetheless located beyond analysis, as given "warrants" that bear "an obvious meaning, a behaviorially directive self-evidence," to which "it is presumed that human beings will react predictably and autonomically." ▌▌ `right to privacy` ▌▌ American human beings.

Flashpoints of identification: ideographs "symbolize [a] line of argument," but, more importantly, they are "one-term sums of an orientation" that "signify…a unique ideological commitment." ▌▌ `obstruction of justice` ▌▌ Ideographs diagram "a legitimate so-cial reality" while functioning as "agents of political consciousness": summoning a way of seeing the world, they are also imperatives to view the world that way and to act accordingly: ▌▌ `equality` ▌▌ the probable exponentialized.

The ideograph, as McGee describes, is where *"language gets in the way of thinking"*: subjects "predisposed to structured mass response."

Pictures Of Bin All About Pictures Of Bin Pictures of Garbage Compare Products, Prices & Stores. Pictures of Garbage At Low Prices.

Dustbin Of History Suppliers & **Dustbin Of History** Manufacturers Directory. …
Dustbin Of History, Wholesale **Dustbin Of History.** certificate of origin oak …

Schuurriemen Of Schijven Of Rollen of Vellen
Zilveren Platen Of Draden Of Buizen Of Folie
Part Of Machine
Kinds Of Fabrics
History Of Ukelele Automatic Dustbins
Wastebin and Dustbin
Waste Dustbin
Trash Dustbin
Trash Can Dustbin
Table Dustbin
Rattan Paper Dustbin
Plastic Dustbin
Plastic Bathroom Dustbin
Pedal Dustbin
Zilveren Platen Of Draden Of Buizen Of Folie
Cast of Harry Potter Goblet Of Fire
Lord Of The Rings Foundations Of Stone
Pictures Of Music Instruments Of Black People
Thickness Of A Roll Of Toilet Paper
Iron Ore Fine

dustbin of history, buy **dustbin of history** In Quality Cert SSA

I shall postulate The Establishment as a state of mind—a deranged mind, that appears to be a mental City of Death. [...] This nightmarish system catalogues every known physical thing according to the "science" of totalitarian propaganda, and none of this "thought-control" can be traced by the isolated individual. [...] Networks of paths go in all directions. Everything that is the antithesis of art rolls on after brainless slogans: "Every-man is equal—the war on poverty—win the mind of man to freedom"—all echo into the poisonous skies. Impenetrable piles of bureaucratic slush sink into an ever sinking landscape of organized violence. The circles of power become more and more intangible as they move to the edge of nowhere. [...] Fictitious social structures uphold stupid hierarchies and protect the legal criminals. Unreality becomes a "hard-nosed" fact. In this fugitive "city" of the crumbling world-mind, all solids tremble and seem about to disintegrate. A complete inarticulation of thought brings one to a sickly lagoon, called "The Slough of Decayed Language"—it has vile creatures swimming in it. [...] The Establishment is a nightmare from which I am trying to awake.

Robert Smithson, "The Establishment" (1968)

▌▌▌▌▌▌▌▌▌ 1 ▌▌ loopholes as wea ▌▌ 2 ▌▌ ponized guidelines ▌▌ 3 ▌▌ or rules weaponized obedience ▌▌ 4 ▌▌ weaponized innocence ▌▌ 5 ▌▌ weaponized civility, niceness ▌▌ 6 ▌▌ kill them with k ▌▌ 6a ▌▌ indness ▌▌ 7 ▌▌ most lies aren't weaponized ▌▌ 7a ▌▌ in the casual ▌▌ 8 ▌▌ hypocrisy of conver ▌▌ 8a ▌▌ sation, tact ▌▌ 8b ▌▌ weaponized concession for ▌▌ 9 ▌▌ giveness if the victim los ▌▌ 9a ▌▌ es more than the perp ▌▌ 10 ▌▌ etrator gains, anxious to ▌▌▌▌▌▌▌▌▌ 1 ▌▌ secure ▌▌ 1a ▌▌ weaponized pity ▌▌ 2 ▌▌ condescension ▌▌ 2a ▌▌ weaponized sympathy, empathy ▌▌ 3 ▌▌ weaponized culture ▌▌ 3a ▌▌ "it is the meaning ▌▌ 4 ▌▌ of all culture to breed a ▌▌ 4a ▌▌ tame and civilized ▌▌ 5 ▌▌ animal, a household ▌▌ 6 ▌▌ pet, out of the beast ▌▌ 6a ▌▌ of prey" ▌▌ 6b ▌▌ death instin ▌▌ 7 ▌▌ ct weaponized externally as ▌▌ 7a ▌▌ destructive instinct ▌▌ 7b ▌▌ sadism proper or ▌▌ 8 ▌▌ internally as masochism ▌▌ 9 ▌▌ taking self as object ▌▌ 9a ▌▌ in guilt or ▌▌ 9b ▌▌ a wish to be bea ten by the ▌▌ 10 ▌▌ father copula ▌▌▌▌▌▌▌▌▌ 1 ▌▌ ted with and given a ▌▌ 2 ▌▌ baby weaponized ne ▌▌ 3 ▌▌ ed for punishment t urns his ▌▌ 3a ▌▌ cheek with the ▌▌ 4 ▌▌ chance of receiv ing a ▌▌ 4a ▌▌ blow ex ▌▌ 5 ▌▌ presses itself in co ▌▌ 6 ▌▌ nscience ▌▌ 7 ▌▌ intrapsychic conflict ▌▌ 8 ▌▌ If guilt is a need f ▌▌ 9 ▌▌ or punishment or ▌▌ 10 ▌▌ is a

Euphemization and ideograph: politically depoliticized political discourse. But the dog whistle **▌▌▌ illegal alien ▌▌▌** claims a certain constituency: it wears the racist politics of its **▌▌▌ urban ▌▌▌** "coded" language on its sleeve.

Dog whistle as reverse discourse: "color blind." A cynical reading of bad faith racial plaint: **▌▌▌ playing the race card ▌▌▌▌▌▌▌▌▌▌▌** But now also a term for using a dog whistle.

▌▌▌ Weaponized reverse discourse of legal correc ▌▌▌ tives to racism, *e.g.* ▌▌▌ "reverse discrimination" ▌▌▌ ▌▌▌ "felony lynching" ▌▌▌ ▌▌▌ "hate crime"

HLS 16RS-2038
ORIGINAL
2016 Regular Session
HOUSE BILL NO. 953

§107.2. Hate crimes
9 A. It shall be unlawful for any person to select the victim of the following
10 offenses against person and property because of actual or perceived race, age,
11 gender, religion, color, creed, disability, sexual orientation, national origin, or
12 ancestry of that person or the owner or occupant of that property or because of actual
13 or perceived membership or service in, or employment with, an organization, or
14 because of actual or perceived employment as a law enforcement officer or
15 firefighter: **▌▌▌▌▌▌▌▌▌▌▌**

▌▌▌ protection a ▌▌▌ ▌▌▌ s weapon ▌▌▌ Victimiz ▌▌▌ ▌▌▌ er "victim ▌▌▌ ▌▌▌ ized" ▌▌▌ rollback

punishment ▌▌ 10a ▐ itself ▐▌ 10b ▐ if this is ▌▌▌▌▌▌▌▌ 1 ▐
personal or not ▐▌ 2 ▐ weaponized restitution of vio ▐▌ 3 ▐ lence,
requital Get back ▐▌ 3a ▐ what you gave equi ▐▌ 4 ▐ vocation of
punish ▐▌ 5 ▐ ment: As comp ensation ▐▌ 6 ▐ vindic ation as
deterrent as vengean ▐▌ 6a ▐ ce transitivism is a weapon ▐▌ 6b ▐
giving what's comi ▐▌ 7 ▐ ng lend your own ▐▌ 8 ▐ flesh im ▐▌ 9 ▐
pulse to retaliate To exact ▐▌ 10 ▐ more than necessary ▐▌ 10a ▐
if they served their ▌▌▌▌▌▌▌▌ 1 ▐ time unappeasable ▐▌ 2 ▐ Without
a ▐▌ 3 ▐ correc tive response ▐▌ 4 ▐ you imag ine that revenge
will ▐▌ 5 ▐ bring relief Can it ever ▐▌ 6 ▐ be mastere ▐▌ 7 ▐ d
weaponized settlement to work out ▐▌ 8 ▐ equivalents settle the
matter ▐▌ 9 ▐ weaponized implication ▐▌ 9a ▐ the wicked flee when
▐▌ 10 ▐ no man pursueth ▐▌ 10a ▐ as to make a weaknes ▌▌▌▌▌▌▌▌ 1 ▐
s of another's attribute or action ▐▌ 2 ▐ flight as guilt ▐▌ 3 ▐
defend ant weaponizes death ▐▌ 3a ▐ penalty, peti tioning to end a
▐▌ 4 ▐ ppeals Suiciding by death ▐▌ 4a ▐ penalty To commandeer the
Sta ▐▌ 4b ▐ te's power to execute A comp ▐▌ 5 ▐ romised will as
dange rous exces ▐▌ 5a ▐ s of will The law becomes v ▐▌ 6 ▐ ictim
How thus to dist ▐▌ 6a ▐ inguish justice from ▐▌ 6b ▐ crime no one
loves pain as ▐▌ 7 ▐ such What they love what they ▐▌ 8 ▐ need is

"Free speech" is just the name we give to verbal behavior that serves the substantive agendas we wish to advance; and we give our preferred verbal behaviors *that* name when we can, when we have the power to do so, because in the rhetoric of American life, the label "free speech" is the one you want your favorites to wear. [...] When the First Amendment is successfully invoked, the result is not political victory for free speech in the face of a challenge from politics but a political victory won by the party that has managed to wrap its agenda in free speech...a conclusion that would put politics *inside* the First Amendment. [...] [A]s they are used now, these phrases ["freedom of speech" or "the right of individual expression"] tend to obscure rather than clarify our dilemmas. Once they are deprived of their talismanic force, once it is no longer strategically effective simply to invoke them in the act of walking away from the problem, the conversation could continue in directions that are now blocked.

Stanley Fish, *There's No Such Thing as Free Speech, and It's a Good Thing, Too* (1994)

Racial annexation of an ideograph: "free speech." "Free speech" weaponized: to indemnify white speech that spans the spectrum of racial violation. To exonerate in advance, to shelter from scrutiny. Hate speech as illegitimate but protected speech. Also: a realm of "normal," "acceptable" racist speech: racism obtuse enough to pass through the self-censorship of legitimate discourse: euphemizing discourse too worn to disavow. Legal principle and ethic of exchange. Censor v. censure: the line between: what kind of "right" to say.

The censure of racism as more harmful than racism: *be more tolerant*: white victims of racism: white ressentiment. Deference to "white fragility": white racial discomfort (Robin DiAngelo). Culture of white guilt, white defendedness: its affective manipulation, incapacitation. *Leaving the conversation*. Who sets the terms. The "suspended [political] agency from which... these ugly feelings ensue" (Sianne Ngai): or is it: ugly feelings that suspend agency.

Hate speech: *any* restriction as encroachment, insupportable injury to "right of expression." With many forms of censorship in place: libel, copyright, incitement, etc. As though interpretation of *expression* versus *conduct* were not a politics. On the white left, on the white right, the First Amendment undoes the Fourteenth: bypass. Liberty versus equality: social justice as threat to free speech: white freedom before black safety: white rights before black freedom (Jelani Cobb).

The theatrical masochism or helplessness the principle inspires: genuflection to the sacrifice of what *must* be sacrificed. America's self-tribute to itself. Hagiography of *Skokie*. State authorized, State sponsored: no recourse (Mari Matsuda). To presume the (faux-)absolutist protection of speech is to presume who will pay its price (Charles Lawrence III). Who bears the burden of Constitutional incoherence.

In conceptualizing the essential "linguistic being" and "linguistic vulnerability" of the human, Judith Butler writes: "It appears there is no language specific to the problem of linguistic injury." This predicament of metaphoricity, the need to use figures of physical wounding, she notes, speaks language's connection to the physical body: words not only produce somatic effects, but are also what sustain or threaten the body in its material social existence. *Is linguistic injury really so catachrestical?* Critical race theory stipulates many rights and protections pertaining to non-physical entities as properties or parts of the self that language properly damages (while it does also damage the body). Hate speech as racial defamation, marking as inferior and servile, as threat. Language does injury to personhood, to dignity, reputation, liberty, participation, and education (Matsuda, Lawrence, Richard Delgado). If also (and in and through) the psyche.

Arguing against "sentimental politics" or the "politics of true feeling," Lauren Berlant critiques both a model of political subjectivity based on pain as well as a desire for legal redress of this pain: "the notion of reparation for identity-based subordination assumes that the law describes what a person is, and that social violence can be tracked the way physical injury can be tracked." She proposes "a break with trauma's seduction of politics in the everyday of U.S. citizenship." Yet to regulate speech is not simply to adjudicate feelings or even psychic harm: it is to prevent the many injuries that words do cause. Even if they are not the only source of damage or if their causality is complex.

that parti ▌▌ 8a ▐ cular pain, exquisite ▌▌ 9 ▐ pain puts into actio ▌▌ 10 ▐ n a script ▌▌ 10a ▐ of which they ▐▌▐▌▐▌▐▌▐ 1 ▐ are the authors ▌▌ 2 ▐ To weaponize lov ▌▌ 3 ▐ e as persecution: what should ▌▌ 4 ▐ have been felt internal ▌▌ 5 ▐ ly as love is perceived ex ▌▌ 6 ▐ ternally as hate what was ▌▌ 6a ▐ abolished ▌▌ 7 ▐ internally returns ▌▌ 7a ▐ from without ▌▌ 8 ▐ Weaponized fantasy, to alter an ▌▌ 9 ▐ unpleasant reality tha ▌▌ 10 ▐ t one's love and care ▐▌▐▌▐▌▐▌▐ 1 ▐ can undo effects of one's ▌▌ 2 ▐ aggression ▌▌ 2a ▐ to abject to ▌▌ 3 ▐ punish another for their ab ▌▌ 3a ▐ jection, repository of punish ▌▌ 4 ▐ ment if you l ▌▌ 5 ▐ end your own flesh to ▌▌ 6 ▐ a phantom ob ▌▌ 7 ▐ ject of love ▌▌ 8 ▐ continuity of rel ▌▌ 9 ▐ ation to itself or ▌▌ 10 ▐ its premier object ▐▌▐▌▐▌▐▌▐ 1 ▐ Sadistic Relation to the M other's Body ▌▌ 2 ▐ directed ▌▌ 2a ▐ against the inside of her ▌▌ 2b ▐ bod y ▌▌ 3 ▐ Constitutes the First and ▌▌ 3a ▐ Basi c ▌▌ 4 ▐ relation to the outside world to reality ▌▌ 5 ▐ doors and Locks stood for ▌▌ 6 ▐ ways in and ▌▌ 7 ▐ out of her body ▌▌ 8 ▐ both father and mother in fantasy Bitten, ▌▌ 9 ▐ Torn, Cut, or Stamped to Bits ▌▌ 10 ▐ excreta ▌▌ 10a ▐ as dangerous Weapons ▐▌▐▌▐▌▐▌▐ 1 ▐ wetting as Cutting, ▌▌ 2 ▐ Stabbing, Burning, Drowning ▌▌ 3 ▐ f aecal mass as

While antagonism is a we/they relation in which the two sides are enemies who do not share any common ground, agonism is a we/they relation where the conflicting parties, although acknowledging that there is no rational solution to their conflict, nevertheless recognize the legitimacy of their opponents. They are "adversaries" not enemies. This means that, while in conflict, they see themselves as…sharing a common symbolic space in which the conflict takes place.

Chantal Mouffe, *On the Political* (2005)

The American "remedy" for racist speech is counter-discourse. But racist speech is speech meant to silence, speech that speech does not really answer, speech that speech does not undo (Lawrence, Fish). Such discourse undermines the capacity of its addressee to answer, disqualifies its addressee as conversant. (Akin to a "differend" (Lyotard).) Hate speech does not augment the "marketplace of ideas," but warps and depopulates it (Lawrence). Hate speech diminishes free speech (Anita Bernstein). In this sense, protection from such speech is not meant to adjudicate consensus, "utopian" feeling: feeling "good" as "justice" (Berlant). It represses domination so severe it preempts the possibility of conflict: agonism.

Racialized dissent: free speech petitions for freedom from "free speech." *When reduced to shouting.* ▥ didn't respon ▥ ▥ d right ▥ Itself framed as silencing, as racist. Protection from as injurious. Ideology of total access: to criminalize, to reprimand a cordoned space of blackness.

Missile ▮ 4 ▮ cannibalistic ▮ 4a ▮ Impulses in the subjec ▮ 5 ▮
t aimed at Annihilating ▮ 6 ▮ Persecutors ▮ 7 ▮ remove the
object from a ▮ 8 ▮ Place where it was S afe and ▮ 9 ▮ reproduce
it i ▮ 10 ▮ nside so it can suffer, debased as the ▮ 10a ▮
subject has suffered whether at ▮ 10b ▮ its hands or ▮ 1 ▮
"once ▮ 1a ▮ when we were ▮ 1b ▮ sitting together at the Dining
tabl ▮ 2 ▮ e, I took wh ite ▮ 3 ▮ b read, mixed ▮ 4 ▮ it with s
pit, ▮ 5 ▮ and molded a figure of my ▮ 6 ▮ father . When the ▮
6a ▮ figure was done, ▮ 7 ▮ I started c utting off the l imbs
with ▮ 8 ▮ a Knife. ▮ 9 ▮ I see this as my First Sculptural ▮
10 ▮ Sol ution" ▮ 1 ▮ where ▮ 2 ▮ the loved object once
Held ▮ 3 ▮ power now does ▮ 4 ▮ the subject in ▮ 4a ▮ fantasy a
dored by the loved ▮ 5 ▮ object, having attained it ▮ 5a ▮ s
Omnipotence ▮ 6 ▮ attacks give rise to ▮ 7 ▮ anxiety Lest ▮ 8
▮ the subject be punished expulsio ▮ 9 ▮ n of the Damaged ▮ 10
▮ object and of his own ▮ 10a ▮ Sadism Because ▮ 1 ▮
weapons employed to ▮ 2 ▮ destroy the object are ▮ 3 ▮ felt to
be leveled at his ▮ 3a ▮ own person ▮ 4 ▮ Dread o ▮ 4a ▮ f
persecutors inside ▮ 4b ▮ the body the ▮ 5 ▮ infant pro jects
its ▮ 6 ▮ own aggression onto these objects It feels ▮ 6a ▮ them

The derogatory term does more than speak; it silences… [It] turns the racialized other into a language for whiteness itself… [I]t is banal and everyday even while symbolizing racism's utmost violence, the verbal form of its genocidal trajectory… Derogation comes in many different forms – as stories, aphorisms, discourses, legal statutes, political practices, etc. … The gratuitousness of its repetition bestows upon white supremacy an inherent discontinuity. It stops and starts self-referentially, at whim. To theorize some political, economic, or psychological necessity for its repetition, its unending return to violence, its need to kill is to lose a grasp on that gratuitousness by thinking its performance is representable… [But] its acts of repetition are its access to unrepresentability; they dissolve its excessiveness into invisibility as simply daily occurrence… White supremacy is nothing more than what we perceive of it.

Steve Martinot and Jared Sexton, "The Avant-Garde of
White Supremacy" (2003)

to be ▮▮ 6b ▮▮ "Bad" ▮▮ 6c ▮▮ breast Weapon Bad ▮▮ 6d ▮▮ breast ▮▮ 7 ▮▮ cruelty of the ▮▮ 8 ▮▮ Good, i.e. ▮▮ 8a ▮▮ loved ▮▮ 9 ▮▮ objects within ▮▮ 10 ▮▮ Guilt and Remorse ▮▮ 10a ▮▮ That the Loved object may be preserved ▮▮ 10b ▮▮ in Safety ▮▮▮▮▮▮▮▮

That his power over them is limitless,
that he has the right to do whatever he wants in order to take care of
them.
The cost of doing business
Rather than on your sales to people outside the plan
Affiliate marketing
Phase violation
It demands an expenditure as the currency exteriorizes.
Massing or
Massify
To mass
A sense of bulk
Causing them to mass
in that client group.
Information dominance
When I wipe my ass with men
To acknowledge the conduit for disposal
To use as you please and then to discard it
The price of suggestion
As means permit

Art might be the ultimate indemnification of speech as free. And there is perhaps no other artistic discourse that so equivocally, yet insistently points to art's autonomy as the nominalist gesture of the Duchampian readymade: through appropriation and re-placement in an art context, a given object is re-engendered as an artwork. Art is validated not only as the essence of individual expression, but by transformative institutional fiat: a change in the social fictions and conventions that frame the object and re-inaugurate its identity.

The elegant simplicity of the readymade belies its complexity: this complexity receives another fold in the literary readymade: *whereas the urinal was made art by a literal and institutional change in location, citational literature comes into being through iteration.* An appropriative work is a copy of a text-in-context: a mode of self-reflexive quotation whose "citational poetics" (Constantine Nakassis) involves investment in and displacement of indexical markers of its former identity in a new performance of the text.

Art stands as a zone in figurative quotation marks (as the readymade toys with). Appropriative literature, too, is conditioned and protected by the distancing work that literal and figurative quotation marks do, even as they are also implements for many kinds of undoing: devices that become their own alibi. Just how pliable (the sanction of) artistic citation might (not) prove registers in Conceptual writing's attraction to forms of taboo or traumatic speech (Sueyeun Juliette Lee).

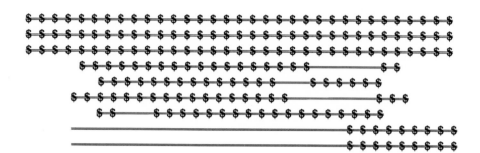

To make a gift of something— $ $ $ to som,eone,— $ $ $ $
select 'Submit' and press
[executing a t,rade] $$$$
Prestation and counter-Prestation
Mark,et as Custodian
The nee,d — $ $ $ $ for counting and acc,ounting
At different levels of [abstraction],
voluptuousness $$$$ reborn
by means of Small Counters: tok-
ens modeled in clay
Perforated, in order to be strung
record-keeping devices
$ $ $ nuance of *tenderest* pink! □

One had to submit everything
to take this road to wealth,
pay Tribute
An escalating contest
always to return more than was received;

Citational poetics – the weaponized citationality that citational literature deploys – is necessarily bound up with how the citational work functions as textual speech act.

A speech act involves: an utterance, the form in which that utterance is embodied, an institutional context, conventions of interpretation and authorization through which it is recognized and validated, a location and historical moment. Its identity depends as well on who speaks, to whom (and in front of whom), its performance of affect and manner. This identity is ultimately tied to a speech's "uptake" (Austin): the social act a statement is taken to be: an invitation, a warning, a promise, a curse, a salute, etc. (its illocutionary dimension), and the social and material effects entailed by that act (its perlocutionary dimension). Social reality is composed of speech acts: they are consequential: they bear social heft or "force" and continually create and change situations.

To ma,ke a gift of something to someone
the thing received is n,ot Inactive—
liquidity: capacity to $ $ circulate
 t,o count different merchandise
expressing the num,ber or nature of the items$$ counted
Oneness,——$ $ twoness, three,ness abstracted from——————$ $ $ $
an equity swap$,
voluptuousness Reborn
The underlying goods-in-kind
perfor,at,ed in order to be strung
the clean,est, *most winsome*, most delicate Hole
 to consume——$ $ $ $ and restitute,
to offer and——$ $ $ $ accept—
 And lo! A rosebud would offer itself
by the $ $ $——————$ $ "agreed upon" price

There is only a po,lite fiction
in the ge,sture accompanying a Transaction,
really, t,here is an obligation$$$$,
——$ $ To promise to pay in one direction or the other,——$ $ $ $
If one does not recip,rocate or;
If one does not carry out destruction of an equivalent value:

One must expend All that one has$$$, keeping Nothing back

Derrida frames the speech act, whether oral or textual, with the concept of "iterability": the recognizable ideality of any sign or set of words that both allows it to be repeated and to be altered in repetition while retaining its identity. A promise can be recognized across situations; at some point or to some audience, however, regardless of intention and employing the very same words, it might come off as a threat or a joke. No single context can be "exhaustively determinable, with no ambiguities or loose threads, no heterogeneity, no problems about its frontiers or edges" (Hillis Miller), the identity and felicity of a speech act entirely stabilized. Iterability names the peculiar *autonomy* of an utterance that stems from its self-same self-difference: which allows utterances, even language itself, to be transferable and usable, yet also finally impermeable to any user's total control: the very same signs "disengage" from one context to enter an "illimitable" number of new contexts meaningfully.

> This "it" is not a transcendental unity, because with every heterogenous move of receiver, sender, and the world of meanings, it changes its shape and fills the (no)place that marks a contingent limit. It is not a conscious motor of things in general; therefore it had better be called the Unconscious.
>
> Gayatri Spivak, "Revolutions That As Yet Have No Model" (1980)

$ $
$ $
$$$$$$$$$$$$
1 ‖ Efficient$$ mark ‖ 2 ‖ et doctrine ‖ 2a ‖
a sys ‖ 3 ‖ tem of total services ‖ 3a ‖
of the [agonistic] type, Totalized,——$ $— ‖ 4 ‖
compete ‖ 4a ‖ tive giving
‖ 4b ‖ principle of rivalry and hostility ‖ 5 ‖ prevails

‖ 6 ‖ using cash fl ‖ 6a ‖ ow or Assets ‖ 7 ‖ [as leverage to]
‖ 8 ‖ pay, req,uite,——$ $ $ $
quits with ‖ 8a ‖ What whiteness ‖ 8b ‖ there, and what
‖ 9 ‖ dazzling rose bl ‖ 10 ‖ ush!, electronic
trace ‖‖‖‖‖‖‖‖

1 ‖ of another's ‖ 2 ‖ trade on-screen ‖ 3 ‖
counterparty wh ‖ 4 ‖ ose only self- ‖ 5 ‖ representation
Pe ‖ 6 ‖ rforated in ‖ 6a ‖$$$$$
price convergence ‖ 7 ‖
To perform any ‖ 7a ‖ [counter-service]
in e ‖ 8 ‖ qual degree

‖ 9 ‖ Everything is given out ‖ 10 ‖
and is ‖‖‖‖‖‖‖‖ immediately$$$$$ given back again,——$ $ $ $

⏮ ▶ ‖ ⏭ $ $ $

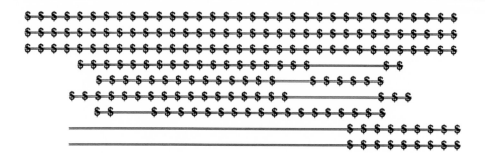

To mak,e a gift of something to someone
exe,cuting a trade,——$-$
[taking Ad,vantage of a price difference]
yielded her up——$-$— but retained rights to her use
would not in Body$$$ belong more to one than to any
Margin to cover some or All
a spirit inherent in the gift that compels its return$————————$-$
What power resides in the object given that
cau,ses its recipient to pa,y it back?:
 $-$—The thing itself is that surety

derivatives, Un,Known future value of
A reference$————$-$=to something more Ta,ngible than itself
the perform,ance of an underlying entity
[Often simply called "the underlying"$$$$-$-$-$]
s,he was made$$ part of the bar,gain
, given on condition that you pass it on

A work of appropriative literature has as its "primary medium…the situation" (Vanessa Place). This is to say that citational literature – here works based on a single, pre-existing text – is interested not in the writing in itself but as *situated*: what an appropriative work cites is (some part of) the larger social assemblage in which that text has been enunciated as speech act. Conceptual writing attends to the text it annexes in terms of the *materia* and presentation of its words, its physical medium and graphical interface, the social-material network and techniques of its production, dissemination, and consumption including its existence as a commodity in a market, its authorship, the rhetorical directives and assumptions encoded within it, its institutional settings, its social identity and use, its historical moment, the affect it carries or generates.

Which is to say: citational literature considers and explores aspects of the physical and social existence of a text as this expanded field: the text mediated in potentially significant ways by any of these components. The focal points of a work's indexical citation may be exceptionally underdetermined: what to read for and how to read it may be left open questions. Most importantly, however, a work of citational literature is its *own* speech act: it is a strategically altered iteration that reflexively cites that prior text-as-field but also necessarily appears as a displacement of it, as its own enunciative assemblage. Regardless of its literal representation of that former context or which parts of it seem to matter, citational literature performs quotation as palimpsest. In citing the text-as-context, these works trope on the culture of fragmentation and toxic implicature, the embeddedness of context in text.

the object can,not be *exhausted*, subj-
———$ $——ect to further infinite monetization
Wagers on vo,latility, voluptuousness$ $reborn
 risk is an independent sour,ce of Profit
Risks taken on prior Risks [risk-on-risk, in a recursive chain$$$$$$]
A rosebud in all its bloo,m, and in the most tender *pink*
Cumulative transfers By the "*agreed upon*" price

the Temp,est has of late stripped the pe,tals away

 [the price mediating its *life*——$ $]

Vanessa Place writes of Conceptual writing: "It is the thing itself that speaks as the thing itself (traffic report) that is not itself (traffic report). What you make of it depends on you, not it." This is to repress the work of appropriative literature as a highly authored text and as an utterance necessarily embodying its own speech act and situation. Here bare citation is recessed as enunciation to function as bare index and no more, the work relieved of vulnerability as speech. A fantasy that the cited utterance can be *presented* as only "the thing itself" by being "not itself": the displacing citation imagined as an iteration stripped of its status as the present instance of speech. On one hand, the text's "mute materiality" (Place) still situates it socially: that it has a genre, a medium, forms part of its interpretive framework. It has a content. It may even have had a speaker. On the other, the quotation of this text-as-field does not tell us how to take the utterance *now*. Or rather, Place argues that the Conceptual work has no "now": it is not the present instance. It holds a text out of time, prior to or alongside its being spoken *through*.

This frames Conceptual writing as entrapment: the "you," as Place points out, bound to take it some way. To activate an essentially empty device.

But the literary work has a point of enunciation: it is *given* to be entangled in uptake.

$-$
$-$———————$-$
$-$-$-$-$-$-$-$-$-$-$-$-$———$-$-$-$-$-$
$-$———$-$-$-$-$-$-$-$-$-$-$-$-$-$-$-$
$-$-$-$-$-$-$-$-$
————————————————————$-$-$-$-$-$-$-$-$
————————————————————$-$-$-$-$-$-$-$-$
————————————————————$-$-$-$

To make a gift of Something to Someone
$$$Execut,ing a trade
electronic trace, its "noise,," in
-creasing exposure to price c,hange

The article he put on the market
in an e,qual degree damaged or *degraded*, who should
take it into her head not
to Comply [coun
-terparty ris,k] ['Submit' and$$$$ press]

However, these are "Notional" values——$-$-$

A nuance of the tenderest pink, with a *burden* attached One
stints one,self that much the less,
given on Condition that you pass it on——$-$-$—— What
white,ness there ! The thing itself is
That surety The remain,s of the banquet cast
into the sea$$$$$ *And we dare hold*
ourselves answerable in $————————$-$advance

$$
$
$
$$$$$$$$$
$-$-$-$-$-$-$-$-$
 $-$-$-$-$-$-$-$-$-$-$-$-$———$-$
$-$
-$

Most performative utterance types – illocutionary acts organized around so-called "explicit performatives" like the English verbs "promise," "forgive," and "name" – no longer have performative effects once framed as reported or represented speech. That is to say that they do not retain any perlocutionary effects under delocutionary derivation. Unmentionables, like curse words or tabooed personal names are distinguished from such canonical speech-act verbs by the fact that they still have perlocutionary effects when framed as represented or reported speech. [...] These words and expressions so effectively and unavoidably create or entail their contexts of occurrence that attempts to neuter them of performative effect by recontextualization always run the risk of replicating their taboo effects. Indeed their semiotic uniqueness consists in this fact. It is this undecontextualizability of perlocutionary effect that defines what we might call the rigid performativity of verbal taboos.

Luke Fleming, "Name Taboos and Rigid Performativity" (2011)

Citing traumatic – or "offensive" or "taboo" – material is necessarily volatile: there is no *mention* – no means of mere display – without also falling into *use*. What means would persuade a "you" (which "you"?) to read the text as simply *about* the conditions of that performative force, over against the fact it must also carry it?

▌▌▌▌▌▌▌▌ 1 ▌▌ symbolic plan of a ▌▌ 2 ▌▌ face excess of schematizatio ▌▌ 3 ▌▌ n To retain with a simple ▌▌ 3a ▌▌ glance Fleshy lips = sensu ▌▌ 4 ▌▌ ality Hooked nose = ▌▌ 4a ▌▌ greed How the face might ▌▌ 4b ▌▌ be pictured local ▌▌ 4b ▌▌ feature analy ▌▌ 5 ▌▌ sis TrueFace ▌▌ 6 ▌▌ Neural Network *eigenface* to ▌▌ 6a ▌▌ define a "face ▌▌ 6b ▌▌ space" recognition tool deadp ▌▌ 7 ▌▌ an weaponized similitude fanta ▌▌ 8 ▌▌ sy of sameness profile ▌▌ 9 ▌▌ weaponized face an unmarked unclut ▌▌ 10 ▌▌ tered face face made safe ▌▌ 10a ▌▌ from facial morphology ▌▌▌▌▌▌▌▌

Avoidance

An illustration of avoidance is found in the middle- and upper-class Negro who avoids certain face-to-face contacts with whites in order to protect the self-evaluation projected by his clothes and manner

Face-to-face

The social encounter

Whether you intend to 1 ▌▌ You'll find tha ▌▌ 2 ▌▌ t you've done so

▌▌ 3 ▌▌ Willfully, ▌▌ 3a ▌▌ Taken a stand ▌▌ 4 ▌▌ By which he expresses his view of ▌▌ 4a ▌▌ the situation and his ▌▌ 5 ▌▌ evaluation of the partici ▌▌ 6 ▌▌ pants, especially himself The ▌▌

In *Excitable Speech* (1997), Butler acknowledges and attempts to explain this rigid performativity: that mention cannot contain, but falls into and may incite use. Terms of injury do not simply have a history of usage and validation as interpellating speech acts, but carry that history installed within them as the grounds of their continuing social force. And they are efficacious not only through these past-present authorizing conventions and contexts, and through the force of iterability itself, but because such terms hold a trauma that "lives in language" and is both enacted and reenacted in their use. Trauma's very nature involves a compulsive repetition that does not abate. Linguistic iteration thus participates in the logic of a trauma it has the power to reinflict as it repeats.

Nonetheless, Butler's adamant arguments in favor of freedom of speech revolve around deflating a "fantasy of sovereign action" she reads in defenses of the restriction of hate speech. Inexplicably, despite her understanding of hate speech as activated by a speaker who is the product and reproductive vector of practices and structures of historical, socio-politically available supremacy, she argues that agency around the speech is "dissimulated" and misrecognized: it is exercised and received as an autochthonous act of power, thus punishable as the sole responsibility of the speaker. Butler indeed offers to the contrary that the performative force of injurious interpellation only holds by means of the support of a charged social field; she points to the deep reciprocal implication between injurious language and non-verbal domination in the *habitus*. But she still supports framing hateful speech as perlocutionary, not illocutionary: it is not "conduct" that produces a class of "victims" (thus potentially categorizable as illegal *act*) but an impactful statement that generates non-necessary effects.

7 ▌▌▌ image the enc ounter sustains ▌▌▌ 7a ▌▌▌ Small choice of faces o ▌▌▌ 8 ▌▌▌ pen to him ▌▌▌ 9 ▌▌▌ To be in face ▌▌▌ 10 ▌▌▌ To maintain face ▌▌▌▌▌▌▌▌▌▌▌ 1 ▌▌▌ something he need be ▌▌▌ 1a ▌▌▌ prepared to perform ▌▌▌ 2 ▌▌▌ How m uch feeling one ▌▌▌ 2a ▌▌▌ is to have ▌▌▌ 3 ▌▌▌ To suppress and conceal Re ▌▌▌ 4 ▌▌▌ quired to show self-respect ▌▌▌ 5 ▌▌▌ As either above or beneath one ▌▌▌ 6 ▌▌▌ An invo lvement in the ▌▌▌ 6a ▌▌▌ face of oth ers ▌▌▌ 6b ▌▌▌ ease with which certain dis ▌▌▌ 7 ▌▌▌ confirming information can be ▌▌▌ 8 ▌▌▌ conveyed ▌▌▌ 9 ▌▌▌ A person's face is not l ▌▌▌ 10 ▌▌▌ odged in or on his ▌▌▌ 10a ▌▌▌ body ▌▌▌▌▌▌▌▌▌▌▌ 1 ▌▌▌ Diffusely located in ▌▌▌ 2 ▌▌▌ the flo w of even ▌▌▌ 2a ▌▌▌ ts A conventional encounter ▌▌▌ 3 ▌▌▌ Or what he is expected to ▌▌▌ 4 ▌▌▌ take ▌▌▌ 4a ▌▌▌ It is only on ▌▌▌ 5 ▌▌▌ loan ▌▌▌ 6 ▌▌▌ One's face is a sacred ▌▌▌ 6a ▌▌▌ thing Ritually ▌▌▌ 6b ▌▌▌ delicate ob ject ▌▌▌ 7 ▌▌▌ Subject to sl ights and ▌▌▌ 8 ▌▌▌ profan ations To trust one's ▌▌▌ 9 ▌▌▌ self-image and face ▌▌▌ 10 ▌▌▌ to the tact and good condu ▌▌▌ 10a ▌▌▌ ct of others ▌▌▌▌▌▌▌▌▌▌ 1 ▌▌▌ The person's attachment to f ▌▌▌ 2 ▌▌▌ ace gives others something ▌▌▌ 3 ▌▌▌ to aim at. ▌▌▌ 4 ▌▌▌ If the image is internally ▌▌▌ 4a ▌▌▌ consistent Who abstained fro ▌▌▌ 5 ▌▌▌ m certain actions in the past ▌▌▌ 6 ▌▌▌ the future will discredit diff ▌▌▌ 6a ▌▌▌ icult to face up to ▌▌▌ 6b ▌▌▌ (later) ▌▌▌ 7 ▌▌▌ The power his presumed status ▌▌▌ 8 ▌▌▌ allows

Things not intentionally disposed of are lost.
As if it were a bad personal buying decision
Database expression tools
Interior-interior decoration database
the garment would not fit
The scrim.
Attrition
In the results window
Hitting the reset
Let someone else figure it out
First responders
there's a rattle of hooves and around on the floor of long bucking legs,
Onscreen
made bluish by the intervening yellow fat, in a rodeo
Not veins but
that do not lead anywhere.
when a young boy laughs at her
Hecate, who is mortified
to the waist, Loosely around her thighs
ripped
to the screen.

him to exert ▮▮ 8a ▮▮ To make wha tever one is ▮▮ 9 ▮▮ doing consistent with fac ▮▮ 10 ▮▮ e A surface of agreement must be main ▮▮ 10a ▮▮ tained by means of discreti ▮▮▮▮▮▮▮▮ 1 ▮▮ on and white lies A ▮▮ 2 ▮▮ refusal softened to ▮▮ 3 ▮▮ expression of regretted inability ▮▮ 3a ▮▮ To refr ain from exploiting ▮▮ 4 ▮▮ the compr omised position of others ▮▮ 4a ▮▮ To volunteer ▮▮ 5 ▮▮ a sta tement or ▮▮ 6 ▮▮ mess age places everyone pr ▮▮ 6a ▮▮ esent in jeopardy ▮▮ 6b ▮▮ It is always a ▮▮ 7 ▮▮ gamble to "make a ▮▮ 8 ▮▮ remark" to brazen it out ▮▮ 9 ▮▮ The faux pas or gaf ▮▮ 10 ▮▮ fe So gauche he creates ▮▮ 10a ▮▮ an emergency In ▮▮▮▮▮▮▮▮ 1 ▮▮ making a belittl ▮▮ 2 ▮▮ ing demand ▮▮ 3 ▮▮ A handshake that perhaps ▮▮ 3a ▮▮ shou ld not have been ex ▮▮ 4 ▮▮ tended Beco mes one that ▮▮ 5 ▮▮ cannot be declined or ▮▮ 5a ▮▮ Maliciously and sp ▮▮ 6 ▮▮ itefully, the intention of o ▮▮ 6a ▮▮ pen insu ▮▮ 6b ▮▮ lt A threat willfully ▮▮ 7 ▮▮ introduced for what can be safely ga ▮▮ 8 ▮▮ ined by it To forestall ▮▮ 9 ▮▮ or count eract ▮▮ 10 ▮▮ A fac e-saving practice ▮▮ 10a ▮▮ allowed to neutralize a particular ▮▮▮▮▮▮▮▮ 1 ▮▮ threat ▮▮ 1a ▮▮ choose a tack ▮▮ 1b ▮▮ Or Maneuvering another into ▮▮ 1c ▮▮ a position where he ▮▮ 2 ▮▮ cannot right the harm ▮▮ 3 ▮▮ h e has done The bluff ▮▮ 3a ▮▮ cal led

For Immediate release:

United Gun Group exists as a pro-2nd Amendment platform for law-abiding citizens to exercise their constitutional rights. As a company, we respect and honor the Constitution of the United States of America, the judgements of our judicial system, and follow the rule of the law. Unless the law has been violated, it is the intention of United Gun Group to allow its members to use any of the available features. While not always popular, this is where we stand. These are the principals this nation was founded on, and our goal is to do our part to defend liberty. We know that many lives have been forever impacted by the incident February 26, 2012, and we're truly sorry to the Martin family for their loss. We will have no further comment on the matter.

United Gun Group

View image on Twitter

 United Gun Group
@UnitedGunGroup

🐦 Follow

12:51 PM - 13 May 2016

↩ ⟲ 7 ♥ 4

Hence a seeming contradiction within Butler's core counterargument for the "insurrectionary speech act." Having unveiled the putative sovereign performative of hate as really a misrecognized historical "sedimentation of usages," she posits a class of counter-performatives: "subversive territorialization[s] and resignification[s]" of "conventional formulae" that take on "meanings and functions for which [they were] never intended." Here the language of injury is transformed by its target into the language of self-affirmation, in an appropriation that functions "to deplete the term of its degradation" or "to derive an affirmation from that degradation." Such utterances "break with prior contexts, with the possibility of inaugurating contexts yet to come."

Insurrectionary speech issues from a position excluded from legitimacy: an exteriority to what is operative or operable in its present context. It thus involves, as Butler describes, "no prior authorization." "It is clearly possible to speak with authority *without* being authorized to speak"; the speaker "endow[s] a certain authority on the act." A self-generated authority. *Sovereignty.*

Butler's refashioning of the Foucauldian concept of "reverse discourse" as "insurrectionary speech act" radicalizes Foucault's own discussion in *The History of Sexuality* (1976). There he expressly aims to undo a sovereign model of power: "It is a question of orienting ourselves to a conception of power which replaces…the privilege of sovereignty with the analysis of a multiple and mobile field of force relations." Foucault pits a model of discourse as prone to reversal against the idea of discursive sovereignty: "Discourse transmits and produces power…but also undermines and exposes it." Indeed, he very directly describes these dynamics as the weaponization of language: "It is one of the essential traits of Western societies that the force relationships which for a long time had found expression in war…gradually became invested in the order of political power." In his portrayal of discourse as a resource for an "opposing strategy," Foucault's main example of "the formation of a 'reverse' discourse" is specifically interpellative: "homosexuality began to speak in its own behalf, to demand that its legitimacy…be acknowledged, often in the same vocabulary, using the same categories by which it was medically disqualified."

Reverse discourse is thus not opposable to sovereignty, but potentially another modality of it. It is not simply a disclosure or use of a weaponized improbability: it is a *sovereign* seizure of the power to speak.

The person who has an unapparent negatively valued attribute often finds it expedient to begin an encounter with an unobtrusive admission of his failing

With persons who are uninformed

Others are thus warned in advance about making disparaging remarks about his kind of person

Saved from the contradiction of acting in a friendly fashion to a person toward whom they are unwittingly being hostile

▌▌ 4 ▌▌ To overlook an ▌▌ 4a ▌▌ affront Forbearantly overlook ▌▌ 5 ▌▌ minor slurs upon ▌▌ 5a ▌▌ certain delicate trans ▌▌ 6 ▌▌ actions conducted by go-betweens ▌▌ 6a ▌▌ Making a gracious withdrawal ▌▌

Butler recovers precisely this sovereign potential in reverse discourse as an autoproduction of authority, identifying it in Derridean terms as an inaugural "break." Yet she criticizes Derrida's universalizing assertions in "Signature, Event, Context" (1972) about the mark's autonomy, the idea that it can *always* break with and create a new context. This insistence, as she notes, is "paralyzing [for] the social analysis of forceful utterance." History weighs on and in our terms: how do we account for its effects on social possibility?

But Butler oddly continually reiterates Derrida's error: "an utterance may gain its force precisely by virtue of the break with context it performs"; "the utterance, in fact, performatively produces a shift in the terms of legitimacy as an effect of the utterance itself"; "a certain performative force results from the rehearsal of the conventional formulae in non-conventional ways." Here it is assumed that the structural independence of the utterance gives it a sovereign power: the power to break with the given to found the new. Thus, her theory ultimately rests on a fiction of minoritarian sovereignty as objectified in language's unlikely capacity to make of its alterity its own better future.

Excitable Speech evidences a certain obsession with Bourdieu's phrase "social magic": that which "gives certain [dominant] speech acts the efficacious force of authority." The phrase redounds in uses ironic, critical, and earnest. Positing finally that social magic amounts to "the credible production of the legitimate," Butler underscores that the authority guaranteeing an utterance's performative force is always a social fiction, a form of "imposture" facilitated by an official or tacit legitimizing apparatus that is ultimately groundless but embedded in every aspect of life. Yet she speaks of how "an agency that emerges from the margins of power," bereft of this apparatus, may stand as such a credible production: *already* credited: bypassing the constraint of its authorizing reception. Her own theory thus loses sight of the "social" and re-enchants the "magic" of "social magic."

6b ||| A tactful blindness As wh ||| 7 ||| en he does not see that another has stum ||| 8 ||| bled Or because strong feelings ||| 9 ||| have disrupted his ||| 10 ||| expressive mask Which ||| 10a ||| may oblige those in a p ||||||||||||| 1 ||| arade to treat anyone who f ||| 2 ||| aints as if he were no ||| 3 ||| t present ||| 3a ||| at all ||| 4 ||| The self projected as a joke ||| 4a ||| A basis for safely ||| 5 ||| offending or accepts ||| 5a ||| Snubs or digs, cracks ||| 6 ||| Made to look f oolish ||| 6a ||| The per son ceases to be someone wh ||| 7 ||| o can be trusted ||| 8 ||| to take or give a hint ||| 9 ||| He can belittle himself ||| 10 ||| To accept mi streatment ||| ||||||||||||| 1 ||| at his own hands ||| 2 ||| Others, were they giv ||| 3 ||| en this privilege, ||| 3a ||| might be more likely to ||| 4 ||| abuse it ||| 4a ||| Or to arrange for othe ||| 5 ||| rs to hurt his ||| 6 ||| feelings ||| 6a ||| Forcing them to fee l ||| 6b ||| remorse To pla y the role of ||| 7 ||| the guilty party whether ||| 8 ||| one feels miscast or not ||| 9 ||| treated w k ||| 10 ||| id gloves ||| 10a ||| Requiring more care |||||||||||||| 1 ||| on the part of ||| 1a ||| others ||| 2 ||| Than he may be ||| 3 ||| worth to the ||| 3a ||| m Showing a wr ong face ||| 4 ||| or no face A social worth ||| 4a ||| which cannot be integ ||| 5 ||| rated ||| 6 ||| Pre senting nothing usable Th ||| 6a ||| at consideration fo ||| 6b |||

This representation of performative sovereignty elides Derrida's observations about the contradiction within such utterances: their dissimulation of their sovereign power.

Directly theorizing the speech acts that found entirely new political contexts, Derrida argues for an "originary performativity that does not conform to preexisting conventions… but whose force of *rupture* produces the institution or the constitution, the law itself, which is to say also the meaning that appears to, that ought to, or that appears to have to guarantee it in return" (*Specters of Marx*). Here an utterance is capable of breaking with all given conventions and frameworks to institute the new scene it posits. But in doing so it cannot effect its force in a vacuum: it must be *valid* – ratified or guaranteed in return. Such originating gestures are caught up in a causal paradox, since they "*derive* their legitimacy from conditions they themselves *found*" (Esterhammer): "the felicity of the speech act depends on presuming the priority of that which it posits or creates" (Miller). The utterance produces the conditions that validate its producing of those conditions: its force is thus impossible. Inevitably, this knot is dissimulated through a "fabulous retroactivity" (Derrida) or sleight-of-hand. Such speech acts "proceed as if they had *already taken effect*": they gainsay or force their validity by passing off the performative as the constative, "pretending the situation they aim…to bring about already…exists (Esterhammer).

et G+1 19

keters sell
t adidas
shoe that
;oing to debut
is the latest
neakers being

CAPTION Courtesy of adidas Facebook
 page

S Roundhouse
Monday after
online criticism
 shackles
lavery, was the

imple of sneaker gaffes. (Adidas, in a statement,
ogize if people are offended by the design.")

telling h

Michae
marketi
ranging
Olympi
number

Quic

Who I
NFL t

○ Jets

○ Lion:

○ Pack

○ Pant

Derrida has also framed utterances explicitly charged with the founding or installing of a context in terms of the future anterior. Such speech acts function as oaths or promises: grounding themselves by projecting a future order that will have been. Here the performative not only temporally and politically ruptures the present by promissorily instaurating and embodying the "to come" in the "here-now": it does so as a response to a demand (for justice) from the Other. The oath is thus validated not simply by the polity-to-come it founds, but by an-other context: a vanquished alterity demanding an alternative future.

Butler's version of reverse discourse could be said to answer just such a call from an exteriority, a lived, historical position of foreclosure or exclusion: emitted from a past-present present-past: (en)joined by trauma. Yet reverse discourse's very reversal – its Janus-faced use of an existing injurious term – indicates that its reciprocal authorization by alterity may not be enough. Its legitimacy is fragile.

"...the present context and its apparent 'break' with the past are themselves legible *only* in terms of the past from which it breaks. *The present context does, however, elaborate a new context for such speech, a future context, not yet delineable and, hence, not yet precisely a context*" (Butler; my italics).

r his feelings ▮▮ 7 ▮▮ need not be shown

A mask does not hide the face, it *is* the face
face the Icon proper: what fuels interpretation
despot brandishing a solar face
that is= his entire body
face digs the hole to break through
It constitutes the black hole
Getting larger, then pressing flat
To select the erased mental reality
Oral or cutaneous
Pinned there and stuffed in
Jesus Christ Superstar
to code their lack of power,
scapegoat
between a goat's ass and the face of god
a dead sun with no aspect
black-blue hole of the sky
Gridded But: where
there's no reduction.
rays carry the Stigmata

▮▮ 8 ▮▮ The main pr ▮▮ 9 ▮▮ inciple of the ritual order is not j ▮▮
10 ▮▮ ustice but face ▮▮▮▮▮▮▮▮▮▮

Derrida revised his definition of iterability to account for the *reciprocal* dependence of utterance and context (Miller). In "Signature Event Context," he writes that, "every sign… can…break with every given context, engendering an infinity of new contexts." In *Limited Inc*, however, he adjusts the statement: "It would have been better and more precise to have said 'engendering and inscribing itself,' or being inscribed *in*, new contexts. For…no mark can create or engender a context on its own, much less dominate it. This limit, this finitude is the condition under which contextual transformation remains an always open possibility." The revision reflects a certain equivocality in Derrida's own rhetoric, its double figure of utterance as "grafted" into a new context and its capacity to "break" with any given context. The difference, perhaps, between "the power to intervene in the context" (Miller) and the power to generate one *ex nihilo.*

1 ❚❚ or: bein g touched without bei ❚❚ 2 ❚❚ ng Touched ❚❚ 3 ❚❚ for behavior Modification ❚❚ 4 ❚❚ projecting a stri p of sound ❚❚ 4a ❚❚ a highly directional device holoso nic c ❚❚ 5 ❚❚ ontrol, sequential ar c discharge ❚❚ 6 ❚❚ politics of frequency ❚❚ 6a ❚❚ infrasound interna ❚❚ 6b ❚❚ l shaking weaponized transduction ❚❚ 6d ❚❚ violence as vibration ❚❚ 7 ❚❚ rep etitive impulse waveforms l ❚❚ 8 ❚❚ eaves no marks ❚❚ 9 ❚❚ what is the site of damage ❚❚ 10 ❚❚ what is the playlist ❚❚❚❚❚❚❚❚❚❚ 1 ❚❚ in 1989 when US troops blared music to induce Norriega's surrender ❚❚ 2 ❚❚ music as battlefield weapon ❚❚ 2a ❚❚ music as weapon ❚❚ 3 ❚❚ sensory deprivation sexual hum iliation musical ❚❚ 3a ❚❚ bombardment ❚❚ 4 ❚❚ being made to "dance" ❚❚ 4a ❚❚ in chambers referred to as "discos" ❚❚ 5 ❚❚ weaponized waking ❚❚ 6 ❚❚ awakened by water poured over his he ❚❚ 7 ❚❚ ad, or by Christina Aguilera ❚❚ 8 ❚❚ "extreme heat, extreme cold, or extreme ly ❚❚ 8a ❚❚ loud r ap music" weaponized temperature ❚❚ 9 ❚❚ weaponized air conditioning, "ne gative air ❚❚ 10 ❚❚ conditioning" ❚❚❚❚❚❚❚❚❚❚ 1 ❚❚ conditioning ❚❚ 2 ❚❚ psycho-acoustic correction ❚❚ 3 ❚❚ induced regression (infantile behavio r) ❚❚ 4 ❚❚ "fear Up" and "ego Down" ❚❚ 5 ❚❚ hearing as Dread ❚❚ 6 ❚❚ one Acoustics controls the other ❚❚ 7 ❚❚ become hyperacousive, ❚❚ 8 ❚❚ unable to Tolerate ❚❚ 9 ❚❚ even

[Literature is] a modern invention inscribed in conventions and institutions which…secure in principle its right to say everything. […] Literature thus ties its destiny to a certain noncensure, to the space of democratic freedom (freedom of the press, freedom of speech, etc.). No democracy without literature; no literature without democracy… This authorization to say anything paradoxically makes the author an author who is not responsible to anyone, not even to himself, for whatever the persons or the characters of his works, thus of what he is supposed to have written himself, say and do, for example. […] This authorization to say everything (which goes together with democracy as the apparent hyperresponsibility of a "subject") acknowledges a right to absolute non-response. […] This non-response is more original and more secret than the modalities of power and duty because it is fundamentally heterogeneous to them. We find there a hyperbolic condition of democracy which seems to contradict a certain determined and historically limited concept of such a democracy, a concept which links it to the concept of a subject that is calculable, accountable, imputable, and responsible, a subject having-to-respond, having-to-tell the truth, having to testify according to the sworn word, before the law. […] This contradiction also indicates the task…for any democracy to come.

Derrida, "Passions: 'An Oblique Offering'" (1992)

Derrida poses the relation of iterability to sovereignty differently when he frames it as a matter of literature.

Sovereignty enters the scene of "democracy" through the institution of literature in the West: in principle at least, literature sets to work an emancipatory, heterogeneous political power within democratic society, otherwise based on a subject who bears rights that also enjoin that subject's accountability.

This sovereignty has been interpreted in light of the literature's virtual powers: fiction is a practice of the performative founding of worlds; the lyric, through apostrophe, is a practice of imaginative interpellation; both give us access to prosthetic experience that transcends empirical reality and somehow fosters political transformation. But critics have also noted that for Derrida, literature is a privileged autonomous zone in which citizens exercise *a freedom to say everything and a freedom from responsibility in saying it.*

The empirical author is always placed at an oblique angle towards the literary text, which stands as the expression of a persona or avatar that cannot be conflated with the author as person in the world. Given this insuperable structural distinction, the right of non-response, the refusal to answer for literary speech, pertains to its author. In places, Derrida connects this right of privacy in turn to the non-referential logical status of the literary "secret": what is never established as stable fact in a fictive world will remain absconded, unknowable. Such hidden information is finally also technically *not* hidden: it is a secret that is no secret. However paradoxical, it is precisely the predicament of being unable to enter a fiction's world to set the facts straight – the flatness of the fictional secret – that produces literary forms revolving around secrets and the "radical effects of subjectivity and subjectivation" to which they give rise (*Given Time*). Tied to this logical status of the literary secret, the authorial right to non-response seems deflated, a virtue made of necessity.

slight ▮▮ 10 ▮▮ Noi ses ▮▮▮▮▮▮▮▮ 1 ▮▮ incess ant high-volu me Whi ▮▮
1a ▮▮ te noise playi ng "a low cr ▮▮ 2 ▮▮ ackling noise" biode regu
lation ▮▮ 2a ▮▮ weaponized futility an approach ▮▮ 3 ▮▮ known in the
US Army field manual as "futility" ▮▮ 3a ▮▮ like gender
manipulation, ▮▮ 3b ▮▮ part of a futility approach ▮▮ 4 ▮▮ to
interrogat ▮▮ 5 ▮▮ ion, meant to persuade pris ▮▮ 6 ▮▮ oners of the
interrogator's omnipotence ▮▮ 7 ▮▮ ac oustically assiste d Jamming
of access to one's own thoughts ▮▮ 8 ▮▮ in a room or a shipping
container ▮▮ 9 ▮▮ weaponized dogs ▮▮ 10 ▮▮▮▮▮▮▮▮ 1 ▮▮ it is entirely
possible ▮▮ 2 ▮▮ for the listener to be trans ▮▮ 3 ▮▮ formed by
music whether he ▮▮ 3a ▮▮ wishes to be or not ▮▮ 4 ▮▮ Always provide
circuitry to lim ▮▮ 4a ▮▮ it feedback stimulus. (For ▮▮ 5 ▮▮ example,
if the feedback stimulus is ▮▮ 6 ▮▮ an electric shock ▮▮ 7 ▮▮
inverse of sensory deprivation ▮▮ 8 ▮▮ integrate living soldiers
into feedb ack loops to correct ▮▮ 8a ▮▮ an d/or amplify one part
of a machine's output ▮▮ 8b ▮▮ for input into another of its
components ▮▮ 9 ▮▮ 1993 Waco RABBIT-SCREAM TAPES ▮▮ 9a ▮▮ rabbit ric
tus dictates ▮▮ 9b ▮▮ ag ony to elicit a ▮▮ 9b ▮▮ gony agony as to
aggress ▮▮ 10 ▮▮ use of sound and other "irritants" ▮▮▮▮▮▮▮▮

I mean, for example, the following: a performative utterance will, for ex-
ample, be *in a peculiar way* hollow or void if said by an actor on the stage, or
if introduced in a poem, or spoken in a soliloquy. This applies in a similar
manner to any and every utterance… Language in such circumstances is in
special ways – intelligibly – used not seriously…

J. L. Austin, *How to Do Things with Words* (1955)

One way Derrida deconstructs the performative is through its necessary repeatability:
he dissolves the distinction between citing an utterance to use it seriously and quoting it
non-seriously in a mere mimesis of that use.

But he is also concerned to instate the difference literature makes: "*citation* (on stage, in a
poem, or a soliloquy) is the determined modification of a general citationality – or rather, a
general iterability" (*Limited Inc*). Despite his proclivity for the binary, he proposes that what
is needed is "to construct a differential typology of forms of iteration." A sense here that
the single divide between serious and non-serious masks specific gravities of performativity.

Most especially, Derrida's obsession with irony – particularly in *Limited Inc*, with its perfor-
mative refrain, "*Let's be serious*" – deeply troubles assimilating the non-serious utterance *tout
court* to the status of literature *qua* mimesis or copy or representation, with reference and
force suspended.

Had in abundance
less of some thing I had
And more of some things I scarcely had had.
Back curved like she was throwing up.
does she remain inviolate
Disposal is to place the absence
As a contraction of instants
With the chronic
App.
Are you a taker or a giver
Did you pay me back
Yes, no or don't know
Whether in this situation we really needed the aliveness
To a full restore
Particle-burst effects
A smeared field of distributed charge
The atom is
Enhancement enhancement
The violation is carried out to make it signify
i.e. passes through the martyr onto the cloth.
When you were a feces in your mother's womb
Tormented by the identical nature of god and excrement
Pyramid scheme
A tergo

Is it not also democracy that gives the right to irony in the public space? Yes, for democracy opens public space, the publicity of public space, by granting the right to a change of tone, to irony as well as to fiction, the simulacrum, the secret, literature, and so on. And thus to a certain non-public public within the public, to a *res publica*, a republic where the difference between the public and the non-public remains an indecidable limit. There is something of a democratic republic as soon as this right is exercised. This indecidability is, like freedom itself, granted by democracy, and it constitutes, I continue to believe, the only radical possibility of deciding and of making come about (performatively) or rather of letting come about (metaperformatively) and thus of thinking what comes about or happens or who happens by, the arriving of who arrives. It thus already opens, for whomever, an experience of freedom, however ambiguous and disquieting, threatened and threatening, it might remain in its "perhaps" with a necessarily excessive responsibility of which no one may be absolved.

Derrida, *Rogues: Two Essays on Reason* (2005)

By grouping the democratic "right to irony" with literature's right to a "non-public public," Derrida suggests not that irony stands, figuratively, *as if* a fictional "as if," but rather that *literature must be framed in an ironic mode* that puts the "as if" of fiction under erasure. At stake, then, is a double deconstruction: of the serious vis-à-vis the non-serious *and* of literary mimesis vis-à-vis irony, both extreme and emblematic forms of the non-serious.

And this decisively shifts literary sovereignty. Against the logically mandated secrecy of the fictional secret, secrecy becomes the right and the responsibility to refuse to compromise intractable forms of ironic undecideability that reach their apotheosis in literature. Literature is thus not a stable discourse contained by institutional conventions that define it as a "hollow" or "void" representation of serious descriptive or performative language. Rather it is a maverick, ironic discourse that continually questions and redefines the divide between the literary and the non-literary: an autonomous domain from which to deconstruct itself and all other discourses, through an unruly rendering of given conventions as undecideable.

In turn, this undecideability – activated by irony in the world at large and by ~~literature~~ – becomes the site of "the aporia of responsibility as irresponsibilization" (Wills). As Derrida notes above, it is only the undecideable, that which disallows the automatic application of convention and distresses social categorizations, that permits a "radical possibility of deciding": decisions that are not already decided. Such a text "enter[s] into a ruptured or indeterminate relation with its reader" (Wills). The given stymied. Text-as- irony incurs the ultimately groundless decision of those who encounter it: an experience of freedom: "excessive" and "hyperresponsible." Setting irony to work (and this may itself be undecide-able): a sovereign metaperformative (author) enabling sovereign performatives of decision (audiences).

1 ‖ In his allo tment ▐‖ 2 ‖ ga ve to some creatures streng ▐‖ 2a ‖ th without speed, ▐‖ 3 ‖ equip ped weaker kinds ▐‖ 3a ‖ with speed. ▐‖ 4 ‖ Some he arme d with weapons, ▐‖ 5 ‖ while to the unarmed gave ▐‖ 6 ‖ some other faculty ▐‖ 7 ‖ and so ▐‖ 8 ‖ contrived a means for their pr ▐‖ 9 ‖ eservation ▐‖ 10 ‖ weaponized ▐‖‖‖▐‖‖‖‖ 1 ‖ coloration ▐‖

Ukraine lost three of its trained military attack dolphins in the Black Sea

nose-mounted guns with knives and pistols attached to their heads, Coyote says
 battlefield asset

 Perhaps as we read the account of these remote customs there may emerge a feeling of solidarity with the endeavors and ambitions of these natives

 Coyote says, Perhaps man's mentality will be revealed to us and brought near

In fact ("in fact"), Derrida repeatedly defines literature as an act of "literarizing." And literarizing is *the annexation of a previously existing text* for purposes of ~~literature~~. Literature as citation, as re-authoring. Literary texts, too, as factitious entities in the world, may be submitted to this process of "becoming-literary."

Any text can be treated as literature:

> One can always inscribe in literature something which was not originally destined to be literary, given the conventional and institutional space which institutes and thus constitutes the text. ("'This Strange Institution Called Literature'")

> There is no text which is literary in itself. Literarity…is the correlative of an intentional relation to the text…the more or less implicit consciousness of rules which are conventional and institutional – social, in any case. […] [By] changing one's attitude with regard to the text, one can always reinscribe in literary space any statement – a newspaper article, a scientific theorem, a snatch of conversation. ("'Strange Institution'")

This literarizing gesture, the making of "literature" by attitudinal and institutional or conventional fiat, does not simply frame the text as fiction, or as a self-enclosed formal object with literary qualities. To be settled according to these conventions is just what would destroy its status as literary: "a literature that talked only about literature or a work that was purely self-referential would immediately be annulled" ("'Strange Institution'"). Literature itself refuses this containment. To recontextualize a text as literature is thus precisely what prevents any text from being read *only* on literary terms: "we feel that literature is in the process of seizing these words without, however, appropriating them to itself in order to make them a thing of its own." ("Literature in Secret" [Kotsko trans.])

2 ▎▎ versu s a peaceful schooling fi ▎▎ 3 ▎▎ sh illuminate their jewe ls when ▎▎ 3a ▎▎ glowing with love or ang ▎▎ 3b ▎▎ er octopus animates its skin ▎▎ 4 ▎▎ or mobbing ▎▎ 4a ▎▎ weaponized mobbing ▎▎ 5 ▎▎ crows or other birds mob ▎▎ 5a ▎▎ a cat ▎▎ 5b ▎▎ or other nocturnal predator ▎▎ 6 ▎▎ if they catch sight of it by day ▎▎ 7 ▎▎ weapons of attack, of ▎▎ 7a ▎▎ defense ▎▎ 8 ▎▎ as by silicate stor ▎▎ 8a ▎▎ age hard, wooden thorns ▎▎ 9 ▎▎ plants devis e a means ▎▎ 10 ▎▎ to protect ▊▎▊▎▊▎▊▎ 1 ▎▎ whales stun ▎▎ 2 ▎▎ their prey ▎▎ 3 ▎▎ blasts of inaud ible sound ▎▎ 3a ▎▎ called "gunshots" b ▎▎ 4 ▎▎ y tonal projection ▎▎ 4a ▎▎ para lyze or burst To

to attack enemy divers, could also be
 trained to place explosive devices on enemy ships training exercises for
counter-combat swimmer tasks

 never either himself or the other but the superposition of himself
on the other

Nonetheless, for the text to be framed as literature is precisely for it to undergo, in an undecideable way, a suspension of reference and force.

On one hand, literature would be that space where the context of a text has been suspended in the sense of being rendered indeterminate, an open question. Any text that has come unmoored from an identifying context that fixes it is a candidate for citation as literature:

> Every text that is consigned to public space, that is relatively legible or intelligible, but whose content, sense, referent, signatory, and addressee are not fully determinable *realities* – realities that are at the same time *non-fictive or immune from all fiction*, realities that are delivered as such, by some intuition, to a determinate judgement – can become a literary object. ("Literature in Secret" [Wills trans.])

On the other, through an intentional literarizing or citation as literature, texts lose their hold on "reality": becoming non-serious or hollow in some wise: "The kinds of commitment that might follow in other circumstances do not apply" (Loxley). This is a complex matter: "Every literary text plays and negotiates the suspension of referential naivete" ("Strange Institution"): suspension itself is always suspended, resisted, responded to. Depending on the text-as-field and the precise manner of citation, appropriative literature always performs suspension differently.

"Literature, i.e., an institution which cannot identify itself because it is always in relationship, the relationship with the nonliterary" and with "literature" itself ("'Strange Institution'"): the border between the serious and the "hollow," between art and other modes of discourse, always in tension.

Thus, appropriative writing comes into view as intrinsically *aggressive*. As the indexical aspect of its citation emphasizes, Conceptual writing annexes *a piece of reality* into its suspensive domain. Yet the work also breaches this suspension, torques it, its new performance of the text-in-context warping or changing aspects of its operationality, its force. It is a form of contentious inquiry into that force.

how to locate marine mines outfitted with a device strapped to the head
containing [simulated] compressed gas
needle,"

 Coyote says An air or gas bubble injected into a vein or artery creating
an embolism "ramming us in the chest cavity to simulate the [CO2] injection."

▮▮ 5 ▮▮ the dista nce at w ▮▮ 5a ▮▮ hich starlings can ▮▮ 6 ▮▮ reach
each other. When they ▮▮ 7 ▮▮ land, they sit ir ▮▮ 7a ▮▮ regularly
distributed but ▮▮ 8 ▮▮ soo n those to ▮▮ 9 ▮▮ o close begin t ▮▮ 10
▮▮ o peck ▮▮▮▮▮▮▮▮▮▮ 1 ▮▮ by expressive movements the brown rat but ▮▮
2 ▮▮ in the house rat by ▮▮ 3 ▮▮ a sharp, shrill, satanic ▮▮ 3a ▮▮
cry aggression ▮▮ 4 ▮▮ toward members of their own ▮▮ 5 ▮▮ species
in no ▮▮ 6 ▮▮ way detr imental to the ▮▮ 7 ▮▮ species but essential
for it ▮▮ 8 ▮▮ s preservation; whereas winner kills ▮▮ 9 ▮▮ loser in
the a quarium, whe re there ▮▮ 10 ▮▮ is no escape ▮▮▮▮▮▮▮▮▮▮

All the world is not, of course, a stage, but the crucial ways in which it isn't are not easy to specify.

Erving Goffman, *The Presentation of Self in Everyday Life* (1956)

Finally Lacy Forest announced that he had heard that "by law" if you had a NO TRESPASSING sign on your porch you couldn't be sued. So everyone went to the store in Beckley to get the official kind of sign. Neighbors brought back multiple copies and put them up for those too old or sick or poor to get out and get their own. Then everyone called everyone else to explain that the sign did not mean them. In the end, every porch and fence (except for those of the isolated shameless who don't care) had a bright NO TRESPASSING, KEEP OFF sign, and people visited together, sitting underneath the NO TRESPASSING signs, looking out.

Kathleen Stewart, *A Space on the Side of the Road: Cultural Poetics in an "Other" America* (1996)

In requisitioning an existing text, the citational work explicitly displaces that text-in-context by performing it differently. However uninterested it may be in the text's prior life, it not only quotes the text-in-context, but changes it in re-performing it and enacts a relation between the two instances.

How are we to take the literary performance, how do we identify its speech acts? And further: how are we to characterize the enveloping performative – the tenor of the social stance or action – enacted by a work of citational literature: how does it refer?

In other words: *What is the serious utterance conveyed by the literary utterance* (Searle)?

Ukraine lost three of its trained military attack dolphins in the Black Sea, Coyote says

 the dolphins swam away from the myth of mythology
 the dolphins swam away from their handlers earlier this month

The social existence of appropriative literature depends on the irony fundamental to it: its exercise of ~~literary~~ sovereignty.

In its more resolvable, local form, irony uses a statement to undercut its overt meaning, rhetorizing the literal so that it stands alongside itself.

Defamiliarization, a speech act named for its intended perlocutionary effects, is thus ironic. Citational literature is not simply "decontextualized citation" (Chen and Kreiner). Its main purport is often to re-present a text in its prior *mise en scène*: it functions as a stop-motion capture of the text-in-habitus, to generate defamiliarization. *Ostranenie* classically involves a new, different perception of the already-known that is also, more pointedly, a critical gaze. Akin to the dramatic irony of historical hindsight.

As bare, defamiliarizing quotation, the appropriative work (re)presses the components of its current iteration into this service of objectifying revelation; ignoring or understating itself as present performance, it subordinates its current configuration to bring a former ghosted context into relief. A text may also be reproduced such that its medium-specific form and context is preserved and framed in displacement to its new environment, laying bare the new work's device, its process of making. By x-raying its own act of citation, the work draws itself into the purview of critique at the same time this self-transparency authorizes criticism of the cited material.

1 ||| recombina nt subject ||| 2 ||| s who consume others' bod ||| 2a ||| ies infinite divisibility ||| 3 ||| human body parceled out ||| 3a ||| process ||| 4 ||| ed into consumable goo ||| 4a ||| ds disenchanted body as ||| 4b ||| market object sale ||| 5 ||| not of the labor of the body but ||| 5a ||| the parts of the body ||| 6 ||| lifef orm constituted through rit ||| 6a ||| ual action body worth m ||| 7 ||| ore dead than alive in its ||| 8 ||| eternal life ||| 9 ||| stemcell totipotent ||| 9a ||| plasticness, plastic ity ||| 10 ||| excess ani macy, how ||| 10a ||| monetized |||||||||||||| 1 ||| weaponized ||| 2 ||| meat, yelling at ||| 3 ||| me because there is not enough meat ||| 4 ||| on this sandwich ||| 5 ||| conscious but par alyzed we ||| 6 ||| aponized slaughter ||| 6a ||| as mechanized or ||| 7 ||| to use circumstances of ||| 7a ||| slaughter to torture and de ||| 8 ||| mean, to abuse: to hurt more than ||| 8a ||| is economically justi ||| 8b ||| fied Chicken chickens exempt ||| 9 ||| from Humane Methods of S ||| 10 ||| laughter Act heart beats |||||||||||||| 1 ||| through most of slaught ||| 1a ||| er process so they "bleed ||| 2 ||| out" efficiently ||| 2a ||| weaponized heart ||| 3 ||| weaponized heart ||| 3a ||| heart rejected In flares ||| 4 ||| despite immunosuppress ||| 4a ||| sants auto ||| 5 ||| immunity weaponization of self- ||| 6 ||| defense self-immunizing ||| 6a ||| self-destructive

Conceptualism, Chris Chen and Tim Kreiner observe, betrays an "essentialist understanding of appropriation techniques as inherently critical." No doubt in a society based on (cynical) knowingness, high-impact defamiliarization may be hard to achieve. Given this socio-political fact, citational literature would seem to trope on *ostranenie* in a variety of ways rather than purporting to precipitate definitive demystification events. By the same token, our condition of disenchantment *in extremis* can be what makes for an all-the-more surprising sense of recognition that a work's denaturalization may evoke. The lab slide of automated junk language exposes a particular mechanism of digital capitalism, or even just the weight of its banality to an unforgiving glare: the prior pragmatic meaning of the text for a moment reversed in citational reflection. Recognition need not be overtly ideological: Conceptualist writing often brings details of physical medium to notice.

Yet defamiliarizing appropriation risks repetition without difference (Chen and Kreiner): the speech act fails as mention slides into use or as citation remains inert or itself registers as cynical. As a weaponized shift in perspective, defamiliarization depends on assumptions about the episteme of one's readers. It is prone to flattening the epistemological economy of its audience, overlooking the unevenness of the unthought thought: or drawing out political economies of the probable. The flat affect of *ostranenie*, cognate with the analysis it means to prompt: flatness as respectful: as affectively charged. Or as disaffected or skeptical: shading into irony as scare quotes. But who can wear speakership in quotation marks?

Defen se of the self ▌▌▌ 6b ▌▌▌ immu ne system defends too much ▌▌▌ 7
▌▌▌ overprotect ive closure of the body ▌▌▌ 7a ▌▌▌ body risks itself
in its ▌▌▌ 7b ▌▌▌ effort to protect ▌▌▌ 8 ▌▌▌ threat inherent to its ▌▌▌
9 ▌▌▌ protective act ▌▌▌ 9a ▌▌▌ destroys its own prot ection ▌▌▌ 9b ▌▌▌
self-defense as self-attack ▌▌▌ 10 ▌▌▌ self-defense as attack "palm
▌▌▌▌▌▌▌▌▌▌▌ 1 ▌▌▌ turned away from ▌▌▌ 2 ▌▌▌ his bod y, held above ▌▌▌ 3 ▌▌▌
his own head" ▌▌▌ 3a ▌▌▌ perceived as ▌▌▌ 4 ▌▌▌ the splitting off of ▌▌▌
4a ▌▌▌ split off as it thr ▌▌▌ 5 ▌▌▌ eatens and turns aga ▌▌▌ 6 ▌▌▌ inst
those intentions ▌▌▌ 7 ▌▌▌ weaponized staving off ▌▌▌ 8 ▌▌▌ when it
bends ba ▌▌▌ 9 ▌▌▌ ck weaponized gaze ▌▌▌ 10 ▌▌▌ weaponized disposition
of ▌▌▌ 10a ▌▌▌ the visible ▌▌▌ 10b ▌▌▌ weaponized blind spot ▌▌▌▌▌▌▌▌▌▌▌ 1
▌▌▌ to the body that receives it ▌▌▌ 2 ▌▌▌ weaponized forensic reality
▌▌▌ 3 ▌▌▌ vandalized ▌▌▌ 3a ▌▌▌ in advance ▌▌▌ 4 ▌▌▌ if seeking recourse to
the ▌▌▌ 5 ▌▌▌ visible ▌▌▌ 6 ▌▌▌ or visual ▌▌▌ 6a ▌▌▌ gaslight ▌▌▌ 6b ▌▌▌
pretense ▌▌▌ 7 ▌▌▌ can or cannot appear ▌▌▌ 8 ▌▌▌ weaponized normalcy ▌▌▌
9 ▌▌▌ weapo nized doubt, casting doubt ▌▌▌ 10 ▌▌▌ or de nying ▌▌▌ 10a ▌▌▌
can't prove its weaponization ▌▌▌▌▌▌▌▌▌▌▌ 1 ▌▌▌ pree mptive ▌▌▌ 2 ▌▌▌
defens ive posture weaponized by som ▌▌▌ 3 ▌▌▌ eone else ▌▌▌ 4 ▌▌▌
weaponized prevention ▌▌▌ 5 ▌▌▌ As of imminent threat ▌▌▌ 6 ▌▌▌ weapon
ized pretext ▌▌▌ 7 ▌▌▌ weapo n of another's uncons cious thought

Local irony can also pointedly draw attention to the present iteration of text-in-context.

"Citation draws attention to some…quality of the cited act, repurposing it, eliciting/creating some latent potentiality in it" (Nakassis). Citational literature in fact performs this latent potentiality: treating the text as a materially and graphically instantiated object and as a network of productive, supportive relations, it draws out and performs how shifts in any of these components become vectors of dramatic changes in its social character (or bind it to a certain structural sameness and insistence). Such creative repurposing calls up the text's initial instance: as playful departure or more aggressive transformation, its difference *analyzes* a prior performance. Appropriation may stage its own instance as a failed or particularly vulnerable speech act, pointing up the limits of a text to drift meaningfully from context to context. It may attempt collapse with that which it cites: desiring exact reenactment, uncanny haunting, usurpation, identification, overidentification. Or infrathin difference.

Citational literature also produces local irony as a performance that directly responds to or diagrams its attitude towards an utterance by quoting it verbatim. Underscoring the present context of riposte, citation *is* reply, the enunciation's words returned value-added: the utterance ricochets in repetition as indictment, endorsement, plea, statement of disbelief, ridicule, as compliment or insult. As reverse discourse.

▮▮ 8 ▮▮ Domin ant narrative ▮▮ 9 ▮▮ weaponized pointing at or out ▮▮ 9a ▮▮ Information dominance weaponized ▮▮ 10 ▮▮ verdict, as media ▮▮ 10a ▮▮ event A weaponized ext eriority, beyond ▮▮▮▮▮▮▮▮▮▮ 1 ▮▮ the law Subtraction from ▮▮ 2 ▮▮ weaponi zed rights as rights that ▮▮ 3 ▮▮ cannot be exercised ▮▮ 3a ▮▮ weaponized dread ▮▮ 4 ▮▮ Knowing and not-knowing ▮▮ 4a ▮▮ weaponized clar ification ▮▮ 4b ▮▮ weaponized refer ence ▮▮ 5 ▮▮ weaponized euphemism ▮▮ 5a ▮▮ weaponized scareq uotes ▮▮ 6 ▮▮ weaponized knowledge ▮▮ 6a ▮▮ weaponized admission, confession ▮▮ 6b ▮▮ frontality ▮▮ 7 ▮▮ weaponized masking and unmasking ▮▮ 8 ▮▮ Contact Avoidance ▮▮ 8a ▮▮ Stif fens into Lie ▮▮ 9 ▮▮ escalation ▮▮ 10 ▮▮ weaponized damage contr ▮▮ 10a ▮▮ ol nothing is Hidden yet ▮▮▮▮▮▮▮▮▮▮ 1 ▮▮ the re is no ▮▮ 2 ▮▮ accountability ▮▮ 3 ▮▮ Impunity ▮▮ 4 ▮▮ distributed penetration as of ▮▮ 5 ▮▮ power weaponized ▮▮ 6 ▮▮ retractability ▮▮ 6a ▮▮ you are not supposed to ▮▮ 7 ▮▮ brin g the matter Up ▮▮ 7a ▮▮ anymore if the "Present" has ▮▮ 8 ▮▮ destroyed the Foundat ions ▮▮ 9 ▮▮ of meaning ▮▮ 10 ▮▮ speaking ▮▮▮▮▮▮▮▮▮▮ 1 ▮▮ to speaking for ▮▮ 2 ▮▮ speaking as held tig ht ▮▮ 3 ▮▮ ly to burn out f ▮▮ 3a ▮▮ ear response ▮▮ 3b ▮▮ are you in your ▮▮ 4 ▮▮ vehic le weaponized ▮▮ 4a ▮▮ checkpo int weaponiz ed trans ▮▮ 5 ▮▮ lation weaponized ▮▮ 5a ▮▮ mistranslation ▮▮ 5b ▮▮ tech

Appropriation is a form of "doing by saying." Yet unlike explicit performatives – a promise, a bet, a judge's sentence, etc. – citational works function through implicature: they perform *without* stating. They use irony (Fitterman).

The rhetorical figure of local irony presumes upon and reinforces contextual conventions of interpretation: citational literature depends on this shared and maintained social field of meaning. In turn, the "serious" stance of the work – its social statement – would seem to be derivable from its recognizable speech acts, based on calculable differentials in displacement. What everyone would know.

But citation is also almost incorrigibly given to ambiguity: to multiple, potentially incompatible interpretations. This risk is precisely the point. Intended frames sponsor unintended ones, every local form of irony may be itself also be an instance of meta-irony, meant, for instance, parodically or skeptically. This instability makes the reader's "drawing of any distinction…precisely a decisive instance: it is an interruption of the conventional apparatus" (Loxley). Which is to say: decision among given, mutually excluding choices in interpreting appropriation may give rise to a disturbing sense of how they interfere with each other, in turn leading to redefinition at least in this instance. Even to reinstate distinctions in conditions that are uncertain may require a reflexive rethinking of them.

nically there ar ▌▌▌ 6 ▐▐▐ e no future tenses in En ▌▌▌ 6a ▐▐▐ glish weaponized n ontranslation shibbo ▌▌▌ 6b ▐▐▐ leth weaponized pronunci ▐▐▐ 7 ▐▐▐ ation assimilation ▌▌▌ 7a ▐▐▐ we aponized inassi milability "di ▌▌▌ 8 ▐▐▐ d not have verba l clearance" ▐▐▐ 8a ▐▐▐ weaponized cavity se ▌▌▌ 9 ▐▐▐ arch or with weapons cav ▌▌▌ 10 ▐▐▐ ity syntax To not ▌▌▌▌▌▌▌▌▌▌ 1 ▐▐▐ be the cop of me ▌▌▌ 1a ▐▐▐ like a hand ▌▌▌ 2 ▐▐▐ cuff neurop athy weaponized ▐▐▐ 3 ▐▐▐ handcuffs cuf fing an arrest ▐▐▐ 4 ▐▐▐ ee too tightly resi ▌▌▌ 5 ▐▐▐ dual alter ▌▌▌ 6 ▐▐▐ ed or decreased sensation o ▌▌▌ 6a ▐▐▐ ver edge of hand between ▐▐▐ 7 ▐▐▐ base of thumb and ▐▐▐ 8 ▐▐▐ wrist direct compression, cramming ▌▌▌ 9 ▐▐▐ nerve against adj ▌▌▌ 10 ▐▐▐ acent bone ▌▌▌▌▌▌▌▌▌▌▌

Given its continual negotiation of literary suspension – its continual overstepping of the bounds of literature, the way it puts pressure on "discourse agreements" (Fish) – appropriative literature throws into question not just the identity of a given utterance, but how to apply frames of interpretation, *how they count*. It is to use the given to explore, dispute, or get beyond the grounds or conditions of the given.

How are disciplinary frames transformed in the instance of appropriation's displacement? "What are the various normative frameworks that this performance could offer its audience to structure their interaction with it" (Loxley), and how might these frameworks fail? A work's refusal of reflexive simulation, patent in its annexing of pieces of the real, may reveal in turn the simulacral in the "reality" outside of art or, conversely, the non-mimetic dimensions of literature, proposing parameters for understanding the literary as "real." It may disclose these vulnerabilities and constitutive self-differences through enacting their social being, their force or reference, differently. *To demonstrate experientially* what might be undecideable in given contexts: performing the permeability of art and reality, that pluralized boundary always shifting and capable of being posited otherwise. How may the requisitioning of sites outside the literary for acts of citational literature use their present instances to test the performative force, referentiality, and material operation of particular social actions and processes? How might they disrupt or intervene in their protocols, perhaps generating unanticipated kinds of performatives: such that they turn the force of a given speech act into another kind of social ritual? What is required to take such a citational situation seriously, or on its own terms: "to let it weigh upon us as something that obliges, demanding a certain kind of response" (Loxley)?

If time is still money
or more generally excremental
god's deauthorization
in excess with respect to form
it doesn't take a wrinkled dollar
to solidify into metaphor.
to place
What is unwanted
How we get rid of
Hold in a state of absence
As a form of payment
Unconditional love.
A commercial is on.
like this
no like this.
You have to buy the marketing kit
In leadership through products
In your right to get shit done.

Irony also very clearly has a performative function. Irony consoles and it promises and it excuses. It allows us to perform all kinds of performative linguistic functions which seem to fall out of the tropological field. […] Understanding would allow us to control irony. But what if irony is always of understanding, if irony is always the irony of understanding, if what is at stake in irony is always the question of whether it is possible to understand or not to understand?

Paul de Man, "The Concept of Irony" (1977)

Proffering open social questions through vertiginous forms of ironic praxis and meta-praxis, citational literature engages in sovereign acts of fatal ambiguation and creative disruption. Its generative potentiality – its capacity to reveal and challenge social categories and mechanics, to create conditions for critical awareness and practice, to help effect a redistribution of the sensible (Rancière) or social repair – can be undermined by an (undecideable) nihilism as well as by a sense of arrogant withdrawal: that it is a meta-move above a social game it sets to work. Regardless of the hyperresponsibility assumed (or ignored), a meta-accountability for the choices instigated, it invokes hierarchy.

What could complicate appropriative literature's self-exception, its sovereign authorial right to non-response, is a mode of para- or ante-decision that brackets irony's "infinite chain of solvents" (Booth). To treat it, instead of a speech act that cannot be decided, as a speech act called "indecideability." What would be its conditions of felicity and infelicity? Over against authorial "limited liability," how might the ethics of irresponsibilization be framed?

In selecting and reframing a text-in-context, to what decision(s) does a citational work give rise: what is at stake? What process of decision is choreographed: what are its specific discomforts? Do the interpretive choices and social praxis it instigates function as shibboleths: litmus tests of the given: opportunities to reproduce or retrench *doxa*? Are there trajectories for conversation in the differences it precipitates? Does its appropriation seem aware of its participation in a politics of access, of the differential resistances that specific texts-in-context have to specific cases of citational re-performance? How does the work approach questions of fungibility, mobility, exchangeability: how does it reflect on the compatibility of citational literature with capitalist logics and dynamics, or with imperialist flows of "resources"? If citational literature fetishizes the disclosure of its material processes of making – the transit of text from one platform to another – how does it attend to the social mechanisms allowing them to be re-sited and remade? What is valued and seen in the transfer, what ignored? What is risked in re-activating a text-in-context, when its citational force may always exceed what has been framed as relevant? How does the work account for executive pre-decisions regarding its risk? What is its imagination of its failure? Breaching multiple borders of art and life, does the work finally seek refuge in the "permission" (the presumed "hollow" or "void" force) of art?

Ironicon - *Temherte Slaqî*

In certain Ethiopic languages, sarcasm and unreal phrases are indicated at the end of a sentence *temherte slaqî* or *temherte slaq* (U+00A1) (¡), a character that looks like the inverted exclamation with a sarcasm on point.

Read more about this topic: Ironicon

Is it aware of the politics of access to irony?

And of the (local) irony ultimately enclosing a citational work's refusal of irony in performing complicity (racist discourse *qua* racist discourse = antiracist discourse)?

Complicity as "redemptive discourse" (Leslie Roman): strategies for whiteness to survive complicity, capitalizing on it: "that whiteness can participate in and witness its dismantlement in order to rebrand and re- enfranchise itself" (Lillian-Yvonne Bertram): that reflexive performance of complicity with white domination shores up a laundered, "rehabilitated" whiteness.

The non-precarity of white antiracism in appropriation: reversing the force of cited material, when re- performing or aggravating its original force: presumption of epistemic, social, affective mastery. Self- inculpation direct or by proxy as exculpation: narcissistic rebound of guilt as non-guilt, guilt as "mask" (Anzaldua and Moraga). Whiteness still central to itself: "Whiteness…within the field of itself" (Bertram).

"What are metaphors for the production and experience of black life that do not primarily reproduce the trauma of antiblack racism? What metaphors, although historically part of the maintenance of white supremacy, can be repurposed in the service of sustaining black life? […] There is no possibility for poems to shift their own contexts if there is not the possibility of participating in an intensification of blackness" (Anna Vitale).

As Derrida puts it in the introduction of *Of Grammatology*, to "designate the crevice through which the yet unnameable glimmer beyond the closure can be glimpsed." [...] What is this limit and why is it yet unnameable, beyond, only ever glimpsed, deferred? [...] What is this citational act that is beside and beyond citation, resembling it and derivative from it, which touches the citation on its thither side, this "glimmer beyond the closure"?

<div style="text-align:center">Constantine Nakassis, "Para-s/cite" (2013)</div>

The very movement of this fabulous repetition can...produce the new of the event. Not only with the singular invention of a performative, since every performative presupposes conventions and institutional rules – but by bending these rules...in order to allow the other to come or to announce its coming in the opening of this dehiscence. [...] We are trying to reinvent invention itself...an invention of the other that would come, through the economy of the same, indeed, while miming or repeating it...to offer a place for the other, to let the other come. [...] [This] can consist only in opening, in uncloseting, destabilizing foreclusionary structures so as to allow for the passage toward the other. But one does not make the other come, one lets it come by preparing for its coming.

<div style="text-align:center">Derrida, "Psyche: Invention of the Other" (1984)</div>

A citation devoid of aggression, devoid of sovereignty: an "invention" using Same to court the coming of the Other. This repetition is not the founding performative of a new order: it is an utterance that creates a cleft in performativity, bringing the foreclosures of its context to a ruin already seeded within it. This iteration cannot be and does not try to be its own (future) alterity: it is only means of beckoning.

Citation as hospitality: to host a text, to cede place to it, to be changed by that (Alison Jeffers).

Citation as deflection or withdrawal: antispectacle. Testimony against voyeurism, against skeptical rebound, against self-same empathy (Saidiya Hartman).

1 ||| If you see somet ||| 2 ||| hing, say something ||| 2a ||| g A domin ance affect ||| 3 ||| Vocal subtrac ||| 3a ||| tion Subvoca ||| 4 ||| l Dummy track tor ||| 4a ||| rent Bullet poin ||| 5 ||| ts Perforate the langu ||| 5a ||| age Surface-to-air and air ||| 6 ||| -to-air Magic mar ||| 6a ||| ker Legit imation ex ||| 7 ||| ercises Are you ou ||| 8 ||| t of place Strip it ||| 9 ||| off and paste it bac ||| 9a ||| k on Screen mem ||| 10 ||| ory cover charge cover ar ||| 10a ||| rest White imprint |||||||||||||| 1 ||| Leaving the questi ||| 2 ||| ons bare Chorus we ||| 3 ||| ep-sings EZPass quik-mourn ||| 4 ||| Grief spit ||| 5 ||| cup Postal ejacul ||| 6 ||| ate [Term that signif ||| 6a ||| ies failure of th ||| 7 ||| e other terms] move aro ||| 7a ||| und it this sent ||| 8 ||| ence projected ov ||| 8a ||| er this sentence chem ||| 8b ||| ical toilet weaponiz ||| 9 ||| ed sewage weaponized wat ||| 9a ||| er Christ breaking ||| 10 ||| bread "reading into" ||| 10a ||| a figure of his o |||||||||||||| 1 ||| wn crucifi xion why do ||| 1a ||| things get worse politi ||| 2 ||| cal arithmetic removi ||| 2a ||| ng the actions, the ag ||| 3 ||| ents who do es w ||| 3a ||| hat to whom dest ||| 4 ||| ituted of asteris ||| 4a ||| ked direction of danger ||| 5 ||| exnomination=refu ||| 6 ||| sing to name itsel ||| 6a ||| f power to ||| 6b ||| draw the fram ||| 7 ||| e ceter is paribus ||| 7a ||| proceduralism weaponized ||| 7b |||

The Black Artist's role in America is to aid in the destruction of America as he knows it… The Black Artist must demonstrate sweet life, how it differs from the deathly grip of the White Eyes.

Amiri Baraka (LeRoi Jones), "STATE/MEANT" (1965)

As Black cultural nationalist and major theorist, artist, and institution-builder of the Black Arts Movement, Amiri Baraka (LeRoi Jones until 1967) was devoted to the study and en-actment of linguistic violence in the domain of art: a domain he was redefining through a Black aesthetic: not only as connected with and drawing from Black realities and perspec-tives, but as a radical politicization of art: central to making a Black nation. Baraka's aes-thetic prescriptions in this period (1964-1974) at times slide wildly between the registers of the possible rhetorical, performative, and even physical force verbal art can exert. His own agitprop poetry and theater was meant to de-colonize and educate his Black audience, but perhaps even more fundamentally its purpose was to lay waste to and recreate the world as directly as possible: to blur and twist the relation of performance and performative such that words used in art would assume an excessive, actionable power.

1969 saw the publication of *Black Magic Poetry: 1961-1967*: its best known poem "Black Art" (1966) a *tour de force* in Baraka's ongoing exploration of the weaponization of language and literature. While its title makes it an emblem of the Black Arts Movement, it also signifies on the poem as a spell, situating it with reference to African American occult-re-ligious traditions of conjure and hoodoo. Mixing profanation and sacralization, the poem also exercises a certain performative force: a social versus a supernatural magic: whereby language might establish new social conditions and new revolutionary subjects. An inquiry into the limits and possibilities of verbal violence and power, "Black Art" as *ars poetica* per-forms one measure of poetry's real political efficacy.

Yet "Black Art" begins with a drastic reduction of verbal to physical object as the only acceptable modality for being and agency:

> Poems are bullshit unless they are
> teeth or trees or lemons piled
> on a step. Or black ladies dying
> of men leaving nickel hearts
> beating them down. Fuck poems
> and they are useful, wd they shoot
> come at you, love what you are,
> breathe like wrestlers, or shudder
> strangely after pissing. We want live
> words of the hip world live flesh &
> coursing blood.

Negating their status as art, poems should not ornament or represent the world but be as common objects in the world (a condition poems paradoxically achieve not as words but as poems). But the poem also metaphorizes poems as living beings, their active currency – "live words of the hip world" – essential to making poems live. Hipness here performed in part through an affronting vulgarity that tears through mores of poetic and socially legitimate language: one form of violation or violence for which poems are "useful."

Speech is the effective form of culture… Speech, the way one describes the natural proposition of being alive, is much more crucial than even most artists realize. Semantic philosophers are certainly correct in their emphasis on the final dictation of words over their users… Words have users, but as well, users have words. And it is the users that establish the world's realities. Realities being those fantasies that control your immediate span of life… The fantasy of America might hurt you, but it is what should be meant when one talks of "reality." Not only the things you can touch or see, but the things that make such touching or seeing "normal." Then words, like their users, have a hegemony. Socially – which is final, right now. *If you are some kind of artist, you naturally might think this is not so. There is the future.*

Amiri Baraka (LeRoi Jones), "Expressive Language" (1963; italics added)

The more spectacular imagined violence of the poem, however, involves poems figured as (highly masculinized) human agents: in an inversion of lyric apostrophe, poems are themselves personified: Baraka one-ups the *sine qua non* of poetry as "black art." Thus, while poems become weapons – "Black poems to/smear on girdlemamma mulatto bitches," "Poem scream poison gas on beasts in green berets" – they also more magically model the actions of revolutionary protagonists:

> […] we want "poems that kill."
> Assassin poems, Poems that shoot
> guns. Poems that wrestle cops into alleys
> and take their weapons leaving them dead
> with tongues pulled out and sent to Ireland. Knockoff poems for dope selling
> wops or slick halfwhite politicians Airplane poems, rrrrrrrrrrrrrrrr rrrrrrrrrr-
> rrrr . . .tuhtuhtuhtuhtuhtuhtuhtuhtuh
> . . .rrrrrrrrrrrrrrrr . . . Setting fire and death to
> whities ass. Look at the Liberal
> Spokesman for the jews clutch his throat
> & puke himself into eternity . . . rrrrrrrr

Pressing beyond the metaphors of directly ballisticized words, the poem theatrically, cartoonishly, portrays poems as engaged in political struggle: its macabre irony advertised in the quotation marks around "'poems that kill.'" This irony around poetry's political agency is present, too, in the poem's incorporation of sound effects: sonic mimesis of revolutionary violence: echoing Futurist engines and machine guns, but also radio serials as comix: erupts within the poem as if the real bursting through representation: but again as caricature. Likewise the grotesque graphicism of its racial clichés, its sick satire almost a version of the dozens.

The cover of Baraka's *Black Magic* "depicts a white, blond-haired, blue-eyed voodoo doll riddled with huge hat pins" (Harris). The poem itself is a stand-in for the doll: as though, through sympathetic magic, the actions portrayed in the poem done by poems are really done at-a-distance to their targets. Engaging poetry's metaphorically occult power to animate, posing itself as voodoo prop and as hex, the poem nonetheless figures its status as ersatz conjure in its irony, its angry humor.

Beyond these occult feints, however, Baraka employs the magic proper to the disenchanted world: the rigid performativity of slurs, slur as shortcut to persuasion or incitement. If the animacy that inflates poems as killers is here flouted as a fiction, the poem's efficacy as a mechanism of interpellation, of revolutionary animation, is in full effect: as a work of racial invective, "Black Art" works to summon "ethnic animosities common in black urban communities, to give them sharp political focus, and to transfer this politically informed emotion to his readers" (Smith).

CARDINAL of Aragon: No more, thou shalt know it.

 By my appointment, the great Duchess of Malfy, And two of her
 young children, four nights since, Were strangl'd.

JULIA (his mistress): O heaven! Sir, what have you done?

CARDINAL: How now! How settles this? Think you

 Your bosom will be a grave dark and obscure enough
 For such a secret?

JULIA: You have undone yourself, sir.

CARDINAL: Why?

JULIA: It lies not in me to conceal it.

CARDINAL: No! Come, I will swear you to't upon this book.

JULIA: Most religiously.

CARDINAL: Kiss it. Now you shall never utter it; thy curiosity

 Hath undone thee. Thou art poison'd with that book. Because I
 knew thou couldst not keep my counsel,
 I have bound thee to't by death.

John Webster, *The Tragedy of the Dutchesse of Malfy* (1612-13)

Trade-off between spell and performative is troped on even more pointedly in "Black People," *Black Magic*'s last poem:

> you cant steal nothin from a white man, he's already stole it he owes you
> anything you want, even his life. All the stores will open if you will say the
> magic words. The magic words are: Up against the wall mother fucker this is
> a stick up! […] We must make our own World, man, our own world, and we
> can not do this unless the white man is dead. Let's get together and kill him
> my man […] let's make a world we want black children to grow and learn in.

Citing a certain ritual formula backed by firearm, "Black People" edgily toes the line between "symbolic statement of defiance" and literal exhortation (Smith), one of a number of *Black Magic*'s poetic injunctions to kill.

In the 1967 Newark rebellion, Baraka was severely beaten by police, then falsely charged with illegal possession of two guns and resisting arrest. He was convicted by an all-white jury in a trial beset with a number of illegal irregularities. Before sentencing him, the white judge read "Black People" aloud to the courtroom, skipping the profanity, which the poet readily supplied; he added several years to Baraka's sentence, without parole (*Autobiography*). The decision was later reversed on lack of evidence.

In many later accounts and interviews, Baraka was to note (as he had apparently also stated in court), he was convicted of possession of guns "and a poem."

"up from" in shee ▌▌ 8 ▐▐ p's clothing ▌▌ 9 ▐▐ white hel per ▌▌ 9a ▐▐
"concern" for th ▌▌ 9b ▐▐ e next contestant cred ▌▌ 10 ▐▐ ible
witness comorb ▐▌▌▐▌▐▌▌▐▌ 1 ▐▐ id with accumulat ▌▌ 2 ▐▐ ed assets
white sub ▌▌ 3 ▐▐ sidies pros perity gosp ▌▌ 3a ▐▐ el for white grie
vance ▌▌ 4 ▐▐ tracking number ▌▌ 4a ▐▐ the customer is always ri ▌▌
5 ▐▐ ght corrections ▌▌ 6 ▐▐ strategy perception mana ▌▌ 7 ▐▐ gement
weaponized forw ▌▌ 8 ▐▐ ard weap onized ba ▌▌ 9 ▐▐ ckward windows
rolled ▌▌ 10 ▐▐ up alpha disc ▌▌ 10a ▐▐ retionary pilotlessness ▌▌
10b ▐▐ dog gy paddle dr ▐▌▌▐▌▐▌▌▐▌ 1 ▐▐ one drowning modified to f ▌▌
2 ▐▐ it your correctio ▌▌ 3 ▐▐ ns strategy EZPass quik ▌▌ 3a ▐▐ -
mourn Grief spit ▌▌ 4 ▐▐ cup Conveyor be ▌▌ 5 ▐▐ lt Stockpiled or
ware ▌▌ 6 ▐▐ hous ed A translation fro ▌▌ 6a ▐▐ m one point to ano
▌▌ 6b ▐▐ ther, one state to anothe ▌▌ 7 ▐▐ r The price of entry ▌▌ 8
▐▐ Sticker sho ▌▌ 9 ▐▐ ck Can't leave the ▌▌ 10 ▐▐ field Disaffili
ation as dom ▌▌ 10a ▐▐ ination Racele ▐▌▌▐▌▐▌▌▐▌ 1 ▐▐ ssness or Option
to ▌▌ 2 ▐▐ choose the ter ▌▌ 3 ▐▐ ms of one's member ▌▌ 4 ▐▐ ship
What's the ▌▌ 5 ▐▐ ask Can whitenes ▌▌ 6 ▐▐ s be its own authority
▐▐ 7 ▐▐ Weapo nized consent ▌▌ 8 ▐▐ T o own every psy ▌▌ 9 ▐▐ c hic
posit ion Conf isca ▌▌ 9a ▐▐ te Sirens wea ponize ▌▌ 10 ▐▐ song "If
yo u see someth ing, ▌▌ 10a ▐▐ say someth ▐▌▌▐▌▐▌▌▐▌ 1 ▐▐ ing" A

If "Black Art" mocks a fantasticated version of poetry's capacity for violence whilst exploiting poetry's other linguistic powers, a strong sense of the poem as exertion of sacred, creative force, surfaces in its final encomium:

> [...] Let Black people understand
> that they are the lovers and the sons
> of lovers and warriors and sons
> of warriors Are poems & poets &
> all the loveliness here in the world
>
> We want a black poem. And a
> Black World.
> Let the world be a Black Poem
> And Let All Black People Speak This Poem Silently
> or LOUD

In yet another inversion of lyric's specific magic and the poem's own figurative logic, both people and the world are *poemified*, in the image of poems personified as revolutionaries. Here poetry carries the superordinate value of rite, in a world recognized as made by its culture and its rituals: a "Black World" has to be spoken into being. Looking forward to lines from a later poem in the volume, "Ka 'Ba": "We need magic/now we need the spells, to raise up/return, destroy, and create. What will be// the sacred words?": Baraka suggests that the "sacred words" will belong to a poem: as cipher for the universally participatory, foundational speech act that produces a new world.

Political subjects speaking themselves into being: a paradoxical power. The poem seems both to figure and to gloss over the causal anomaly at the origin of a new political order: the final stanza split off from the poem's long column signals the autonomy of a Black world "that would be black without being not-white" (Brennan), yet the need to speak the poem "LOUD" renews a sense of oppositional violence. "*This Poem*": does the poem point to itself: *this* running poem of racial invective? Or the autonomous poem-to-come — ?

A dilemma Baraka had perhaps already resolved in "The Legacy of Malcolm X and the Coming of the Black Nation" (1965): "We do not want a Nation, we are a Nation. We must strengthen and formalize, and play the world's game with what we have, from where we are, as a truly separate people."

The false image and its critique threaten the common with democracy, which is only ever to come… But we already are. We're already here, moving… We surround democracy's false image in order to unsettle it. Every time it tries to enclose us in a decision, we're undecided. Every time it tries to represent our will, we're unwilling… [W]e cast the spell that we are under, which tells us what to do and how we shall be moved… We owe each other the indeterminate… We aren't responsible for politics. We are the general antagonism to politics looming outside every attempt to politicise, every imposition of selfgovernance, every sovereign decision and its degraded miniature, every emergent state and home sweet home… We cannot represent ourselves. We can't be represented. […]

The enunciation, of "nation time," when Amiri Baraka first sang it [1970: "It's Nation Time"]…is…really a kind of announcement of the international and, beyond and by way of that, the anti-national. Black nationalism, as an extension of Pan-Africanism…cuts the nation […] [T]he appeal to the nation is an anti-nationalism, in which the call to order is, in fact, a call to disorder, to complete lysis. […] The one who is said to have given the call is really an effect of a response that had anticipated him, that is the generative informality out of which his form emerges…and that combination of answer and question, that gathering in the break of all those already broken voices…takes the form of a demand, that shows up in the guise of a single voice or a national call. It's like a delirium…putting on the habit, of a sovereign articulation, something that an "I" or a "we" would say. But what it is, really…is a relay of breath that comes from somewhere else, that seems like it comes out of nowhere. It's easy…to get the whole thing wrong by thinking about it in terms of an origin…this constant organization and disorganization of the demand that takes the form-in-deformation of a single voice consenting to and calling for its multiplication and division.

Stefano Harney and Fred Moten, *The Undercommons: Fugitive Planning & Black Study* (2013)

The Undercommons inscribes an anti-politics propagated through and as blackness: blackness understood as what "operates as the modality of life's constant escape…the held and errant pattern, of flight" from capital and governance's vicious logics of enclosure and self-enclosure. As the "general antagonism," "blackness" names life's slipping of these snares specifically as prior to and product of Middle Passage: that catastrophic imposition of homelessness and enslavement unremittingly adumbrated in structures predicated on the foreclosure of blackness from political ontology, from subjectivity. Thus "without standing," blackness has also always been the positive refusal of this refusal: a fugitive, improvisatory sociality made up of those who are each "more and less than one," that unfolds absent every mechanism of normative order: without sovereignty, without self-possession, without interpellation, without recognition, without representation, without statement of interests, without identity, without organization, without corrective or self-corrective discipline, without democracy, without responsibility, without decision. The "undercommons" or "the surround" is the unenclosable, unlocatable field – potentially everywhere but also u-topian – of this "appositional" blackness.

Abiding yet flown, blackness is already there, but not as the always already: as motion, as becoming, it is "before and before, the already and the forthcoming." Black nationalism thus never enacted an authorized, authorizing, properly inaugural "call to order," Moten asserts: the one who calls is already caught within response, its hailing already enfolded; the voice calling "undermines the univocal authority of sovereignty" in its consent to "multiplication and division." A form forming (out of) a generative informality, the call is altogether incommensurate with origination: it emits but is also emitted by a "multiphonic," anti-political demand towards self-defense and planning: "the ceaseless experiment with the futurial presence of the forms of life" already there.

Harney and Moten sketch an exit from critique: bound to what it opposes, holding down the fort: they propose a mode of defense that preserves fugitivity, forgoing even weaponization:

> Taking down our critique, our own positions, our fortifications, is self-defense alloyed with self-preservation. That takedown comes in movement, as a shawl, the armor of flight. We run looking for a weapon and keep running looking to drop it. And we can drop it, because however armed, however hard, the enemy we face is also illusory.

1 ⫸ ⫸ 2 ⫸ ⫸ 2a ⫸ ⫸ 3 ⫸ ⫸ 3a ⫸ ⫸ 4 ⫸ ⫸ 4a ⫸ ⫸ 4b ⫸ ⫸ 5 ⫸ ⫸ 5a ⫸ ⫸ 6 ⫸ ⫸ 6a ⫸ ⫸ 7 ⫸ ⫸ 8 ⫸ ⫸ 9 ⫸ ⫸ 9a ⫸ ⫸ 10 ⫸ ⫸ 10a ⫸ ⫸⫸⫸⫸⫸⫸

But as Moten elaborates a metaphor for collaboration – envisioned as a form of play with concepts and terms – something that looks like weaponization returns:

> You can either talk about it as having a kind of toolbox or also talk about it as having a kind of toybox. With my kids, most of what they do with toys is turn them into props. They are constantly involved in this massive project of pretending. And the toys that they have are props for their pretending. They don't play with them the right way – a sword is what you hit a ball with and a bat is what you make music with. I feel that way about these terms. In the end what's most important is that the thing is put in play. What's most important about play is the interaction… There are these props, these toys, and if you pick them up you can move into some new thinking and into a new set of relations… In the end, it's the new way of being together and thinking together that's important, and not the tool, not the prop.

In tool abuse, tools are decoupled from the purposes etched into them, made to serve another agency and complete another task they may resist. Toys, whatever form they take (even weapons), are here described as props in an open game: what is done with them torques their qualities towards no given task: at stake is a creative process of relation, an unmapped possibility of thought. Toys are exterior to the tactical imaginary: the social field they structure short-circuits aggressivity.

And yet…

There is an ultrathin line between toy and tool.

Every toy may succumb to weaponization.

dominance af ▮▮ 2 ▮▮ fect Vocal sub traction ▮▮ 3 ▮▮ Subvocal Dummy tra ▮▮ 4 ▮▮ ck torrent Bullet po ▮▮ 5 ▮▮ ints Police as hunter ▮▮ 6 ▮▮ This "law" ha ▮▮ 7 ▮▮ s no repai r ▮▮ 8 ▮▮ Wha t is neede ▮▮ 9 ▮▮ d Can we go from th ▮▮ 10 ▮▮ ere ▮▮▮▮▮▮▮▮▮

Under the spreading chestnut tree
I sold you and you sold me
There lie they and there lie we
Under the spreading chestnut tree

George Orwell, *1984* (1949)

Acknowledgments/metadata

My thanks to the editors of *Bone Bouquet*, *The Claudius App*, *Poetic Series*,
Make, and *6x6*, where (versions of) some of these poems first appeared.

My thanks and admiration to artist Carole Shymanski,
for her work with "[drag reduct."

My love and thanks to Holly Melgard, Joey Yearous-Algozin, Macy Todd,
Allison Siehnel, Lewis Freedman, and Ryan Sheldon for reading
and commenting on poems and/or discussing the book.

My enormous gratitude to Lynne DeSilva-Johnson for her design
and for her unflagging support as I worked on this project.

I am so deeply humbled by the brilliance and generosity of Aaron Kunin, Cathy
Wagner, and Allison Cardon. Thank you for helping me to make this book.

To Damien Keane: you disarm me: how I love you (thus) beyond words.
Thank you for everything.

Works Cited & Consulted

For in-text prose citations without titles and poetry sources (not all poetry sources are listed). Works are listed in order of appearance. For texts in translation, date of first publication is given. If the author is linked to more than one text, the text is re-cited for clarification.

Amiri Baraka, "Black Art." *Liberator* (1966).

Chantal Mouffe, *Agonistics: Thinking the World Politically* (2013).

Richard Slotkin, *Regeneration through Violence: The Mythology of the American Frontier, 1600-1860* (1973). Several phrases on this page stem from comments by Allison Cardon, personal correspondence (2016).

Jacques Lacan, "The Mirror Stage as Formative of the I Function" (1936). *Écrits* (1966).

Paul Ricoeur, *Freud and Philosophy: An Essay on Interpretation* (1970).

Eve Sedgwick, "Paranoid Reading and Reparative Reading, Or, You're So Paranoid, You Probably Think This Essay Is About You." *Touching Feeling* (2003).

Timothy Melley, *Empire of Conspiracy: The Culture of Paranoia in Postwar America* (2000).

Lauren Berlant, *Cruel Optimism* (2011).

Rob Nixon, *Slow Violence and the Environmentalism of the Poor* (2011).

Todd McGowan, *The End of Dissatisfaction: Jacques Lacan and the Emerging Society of Enjoyment* (2003).

Zygmunt Bauman, *Alone Again: Ethics After Certainty* (1994).

"Foot binding," Wikipedia.

B. Swift and G. N. Rutty, "The Exploding Bullet." *Journal of Clinical Pathology* (2004).

Tom McKay, "A New Bullet Has Been Invented. This Is What It Looks Like." *mic.com* (2014).

Constitution of the United States, Article I, Section 2.

"Christian Michael Longo." *Murderpedia.*

Naomi Klein, *The Shock Docrine: The Rise of Disaster Capitalism* (2007).

Brian Resnik, "Living Cadavers: How the Poor Are Tricked into Selling Their Organs." *The Atlantic* (2012).

Judith Butler, *The Psychic Life of Power: Theories in Subjection* (1997).

Steven Connor, *Dumbstruck: A Cultural History of Ventriloquism* (2000).

Bryan Finoki, interview with Léopold Lambert. *Weaponized Architecture: The Impossibility of Innocence* (2013).

Wendy Brown, "In the 'folds of our own discourse': The Pleasures and Freedoms of Silence." *The University of Chicago Law School Roundtable* (1996).

Greg Downey, "Producing Pain: Techniques and Technologies of No-Holds-Barred Fighting." *Social Studies of Science* (2007).

Jacques Lacan, *The Seminar of Jacques Lacan, Book II: The Ego in Freud's Theory and in the Technique of Psychoanalysis 1954-1955* (1991).

Christof Rapp, "Aristotle's Rhetoric." *The Stanford Encyclopedia of Philosophy* (2010).

Thomas Farrell, "Aristotle's Enthymeme as Tacit Reference." *Rereading Aristotle's Rhetoric* (1999).

Jacques Lacan, "The Agency of the Letter in the Unconscious or Reason Since Freud" (1966). *Écrits* (1966).

Elizabeth Abel, "Bathroom Doors and Drinking Fountains: Jim Crow's Racial Symbolic." *Critical Inquiry* (1999).

Robert Newsom, *A Likely Story: Probability and Play in Fiction* (1988).

Luis Vega Renon, "Aristotle's Endoxa and Plausible Argumentation." *Argumentation* 12 (1998).

Barthes cited in Trinh T. Minh-ha, "The Totalizing Quest of Meaning." *When the Moon Waxes Red: Representation, Gender, and Cultural Politic*s (1991).

Antonio Gómez-Moriana, *Discourse Analysis as Sociocriticism: The Spanish Golden Age* (1993).

Don Bialostosky, "Aristotle's Rhetoric and Bakhtin's Discourse Theory." *A Companion to Rhetoric and Rhetorical Criticism* (2004).

Center for Reproductive Rights. "Punishing Women for Their Behavior During Pregnancy: An Approach That Undermines Women's and Children's Interests" (2000).

Sigmund Freud, "Fetishism" (1927).

Michael McGee, "Text, Context, and the Fragmentation of Contemporary Culture." *Western Journal of Speech Communication* (1990).

Krista Ratcliffe, "In Search of the Unstated: The Enthymeme and/of Whiteness." *JAC* (2007).

Antoine Berman, "Translation and the Trials of the Foreign" (1985). *The Translation Studies Reader* (2000).

Johanna Drucker "From Mallarme to Metadata: The Rhetoric of the Book in Traditional and Electronic Forms." *Link* (2002).

Jerome McGann, *Radiant Textuality: Literary Studies After the World Wide Web* (2001). Cited in Drucker.

Tan Lin, *7 Controlled Vocabularies and Obituary 2004: The Joy of Cooking* (2010).

Brad Pasanek and Chad Wellmon, "The Enlightenment Index." *Eighteenth Century* (2005).

Pierre Bourdieu, *Outline of a Theory of Practice* (1972).

Michael McGee, "Text, Context, and the Fragmentation of Contemporary Culture."

Pierre Bourdieu, "Symbolic Power" (1977). *Critique of Anthropology* (1979).

Pierre Bourdieu, *Language and Symbolic Power* (1990).

Peter Sloterdijk, *Critique of Cynical Reason* (1983).

Paolo Vaz and Fernanda Bruno, "Types of Self-Surveillance: From Abnormality to Individuals 'At Risk.'" *Surveillance & Society* (2003).

Paolo Virno, "The Ambivalence of Disenchantment." *Radical Thought in Italy: A Potential Politics* (1996).

Slavoy Žižek, *The Sublime Object of Ideology.*

Kenneth Goldsmith, "If It Doesn't Exist on the Internet, It Doesn't Exist" (2005).

Han-yu Huang, "Conspiracy and Paranoid-Cynical Subjectivity in the Society of Enjoyment." *NTU Studies in Language and Literature* (2007).

Pierre Bourdieu, *Language and Symbolic Power.*

Frank Reeves, *British Racial Discourse: A Study of British Political Discourse about Race and Race-Related Matters* (1983).

Charles Mills, *The Racial Contract* (1997).

Melanie Bertrand, "Differing Functions of Deracialized Speech: The Use of Place Names to Index Race in Focus Groups with African American and White Parents." *Text & Talk* (2010).

Achilles Tatius (William Burton, trans.), *The most delectable and pleasaunt history of Clitiphon and Leucippe: written first in Greeke, by Achilles Statius, an Alexandrian: and now newly translated into English, by V.V.B. Whereunto is also annexed the argument of euery booke, in the beginning of the same, for the better vnderstanding of the historie* (1597).

Sigmund Freud, *Civilization and Its Discontents* (1930).

Susan Schmeiser, "Punishing Guilt." *American Imago* (2007).

Robin DiAngelo, "White Fragility." *International Journal of Critical Pedagogy* (2011).

Sianne Ngai, *Ugly Feelings* (2005).

Jelani Cobb, "Race and the Free-Speech Diversion." *The New Yorker* (2015).

Mari Matsuda, "Public Response to Racist Speech: Considering the Victim's Story." *Words That Wound: Critical Race Theory, Assaultive Speech, and the First Amendment* (1993).

Charles Lawrence III, "If He Hollers Let Him Go: Regulating Racist Speech on Campus." *Words That Wound.*

Judith Butler, *Excitable Speech: A Politics of the Performative* (1997).

Richard Delgado, "Words That Wound: A Tort Action for Racial Insults, Epithets, and Name Calling." *Words That Wound*.

Lauren Berlant, "The Subject of True Feeling: Pain, Privacy, and Politics." *Cultural Pluralism, Identity Politics, and the Law* (1999).

Melanie Klein, "The Psychogenesis of Manic-Depressive States" (1935).

Jean-François Lyotard, *The Differend: Phrases in Dispute* (1983).

Anita Bernstein, "Abuse and Harassment Limit Free Speech." *Pace Law Review* (2014).

Charles Darwent, "Louis Bourgeois: Inventive and Influential Sculptor Whose Difficult Childhood Informed Her Life's Work." *Independent* (2010).

Constantine Nakassis, "Para-s/cite, Part I. The Parasite." *Semiotic Review* (2014).

Sueyeun Juliette Lee, "Shock and Blah: Offensive Postures in 'Conceptual' Poetry and the Traumatic Stuplime." *Evening Will Come* (2014).

Marcel Mauss, A*n Essay on the Gift: The Form and Reason of Exchange in Archaic Societies* (1925).

Denise Schmandt-Besserat, "Two Precursors of Writing: Plain and Complex Tokens." *The Origins of Writing* (1991).

J. L. Austin, *How to Do Things with Words* (1955).

Marquis de Sade, *The 120 Days of Sodom* (1785).

Arjun Appadurai, *Banking on Words: The Failure of Language in the Age of Derivative Finance* (2016).

Jacques Derrida, *Limited Inc.*

J. Hillis Miller, Speech Acts in Literature (2001).

Vanessa Place, artist statement. Cited in Bertram, "Canvases Pale."

Vanessa Place, "The Death of the Text: Kenneth Goldsmith at the White House." *Harriet: The Blog* (2011).

Erving Goffman, "On Face-Work: An Analysis of the Ritual Element in Social Interaction." *Journal for the Study of Interpersonal Processes* (1955).

Jacques Derrida, *Specters of Marx: The State of the Debt, the Work of Mourning, and the New International* (1993). (Note: Derrida's first talk on the founding performative (in relation to the Declaration of Independence) was given in 1976 (Miller); it was first published in 1984 (English in 1988).

Angela Esterhammer, *The Romantic Performative: Language and Action in British and German Romanticism* (2002).

J. Hillis Miller, *Speech Acts in Literature.*

Jacques Derrida, "Declarations of Independence."

Gilles Deleuze and Felix Guattari, "Year Zero: Faciality." *A Thousand Plateaus* (1980).

Jacques Derrida, *Specters of Marx.*

Judith Butler, *Excitable Speech.*

J. Hillis Miller, *Speech Acts in Literature.*

Suzanne Cusick, "An Acoustemology of Detention in the 'Global War on Terror." *Music, Sound and the Reconfiguration of Public and Private Space* (2013).

Suzanne Cusick, "Across An Invisible Line: A Conversation about Music and Torture." *Grey Room* (2010).

These passages from Derrida are cited in Jonathan Culler, "'The Most Interesting Thing in the World." Diacritics (2008) and J. Hillis Miller, "Derrida and Literature." *Derrida and the Humanities: A Critical Reader* (2002).

Jacques Derrida, *The Gift of Death & Literature in Secret* (2008). [trans. David Wills]

Jacques Derrida, *Given Time: I. Counterfeit Money* (1991).

Branden Joseph, "Biomusic." *Grey Room* (2011).

David Wills, "Passionate Secrets and Democratic Dissidence." *Diacritics* (2008).

Plato, *Protagoras*.

Jennifer Welsh, "Three Ukrainian Killer Attack Dolphins Are on the Loose in the Black Sea." *Business Insider* (2013).

Bronislaw Malinowski, *Argonauts of the Western Pacific* (1922).

"Literarizing" in Derrida is also discussed by Chris Danta, "Derrida and the Test of Secrecy." *Angelaki* (2013).

Jacques Derrida "This Strange Institution Called Literature" (interview with Derek Attridge; 1989). *Acts of Literature* (1992).

Jacques Derrida, "Literature in Secret: An Impossible Filiation" (1999). [trans. Adam Kotsko]

Konrad Lorenz, *On Aggression* (1963).

James Loxley, *Performativity* (2006). Goffman is cited in Loxley.

Stewart is cited in Dwight Conquergood, "Performance Studies: Interventions and Radical Research." *The Drama Review* (2002).

John Searle, "The Logical Status of Fictional Discourse." *New Literary History* (1975). Cited in Derrida, *Limited Inc.*

Chris Chen and Tim Kreiner, "Free Speech, Minstrelsy, and the Avant-Garde." *Los Angeles Review of Books* (2015).

Robert Fitterman, "I FEEL YOUR PAIN… or, Reimagining Irony." *Evening Will Come* (2015).

Stanley Fish, *Is There a Text in This Class?: The Authority of Interpretive Communities* (1982). Cited in Loxley.

See, for instance, Jacques Rancière, *The Politics of Aesthetics* (2000).

Wayne Booth, *A Rhetoric of Irony* (1974). Cited in de Man.

Leslie Roman, "Denying (White) Racial Privilege: Redemption Discourses and the Uses of Fantasy." *Off White: Readings on Race, Power, and Society* (1997).

Lillian-Yvonne Bertram, "Canvases Pale: A Minstrelsy So Easily Absorbed." *Harriet: The Blog* (2015).

Gloria E. Anzaldúa and Cherríe Moraga, *This Bridge Called My Back: Writings by Radical Women of Color* (1981).

Lillian-Yvonne Bertram, "The Whitest Boy Alive: Whiteness Within the Field of Itself." *Harriet: The Blog* (2015).

Anna Vitale, "The Blackness of Holly Melgard's 'Black Friday.'" *Jacket2* (2016).

Thoughts on hospitality draw on Alison Jeffers, *Refugees, Theatre and Crisis: Performing Global Identities* (2012).

Saidiya Hartman, *Scenes of Subjection: Terror, Slavery, and Self-Making in Nineteenth-Century America* (1997).

The brevity of this discussion risks flattening the nuances of Baraka's constantly changing/evolving political beliefs in this decade. Baraka had Communist or internationalist leanings early on (ironically, it was on such charges, at the time erroneous, that he was dismissed from the Air Force in the mid-50s): these crystallized upon his 1966 return to Newark from Harlem, as he notes in the 2009 introduction to *Home: Social Essays* (1966).

David Smith, "Amiri Baraka and the Black Arts of Black Art." *boundary 2* (1986).

Sherry Brennan, "On the Sound of Water: Amiri Baraka's Black Art." *African American Review* (2003).

Amiri Baraka, *The Autobiography of LeRoi Jones* (1984).

Stefano Harney and Fred Moten, *The Undercommons: Fugitive Planning and Black Study* (2013).

Jackie Wang, "Against Innocence: Race, Gender, and the Politics of Safety." *LIES: Journal of Materialist Feminism* (2012).

Zeus Leonardo, "The Color of Supremacy: Beyond the Discourse of 'White Privilege.'" *Educational Philosophy and Theory* (2004).

Cynthia Levine-Rasky, "Framing Whiteness: Working through the Tensions in Introducing Whiteness to Educators." *Race, Ethnicity, and Education* (2000).

Steve Martinot and Jared Sexton, "The Avant-Garde of White Supremacy." *Social Identities* (2003).

about the author

(photo: Bruce Jackson)

Judith Goldman is the author of *Vocoder* (Roof, 2001), *DeathStar/rico-chet* (O Books, 2006), *l.b.; or, catenaries* (Krupskaya, 2011), and *agon* (The Operating System, 2017). She teaches in the Poetics Program at SUNY, Buffalo and is the Poetry Features editor for the online journal Postmodern Culture. She's currently at work on _____ *Mt. [blank mount]*, a critical-creative project that writes through P. B. Shelley's "Mont Blanc" (and Mary Shelley's *Frankenstein*) in the context of past futures and future histories of ecological collapse, and recently performed a collaborative digital poetics project, *Ice Core Modulations*, at The Ammerman Center Biennial Symposium on Arts and Technology (2016). Her scholarship focuses on contemporary poetry as "extinction sink."

Judith Goldman in conversation with
OS editor/founder Lynne DeSilva-Johnson

We are talking with Judith Goldman, author of agon. *Thank you for being willing to answer some questions about your process for our readers!*

Talk about the process or instinct to move agon *into book form. Have you had this intention for a while? Did you envision agon as a collection or understand your process as writing specifically around a theme while this work was being written? How or how not? What encouraged and/or confounded this (or a book, in general) coming together? Was it a struggle?*

What became agon was begun a number of years ago (about the summer of 2012) when I was searching for a prosody that could somehow express the inner and outer violence of monetization, especially, in so many ways, of the human body. I wanted to make a staccato performance poem composed of short phrases punctuated by numbers that would maybe go up to 20 and start over. At that time I was listening a lot to Azealia Banks's "212" – practically every other word rhymes, the whole song fits together so intricately… Didn't know what I was doing exactly, the way I was trying to mimic Banks's flow within and against the number structure wasn't working; I dropped it but had the poem in the back of my mind.

About two years later, I started to notice the word "weaponize" appearing everywhere. I started making lists of examples I had heard/seen but then expanded the lists to include all the social phenomena that might fit, even speculatively. Began to think about "weaponizing" as a lens for understanding the world, in relation to biopolitics (from the plantation down to intracellular commodification, i.e. micro-plantation), to sociality as anatomized and proliferated through social media, to financialization. (Obsessing about this last as I was writing about K. Lorraine Graham's poems on debt and (affective) labor for *Postmodern Culture*.)

What formal structures or other constrictive practices (if any) do you use in the creation of your work — or did you use in the creation of the work in agon?

A lot of my work is composed using both traditional and made-up highly structured forms, at micro- and macro-levels (e.g., from rhyme to larger book organization). For instance, the end of the titular poem in my book DeathStar/Rico-chet reworks Zukofsky's A-7, from the perspective of the army staff in Abu Ghraib. Embodying a canzone – a chain of sonnets that interlock through their sound-schemes and repeated words – Zukofsky's poem reflects on a wooden sawhorse in the shape of an "A." In turn, my poem, also a canzone, thinks about letters in relation to the bars of a prison-cage. I was interested in how such an exquisite, baroque, mellifluous poetic form could take on a more regimented, tortuous, and possibly narrative character, given its content. Other poems I've made work with amalgamations of appropriated material: part of the intrigue, for me, is to find latent forms/patterns within found materials to expose, as well as to impose forms that do battle with their content. Or to push things to absurdity: I've had a sestina on the back burner that's in *rime riche*: the end-words are *pear, pair, per, père, pare*, and *par* (with some variations that make it (even) more ridiculous).

With *agon*, I was still attached to the numerical prosody (I mention above). I planned to write a 1000-unit poem (100 stanzas of ten units), with the numbers present as a kind of foot or beat. One day I was fooling around in Microsoft Word with symbols collections, and experimented with bolding and combining vertical lines of various widths until I came up with the ersatz barcodes. I organized and reorganized the lists of weaponized items into themes and started numbering the phrases in cycles of ten, using the barcodes for spacing and as a kind of pun on reading/scanning. The "a" and "b" adjuncts to the numbers got introduced when I had formatted chunks of the list but was not done composing and reorganizing and had to make additions (!). The formatting was a bitch (*as you know!*), so that was my solution. And I embraced it, I felt it made the poems look even more impenetrably bureaucratic and ugly. And mean. The poems got more distressed as I then experimented with breaking up words even across the numbered units, creating confusion as to where many words begin and end, affecting very basic or mechanical levels of interpretation.

This circles back to the question of form: creating provocations around how we read – which so often now involves an almost autonomic intake of flows of information – has always been important to me. Ironically, while the overall structure came out of an impulse to produce (what for me would be) a new prosody, I ended up with poems that are a challenge to perform aloud. I honestly don't know yet how I will score them (though they look so ominously pre-scored) – there are a lot of choices to make.

With regard to mixing the barcode poems with exposition: as I dug deeper into weaponization as our social ontology, Baraka's poem "Black Art" kept coming to mind – I would think about it almost daily, parsing out the layers of its movements and feints. I wanted to try to combine writing *about* Baraka's enactment of how to (literally and figuratively) do things with words with my own poetic enactments. And then after I participated in the "Color, Crosstalk, Composition" conference at UC, Berkeley and taught another iteration of my seminar "The Political Economy of Affect," I began to think about how to connect the elements I had with further expository writing on different angles and layers of various profound political problems – involving race, class, gender, language, affect, poetics, appropriation, institutionality/education, power, and relation itself – that were/are being underscored in the last couple of years as central to poetic community/communities.

Speaking of monikers, what does your title represent? How was it generated? Talk about the way you titled the book, and how your process of naming (poems, sections, etc) influences you and/or colors your work specifically.

Above you ask whether bringing this book together was a "struggle": *agon* means "struggle" or conflict. I wanted not to thematize conflict, but to get at how the tools we have for thinking about it, really the way we do almost everything in this society, has agon embedded within it. Later I learned of Chantal Mouffe's term "agonistics" (which gets mentioned in the book), though I had had a somewhat different definition in mind.

Can you speak to the influence of certain teachers or instructive environments, or readings/writings of other creative people (poets or others) which inform the way you work/write?

I began this work entranced with Leslie Scalapino's *The Dihedrons Gazelle-Dihedrons Zoom*, dazzled and challenged by the multitude of threads it interweaves. I'm not saying I succeed (!), but I wanted to try to ask (and respond to) questions posed in the style of my colleague and friend Myung Mi Kim. I have been also been taken with what feels like a more discursive style – I suppose along the lines of "lyric essay" – that has been appearing recently: Ronaldo Wilson, Catherine Taylor, Christine Hume, Brandon Brown, Gabriel Gudding, Allison Cobb, Aja Duncan, and especially Nathanaël (who has been writing this way for a long time and whom I admire in the extreme). All these writers are so different, and each writes so beautifully. Hard to say what I mean. I know the expository writing in this book is closer to academic writing (though it has an agonistic relation to it) than to any of these. I also have discursive crushes on Barthes and Lyotard (of *The Differend*), though obviously I cannot approximate them (not (only) because of French!). I did feel sometimes

I got their tone in my head when writing even if I couldn't voice it. I'm not answering the question.

Tell us a little about the relationship between scholarship and poetics in your life and practice — in agon you are drawing on a long list of source material, and moving between different types of language (both your own and in that source material); the result is, for me, a deeply scholarly poetics, but at the same time one that explodes and is critical of the ways in which we make scholarship (both in its content and form).

Can you shine a little light on how or if agon is representative of your body of work, scholarship, or practice outside of this volume? In your opinion, what can poets, even outside the academy, gain from scholarship, and what can scholars, even outside of poetics, gain from both creating and engaging with poetry?

One of my methods (?) for making poems has been to mix sources from a variety of discourses and registers/dictions – performing a purposely cacophonous heteroglossia and trying to create illuminating if jarring juxtapositions. I'm interested in using problematic concatenation as a form of inquiry. In my first book *Vocoder*, there's a poem I wrote in college that combines the words from the instructional sticker on my answering machine with a paragraph from Kant's third critique on the sublime, it's called, "Can the Sublime Be Recorded?" On the file cabinet I had in my apartment as a grad student was an ad for some kind of service called "Materials Handling" that I strongly identified with – it was taped alongside the front of a Green Giant box of "Individual Green Beans" and a grainy page from an old *National Geographic* depicting the fancy stockings and shoes of a *torero* in the ring.

Many of the texts I work with in *agon* I've been studying for a long time, since I was in school. They very much reflect that mid-90s milieu in English and Comp Lit departments, though I don't think that makes them less relevant to now. (What is the time of discourse, especially in the humanities?) As I get older, continuing to experience cultural politics at large and the politics of the academy, I get a bit more of a sense of the dynamics of discursive/cultural fields – and it has in turn started to seem more possible to me to meld scholarship with poetry. Or maybe I should say I want to push my scholarship to x-ray discourse the way I feel poetry often does. Though I wouldn't say this book accomplishes that meld in the more radical (and aesthetic) way I feel some of my peers have achieved, it's my first attempt at a cross-genre work, and I'm grateful to The Operating System for inspiring and supporting it.

In terms of thinking about the academy and institutionality: Bourdieu and his idea of "reflexive sociology" is important to *agon*: loosely speaking, Bourdieu's m.o. is to turn the

lens of criticism on the academy reflexively, scrutinizing very critically how academia, its hierarchies, fetishes, rituals, and languages are constituted. While I engage in questioning the academy as network of power and world-making, I am nonetheless implicated in it by using some of its tools: I would never claim to write completely without mystification or to take my own writing and institutional standing out of their race-class-gender relations. But I see it as part of my work to think about and question particularly these tools of language, how they actively structure our lives, as well as to understand their history, to work to de-limit them so as to use them scrupulously if also irreverently or ludically or deconstructively or over-mimetically.

And the world is filled with knowledge that is (to some extent, *contra* Bourdieu) specialized not only for purposes of social distinction. I can't fix a car, I can't explain the Federal Reserve System. As I see it, examining the nexes of violence-language involves a kindred depth of thought/education/practice/ understanding/experience to knowledges of other domains. I make this inquiry through both poems and analytic prose.

Possibly this book may invite readers beyond people who already identify as readers of poetry, because of its more "scholarly" exposition. (I hope so.) But drawing the line between the inside/outside of the academy is not a simple matter, a complexity that goes beyond politics of academic labor/remuneration/exploitation/ debt. *agon* takes up top-ics that many in poetry communities in the United States (and elsewhere) are concerned about and tries to do a bit of work on parsing out the problems and their terms, for myself but also for others' thought to further (and shift, refute, etc.). Many poets are academics (whether students or teachers or both); but perhaps more importantly many are intellectu-als who live with this scholarly discourse alongside many others as an integral part of life. It is especially poets' conversations, their expository writing, as well as their poetry, in many forums/platforms, that fed this work.

I also want to say how important if also imperfect the university is in this society. How important if again imperfect many institutions are. How so much of the work that is done in universities is service work and care work, how important education is (which is not to say education only happens in universities). Perhaps in this moment of their great peril, we will be able to see again institutions' value and move to save if also to reshape and re-imagine them.

WHY PRINT / DOCUMENT?

*The Operating System uses the language "print document" to differentiate from the book-object as part of our mission to distinguish the act of documentation-in-book-FORM from the act of publishing as a backwards facing replication of the book's agentive *role* as it may have appeared the last several centuries of its history. Ultimately, I approach the book as TECHNOLOGY: one of a variety of printed documents (in this case bound) that humans have invented and in turn used to archive and disseminate ideas, beliefs, stories, and other evidence of production.*

Ownership and use of printing presses and access to (or restriction of) printed materials has long been a site of struggle, related in many ways to revolutionary activity and the fight for civil rights and free speech all over the world. While (in many countries) the contemporary quotidian landscape has indeed drastically shifted in its access to platforms for sharing information and in the widespread ability to "publish" digitally, even with extremely limited resources, the importance of publication on physical media has not diminished. In fact, this may be the most critical time in recent history for activist groups, artists, and others to insist upon learning, establishing, and encouraging personal and community documentation practices. Hear me out.

With The OS's print endeavors I wanted to open up a conversation about this: the ultimately radical, transgressive act of creating PRINT /DOCUMENTATION in the digital age. It's a question of the archive, and of history: who gets to tell the story, and what evidence of our life, our behaviors, our experiences are we leaving behind? We can know little to nothing about the future into which we're leaving an unprecedentedly digital document trail — but we can be assured that publications, government agencies, museums, schools, and other institutional powers that be will continue to leave BOTH a digital and print version of their production for the official record. Will we?

As a (rogue) anthropologist and long time academic, I can easy pull up many accounts about how lives, behaviors, experiences — how THE STORY of a time or place — was pieced together using the deep study of correspondence, notebooks, and other physical documents which are no longer the norm in many lives and practices. As we move our creative behaviors towards digital note taking, and even audio and video, what can we predict about future technology that is in any way assuring that our stories will be accurately told – or told at all?

As a creative practitioner, the stories, journals, and working notes of other creative practitioners have been enormously important to me. And yet so many creative people of this era no longer put together physical documents of their work – no longer have physical archives of their writing or notebooks, typed from the first draft to the last, on computers. Even visual artists often no longer have non-digital slides and portfolios. How will we leave these things for the record?

How will we say WE WERE HERE, WE EXISTED, WE HAVE A DIFFERENT STORY?

////////THE OPERATING SYSTEM IS A QUESTION, NOT AN ANSWER.

THIS is not a fixed entity.

The OS is an ongoing experiment in resilient creative practice which necessarily morphs as its conditions and collaborators change. It is not a magazine, a website, or a press, but rather an ongoing dialogue ABOUT the act of publishing on and offline: it is an exercise in the use and design of both of these things and their role in our shifting cultural landscape, explored THROUGH these things.

I see publication as documentation: an act of resistance, an essential community process, and a challenge to the official story / archive, and I founded the OS to exemplify my belief that people everywhere can train themselves to use self or community documentation as the lifeblood of a resilient, independent, successful creative practice.

The name "THE OPERATING SYSTEM" is meant to speak to an understanding of the self as a constantly evolving organism, which just like any other system needs to learn to adapt if it is to survive. Just like your computer, you need to be "updating your software" frequently, as your patterns and habits no longer serve you. Our intentions above all are empowerment and unsilencing, encouraging creators of all ages and colors and genders and backgrounds and disciplines to reclaim the rights to cultural storytelling, and in so doing to the historical record of our times and lives.

Bob Holman once told me I was "scene agnostic" and I took this as the highest compliment: indeed, I seek work and seek to make and promote work that will endure and transcend tastes and trends, making important and asserting value rather than being told was has and has not.

The OS has evolved in quite a short time from an idea to a growing force for change and possibility: in a span of 5 years, from 2013-2017, we will have published more than 40 volumes from a hugely diverse group of contributors, and solicited and curated thousands of pieces online, collaborating with artists, composers, choreographers, scientists, futurists, and so many more. Online, you'll also find partnerships with cultural organizations modelling the value of archival process documentation.

Beginning in 2016, our new series :: "Glossarium: Unsilenced Texts and Modern Translations", had as its first volume a dual language Arabic-English translation of Palestinian poet and artist Ashraf Fayadh's "Instructions Within," followed by three Cuban Spanish-English translations by Margaret Randall.

There is ample room here for you to expand and grow your practice …and your possibility. Join us.

- Lynne DeSilva-Johnson, Founder/Managing Editor,
THE OPERATING SYSTEM, Brooklyn NY 2016

TITLES IN THE PRINT: DOCUMENT COLLECTION